ROBERT RAUSCHENBERG

OCTOBER FILES

ROBERT RAUSCHENBERG

edited by Branden W. Joseph

essays by Leo Steinberg, Rosalind Krauss, Douglas Crimp, Helen Molesworth, and Branden W. Joseph

OCTOBER FILES 4

The MIT Press
Cambridge, Massachusetts
London, England

This book was set in Bembo and Stone Sans by Graphic Composition, Inc., Athens, Georgia, and was printed and bound in the United States of America.

Library of Congress Cataloging-in-Publication Data

Robert Rauschenberg / edited by Branden W. Joseph ; essays by Leo Steinberg . . . [et al.].
 p. cm. — (October files ; 4)
 Includes index.
 ISBN 0-262-10096-7 (hc. : alk. paper) — ISBN 0-262-60049-8 (pbk. : alk. paper)
 1. Rauschenberg, Robert, 1925– —Criticism and interpretation. I. Rauschenberg, Robert, 1925– II. Series.

N6537.R27 R63 2002
709'.2—dc21

2002071823

Contents

OCTOBER Files addresses individual bodies of work of the postwar period that meet two criteria: they have altered our understanding of art in significant ways, and they have prompted a critical literature that is serious, sophisticated, and sustained. Each book thus traces not only the development of an important oeuvre but also the construction of the critical discourse inspired by it. This discourse is theoretical by its very nature, which is not to say that it imposes theory abstractly or arbitrarily. Rather, it draws out the specific ways in which significant art is theoretical in its own right, on its own terms and with its own implications. To this end we feature essays, many first published in *OCTOBER* magazine, that elaborate different methods of criticism in order to elucidate different aspects of the art in question. The essays are often in dialogue with one another as they do so, but they are also as sensitive as the art to political context and historical change. These "files," then, are intended as primers in signal practices of art and criticism alike, and they are offered in resistance to the amnesiac and antitheoretical tendencies of our time.

The Editors of *OCTOBER*

Acknowledgments

Leo Steinberg's "Reflections on the State of Criticism" was first published in *Artforum* 10, no. 7 (March 1972) as an excerpt from the title article of the author's book *Other Criteria: Confrontations with Twentieth-Century Art* (New York: Oxford University Press, 1972). "Rauschenberg and the Materialized Image" by Rosalind Krauss appeared originally in *Artforum* 13, no. 4 (December 1974). Douglas Crimp's "On the Museum's Ruins" was published originally in *October* 13 (Summer 1980) and then, in the slightly revised form reprinted here, in Douglas Crimp, *On the Museum's Ruins* (Cambridge: MIT Press, 1993). "Before *Bed*" by Helen Molesworth first appeared in *October* 63 (Winter 1993). "Perpetual Inventory" by Rosalind Krauss was originally published in the exhibition catalogue *Robert Rauschenberg: A Retrospective,* ed. Walter Hopps and Susan Davidson (New York: Solomon R. Guggenheim Museum, 1997). Branden W. Joseph's essay was published as "'A Duplication Containing Duplications': Robert Rauschenberg's Split Screens" in *October* 95 (Winter 2001). Where necessary, the published texts have been minimally edited for consistency and factual accuracy. The titles of Rauschenberg's works—e.g., black paintings, but *Red Paintings*—follow those established in Walter Hopps, *Robert Rauschenberg: The Early 1950s* (Houston: Houston Fine Arts Press, 1991), and in *Robert Rauschenberg: A Retrospective.*

This book would not have been possible without the generosity of Robert Rauschenberg. In addition, I would like to thank Matthew Abbate, Thomas Buehler, Susan Davidson, Hal Foster, Larissa Goldston, Sheila Schwartz, David White, Paula Woolley, and the authors. I am also grateful for the support of the Princeton University Committee on Research in the Humanities and Social Sciences.

ROBERT RAUSCHENBERG

Branden W. Joseph

What was needed in the mid-sixties was resistance to Clement Green-
berg, and I figured that to do it, to champion Rauschenberg, required
a special strategy.

—Leo Steinberg, *Encounters with Rauschenberg* (2000)

In March of 1968, at the Museum of Modern Art in New York, Leo
Steinberg delivered the lecture that would eventually become known as
"Other Criteria," the single most important article on Rauschenberg's
production. As only hinted by the title under which it first appeared in
Artforum four years later, Steinberg's "Reflections on the State of Criti-
cism" squarely took aim at the hegemony of a Greenbergian doctrine that
had turned into an oppressive dogma, what Steinberg in the first line of
his article called formalism's "interdictory stance."[1]

Such a rigid formalism, Steinberg argued, failed to consider any part
of an artwork's content, pushing all such considerations to one side in fa-
vor of an exclusive concentration on purely technical transformations
within a single, linear trajectory of legitimate art. Rauschenberg, needless
to say, stood outside of that trajectory, so much so in fact that Clement
Greenberg had not even mentioned him in print until the article "Re-
centness of Sculpture" of 1967.[2]

Ten years earlier, Rauschenberg had been similarly, if more explicitly,
dismissed from Steinberg's view of legitimate art as well, one that at the
time was favorable to the second-generation Abstract Expressionism of
artists such as Joan Mitchell. Reviewing the contemporary group show
assembled by Thomas Hess at the Stable Gallery in 1956, Steinberg

dispensed with Rauschenberg in three sentences, which began by noting, "On the merry work of Robert Rauschenberg the kindest comment I can make is that some of my friends, whose (other) judgments I respect, think it not out of place in an art exhibition."[3] As unjust as it now sounds, Steinberg's reaction was typical of the period.[4] Entirely untypical was his subsequent regret at having voiced such an opinion, which he retracted two years later in a letter published under the heading "Footnote": "I want to take this opportunity," his brief statement concluded, "to say that Rauschenberg's latest show at Leo Castelli's seems to me to include two or three pictures of remarkable beauty."[5]

It was not, however, on the issue of aesthetic quality that Steinberg would choose to confront formalism on Rauschenberg's behalf, but rather on that of artistic content. If, as Steinberg's retrospective assessment suggests, it was necessary to "resist" Greenberg in order to "champion" Rauschenberg, this was, in part, because Rauschenberg's collaged and silkscreened words and images—like all of "Pop" generally—brought content and signification back in an overt and unavoidable manner.

"Why they [Pop artists] assign this new role to subject matter after almost a century of formalist indoctrination is not easy to say," Steinberg mused in 1963.[6] Already at that time, however, he knew that the answer did not imply a *rappel à l'ordre,* a return to earlier modes of iconographic analysis, any more than it had benefited from orthodox formalist denunciations.[7] Much of "Reflections on the State of Criticism" (more, in fact, than was devoted to Rauschenberg or contemporary art) was devoted to examining the complexities of Old Master painting, which Greenberg had polemically reduced to an ineluctably illusionist straw figure. In opening Old Master art back up to the myriad ways in which artistic self-definition could manifest itself, Steinberg successfully relativized Greenberg's position. More than this, however, he articulated the necessity of analyzing an artwork's "formal self-consciousness" in relation to the particular beholder that it posited—the "conception of humanity" toward which it was directed—as the means of understanding its content, or meaning, in relation to its time. Steinberg's critical approach would not only lead him to the famous analysis of Rauschenberg's "flatbed picture plane" for which the article is most known, but would also enable him to link the supposedly autonomous, modernist painting championed by Greenberg to developments within corporate capitalism. It is this more complex and demanding standard of interpreting "content" that those readings of Rauschenberg's production that rely on an ahistorical or merely antiformalist iconographic analysis so often fail to attain.[8]

"Reflections on the State of Criticism," however, is more than a methodological treatise or a reminder of the complexities of art history. If it was necessary to resist Greenberg, it was necessary, in order to do so effectively, to champion Rauschenberg as well. Steinberg's "special strategy" needed to demonstrate not only the partiality of formalist analysis, but also the significance of the artistic developments to which it was blinded. Steinberg's other criteria, in other words, could not simply be a matter of taste; they would have to produce a more consequential understanding of contemporary art and the historical conditions that engendered it.[9] To this end, Steinberg marshaled the comments of Minimalist sculptor Donald Judd in relegating the persistent illusionism of earlier art (modernist, Abstract Expressionist, and Old Master alike) to a less relevant, less interesting, or somehow less contemporary past.[10] As Steinberg stated elsewhere of his reaction to Jasper Johns, another flatbed painter: "The pictures of de Kooning and Kline, it seemed to me, were suddenly tossed into one pot with Raphael and Giotto. All alike suddenly became painters of illusion."[11] The anti-illusionistic picture plane that Rauschenberg had pioneered was thus, as Steinberg put it at the end of his "Reflections," a "post-modernist" one.

It is well known that Steinberg's is one of the earliest contemporary uses of the term *postmodernism*.[12] And it is a testament to Steinberg's interpretive method—as much as it is to Rauschenberg's art—that the final section of his article addresses so much of what the debates about postmodernism would subsequently develop: the role of media and electronic communication, the "contamination" of "purified" disciplinary and artistic categories, the advent of simulacral "images of images," and the eclipse of a natural realm by representation and signification. Yet, unlike too many of the facile acclamations of postmodernity that followed, Steinberg's article continues to indicate the complex social stakes involved in transformations of artistic signification. It is for this reason that, three decades after its appearance, "Reflections on the State of Criticism" remains a touchstone for so many attempts to understand Rauschenberg's art. In part, the essays in this collection have been selected in order to foreground the critical discourse that it initiated, thereby demonstrating that the elaboration of such other criteria remains an ongoing concern.

Notes

1. At the time of Steinberg's lecture, not a year had passed since the publication of Michael Fried's "Art and Objecthood," which defended the position inherited from Clement

Greenberg, as well as the artists associated with it, against the "theatricality" of Minimalist sculpture, Robert Rauschenberg, John Cage, and even certain positions taken by Greenberg himself (Michael Fried, "Art and Objecthood," *Artforum* 5, no. 10 [June 1967], pp. 12–23).

2. Clement Greenberg, "Recentness of Sculpture" (1967), in *The Collected Essays and Criticism*, ed. John O'Brian, vol. 4 (Chicago: University of Chicago Press, 1993), pp. 250–256.

3. Leo Steinberg, "Month in Review: Contemporary Group at Stable Gallery . . . ," *Arts* 30, no. 4 (January 1956), p. 46. Steinberg's review of Joan Mitchell appears on the same page.

4. See, for example, Hubert Crehan's exasperated review from the year before (Hubert Crehan, "Fortnight in Review: Rauschenberg," *Arts Digest* 29, no. 7 [January 1, 1955], p. 30).

5. Leo Steinberg, "Footnote," *Arts* 32, no. 8 (May 1958), p. 9.

6. In Peter Selz, Henry Geldzahler, et al., "A Symposium on Pop Art," *Arts Magazine* 37, no. 7 (April 1963), p. 40.

7. Rather, Steinberg suspected that it was to be found in "a particular, unique and perhaps novel relation with reader or viewer" (ibid.).

8. See Steinberg's recent comments on the use of a simplistic iconographic analysis to reduce Rauschenberg to "the commonplace of mere meaning," one often centered on an illustration of the artist's sexual orientation (Steinberg, *Encounters with Rauschenberg* [Houston and Chicago: Menil Collection and University of Chicago Press, 2000], p. 62). Steinberg rightly does not, however, oppose all forms of analysis that treat the issue of sexuality, praising (in note 7) Kenneth Silver's "Modes of Disclosure: The Construction of Gay Identity and the Rise of Pop Art" (in Russell Ferguson, ed., *Hand-Painted Pop: American Art in Transition, 1955–62* [Los Angeles and New York: Museum of Contemporary Art, Los Angeles, and Rizzoli, 1993], pp. 179–203).

9. A transformation in the "history of taste"—one that was inconsequential for the history of art—was how Greenberg explained away those developments (such as Pop art) with which he did not agree. See, for example, Clement Greenberg, "Post Painterly Abstraction" (1964), in *The Collected Essays and Criticism*, vol. 4, p. 197. See also Thomas Crow's discussion of Steinberg and the epithet of "taste" hurled by Hilton Kramer at Rauschenberg and Jasper Johns (Crow, "This Is Now: Becoming Robert Rauschenberg," *Artforum* 36, no. 1 [September 1997], p. 139).

10. Leo Steinberg, "Reflections on the State of Criticism," reprinted in this volume, p. 13.

11. Leo Steinberg, "Contemporary Art and the Plight of Its Public" (1962), in *Other Criteria: Confrontations with Twentieth-Century Art* (New York: Oxford University Press, 1972), pp. 12–13. Many observations about what would be called the flatbed picture plane are visible in Steinberg's earlier article on Johns. Indeed, it is probable that exposure to the Johns exhibition at Castelli in January 1958 prepared Steinberg for his reappraisal of Rauschenberg's work three months later. Steinberg knew where the innovations he was addressing had originated, however, and had already begun lecturing on Rauschenberg as early as 1959 (Steinberg, *Encounters with Rauschenberg*, p. 23).

12. The term was also used in 1972 by David Antin, whose analysis of Andy Warhol Steinberg approvingly quoted at length in "Reflections on the State of Criticism." Antin published "Modernism and Postmodernism: Approaching the Present in American Poetry" that fall in the inaugural issue of *boundary 2: A Journal of Postmodern Literature*. See Perry Anderson's brief discussion of Antin (and the centrality of Rauschenberg's art) in *The Origins of Postmodernity* (London: Verso, 1998), pp. 15ff. Steinberg's essay is mentioned on p. 96.

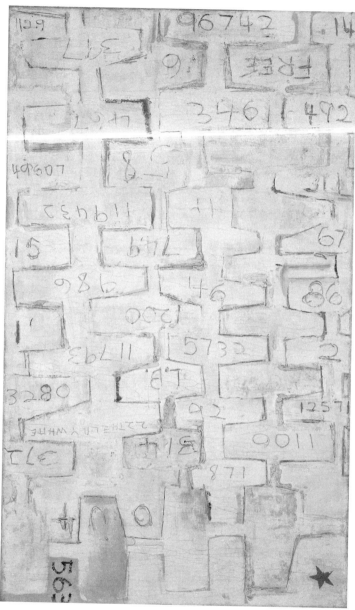

22 The Lily White [formerly titled *White Painting with Numbers*], c. 1950. Oil and pencil on canvas, 39 ½ × 23 ¾ in. Collection of Nancy Ganz Wright.

Reflections on the State of Criticism

Leo Steinberg

I don't mind the positive work done by formalist critics, but I dislike their interdictory stance—the attitude that tells an artist what he ought not to do, and the spectator what he ought not to see. Preventive aesthetics, I call it.

When was it that formalist art criticism first conceived of itself as a prohibitive function? At a certain point we begin to be told that there is only one thing, one alone, to be looked for in art. Thus Baudelaire in his 1863 essay on Delacroix:

> A well-drawn figure fills you with a pleasure that is quite alien to the theme. Voluptuous or terrible, this figure owes its charm solely to the arabesque it describes in space. The limbs of a flayed martyr, the body of a swooning nymph, if they are skillfully drawn, connote a type of pleasure in which the theme plays no part, and if you believe otherwise, I shall be forced to think that you are an executioner or a rake.

No one will want to argue the opposite—that you savor a Delacroix for the tang of massacre only. But earlier critics, and I suspect the painter himself, might have allowed one to see a coincidence, a magic identity of pathos and arabesque. Now, at the risk of Baudelaire's disapproval, this will no longer do: short of confessing that you look to art to gratify prurient or sadistic appetites, you had better see those nude limbs *solely* as arabesques described in space.

Or compare this from Roger Fry's *Last Lectures:*

The sensuality of Indian artists is exceedingly erotic—the *leitmotif* of much of their sculpture is taken from the more relaxed and abandoned poses of the female figure. A great deal of their art, even their religious art, is definitely pornographic, and although I have no moral prejudices against that form of expression, it generally interferes with aesthetic considerations by interposing a strong irrelevant interest which tends to distract both the artist and spectator from the essential purpose of a work of art.[1]

The provincialism of this passage is characteristic. Indifferent to the intent of the art he condemned, Fry could not see that erotic sculptures on Indian temples are "pornographic" only to the extent that Western images of Crucifixion and martyrdom are "sadistic." If Fry found the love of Shiva and Parvati more distracting than the agony of Christ, this tells us something of his personal background, but very little about "the essential purpose of art."

Similar warnings against distracting interference with aesthetic form come from most formalist writers. They deplore the tendency artists have of trying to make pictures move you in illegitimate ways—as when Albert C. Barnes says of Michelangelo's *Fall of Man* on the Sistine Ceiling that "the effect of movement is vigorous and powerful but tends to be overdramatic."[2] An artist who "overdramatizes" his work with expression has wrongheaded values and must pay the price. *Serves him right* is the implicit moral of Clement Greenberg's discovery that Picasso began at one definable moment to lose his certainty as an artist:

A painting done in 1925, the striking *Three Dancers,* where the will to illustrative expressiveness appears ambitiously for the first time since the Blue Period, is the first evidence of a lessening of this certainty. . . . The *Three Dancers* goes wrong, not just because it is literary . . . , but because the theatrical placing and rendering of the head and arms of the center figure cause the upper third of the picture to wobble.[3]

My purpose is not to argue whether the *Three Dancers* goes wrong. What matters is that an alleged fault of unstable design is blamed upon interference from a "theatrical," i.e., alien, intention—"the will to expressiveness." This is pure prejudice. Another critic, assuming he found the same fault, might feel that this upper portion had failed through overconcern with

formal arrangement. If the artist "went wrong," who decides which lobe of his Manichaean brain was responsible, the bright half whence pure design is distilled, or that darker side where the will to expressiveness lurks?

Reducing the range of reference has always been the appointed task of formalist thought, but there has been much hard, serious thinking in it. Given the complexity and infinite resonance of works of art, the stripping down of artistic value to the single determinant of formal organization was once—in the nineteenth century—a remarkable cultural achievement. The attempt was to discipline art criticism in the manner of scientific experiment, through the isolation of a single variable. Art's "essential purpose"—call it abstract unity of design or whatever prevents buckling and wobbling—was presumed to be abstractable from all works of art. And the whole range of meaning was ruled to be disposable "subject matter," which at best did no harm but which more commonly burdened the form. In the formalist ethic, the ideal critic remains unmoved by the artist's expressive intention, uninfluenced by his culture, deaf to his irony or iconography, and proceeds undistracted, programmed like an Orpheus making his way out of hell.

It does not seem to me that the aesthetic quality of works of art was ever more than a notional fiction, that it can be experienced as an independent variable, or that it is really isolated by critical judgment. Our experience indicates rather that quality rides the crest of a style, and that when a movement or style as such is resisted, the qualitative differences within that style become unavailable. Ten years ago, all American formalist critics spurned Pop art *in toto,* and their wholesale rejection admitted no consideration of individual quality or distinction. Whatever merit a Claes Oldenburg may have had remained imperceptible, while the names "Lichtenstein, Rosenquist, Warhol" were run off like the firm name Carson, Pirie, Scott & Co. What interests me here is not to what extent those early denunciations of Pop might need readjustment. The point is that formalist critics could not even confront the question of quality; or were loath to do so lest the exercise of aesthetic judgment bestow undue dignity on an aberration. There was to be no voting across party lines.

Contemporary American formalism owes its strength and enormous influence to the professionalism of its approach. It analyzes specific stylistic advances within a linear conception of historic development. Its theoretical justification was furnished by Clement Greenberg, whose essay "Modernist Painting" (1965) reduces the art of a hundred years to an

elegant one-dimensional sweep. Following is a brief summary, given as far as possible in the author's own words.[4]

"The essence of Modernism lies . . . in the use of the . . . methods of a discipline to criticize the discipline itself—not in order to subvert it, but to entrench it more firmly in its areas of competence." As Kant used logic to establish the limits of logic, so, argues Greenberg, "Modernism criticizes from the inside, through the procedures themselves of that which is being criticized." How then does this self-criticism proceed? "The task of self-criticism became to eliminate from the effects of each art any . . . effect that might conceivably be borrowed from . . . any other art. Thereby each art would be rendered 'pure'. . . ." This purity, Greenberg continues, "meant self-definition, and the enterprise of self-criticism in the arts became one of self-definition with a vengeance." How did this process of self-definition find expression in painting? Pictorial art, Greenberg explains, "criticized and defined itself under Modernism" by "stressing the ineluctable flatness of the support. . . . Flatness alone was unique and exclusive to that art . . . and so, Modernist painting oriented itself to flatness as it did to nothing else."

We may take it for granted that in this system all narrative and symbolic content had to drain out of painting because that kind of content was held in common with literature. The depiction of solid forms was abandoned because "three-dimensionality is the province of sculpture, and for the sake of its own autonomy painting has had above all to divest itself of everything it might share with sculpture." Recognizable entities had to go because they "exist in three-dimensional space and the barest suggestion of a recognizable entity suffices to call up associations of that kind of space . . . and by doing so, alienates pictorial space from the two-dimensionality which is the guarantee of painting's independence as an art."

Whatever else one may think of Greenberg's construction, its overwhelming effect is to put all painting in series. The progressive flattening of the pictorial stage since Manet "until its backdrop had become the same as its curtain"[5]—the approximation of the depicted field to the plane of its material support—this was the great Kantian process of self-definition in which all serious modernist painting was willy-nilly engaged. The one thing which painting can call its own is color coincident with the flat ground, and its drive toward independence demands withdrawal from anything outside itself and single-minded insistence on its unique property. Even now, two hundred years after Kant, any striving for other goals

becomes deviationist. Despite the continual emergence in our culture of cross-border disciplines (ecology, cybernetics, psycholinguistics, biochemical engineering, etc.), the self-definition of advanced painting is still said to require retreat. It is surely cause for suspicion when the drift of third-quarter twentieth-century American painting is made to depend on eighteenth-century German epistemology. Are there no contractionist impulses nearer at hand? Was it Kantian self-definition which led the American woman into what Betty Friedan calls the "Feminine Mystique," wherein "the only commitment for women is the fulfillment of their own femininity"?[6]

A graver objection concerns Greenberg's management of premodern art, and this needs discussion because Greenberg's modernism defines itself in opposition to the Old Masters. If that opposition becomes unstable, modernism may have to be redefined by other criteria.

The problem, it seems, hinges on the illusionism of Old Master paintings—the supposed intent of their art to deceive and dissemble. Now, there can be no doubt that there are, and that there have always been, people who look at realistic images as though they were real—but what kind of people? On August 13, 1971, the cover of *Life* magazine featured a nude *Eve* by Albrecht Dürer side by side with the photograph of a modern young woman in dungarees. In the weeks following, close to 3,000 Middle American readers canceled their subscriptions to *Life,* protesting the shamelessness of the nude. Many took her for real and thought she had stripped for the photographer. But these people, whatever their moral standards, are not the definers of art.

Yet Greenberg's contrasting definition of Old Master art relies on just this sort of reading. "Realistic, illusionist art had dissembled the medium, using art to conceal art"; whereas "Modernism used art to call attention to art."[7] It is as though we were told that modern poetry for the first time draws attention to its own process, whereas Dante, Shakespeare, and Keats had merely used meter and rhyme to tell stories. Has Greenberg been taken in by the illusionism of the Old Masters? Obviously not, for he has a remarkably good eye for painting. And in fact his actual observations constantly overturn the polarity he seeks to establish. Thus: "The Old Masters always took into account the tension between surface and illusion, between the physical facts of the medium and its figurative content—but in their need to conceal art with art, the last thing they had wanted was to

make an explicit point of this tension."[8] The defining contrast then is not a matter of essence, but only of emphasis; the Old Masters do acknowledge the physical facts of the medium—but not "explicitly." On closer inspection the difference between their goals and those of modernist painting becomes even more elusive:

> The Old Masters had sensed that it was necessary to preserve what is called the integrity of the picture plane: that is, to signify the enduring presence of flatness under the most vivid illusion of three-dimensional space. The apparent contradiction involved—the dialectical tension, to use a fashionable but apt phrase—was essential to the success of their art, as it is indeed to the success of all pictorial art. The Modernists have neither avoided nor resolved this contradiction; rather, they have reversed its terms. One is made aware of the flatness of their pictures before, instead of after, being made aware of what the flatness contains. Whereas one tends to see what is *in* an Old Master painting before seeing it as a picture, one sees a Modernist painting as a picture first. This is, of course, the best way of seeing any kind of picture, Old Master or Modernist, but Modernism imposes it as the only and necessary way, and Modernism's success in doing so is a success of self-criticism.[9]

Are we still on firm factual ground? The "objective" difference between Old Master and modernist reduces itself to subjective tendencies in the viewer. It is he who in looking at Old Master paintings *tends* to see the illusion "before seeing it as a picture." But what if he doesn't? What if he sees a Giotto, a Poussin, or a Fragonard as a picture first, habitually screening out the deep space indications until he has seen the surface disposition of its formal elements? Does an Old Master painting forgo its Old Master status if it is seen in primary flatness and only secondly as a vivid illusion? Consider that typical Old Master expression, the rapid sketch. Does Rembrandt's drawing become modernist if its pen strokes and bister washes emerge for us before, or along with, the old lady's image? It seems to me that the last thing this draftsman wants is to dissemble his medium, or conceal his art; what he wants, and gets, is precisely a tension, made fully explicit, between the figure evoked and the physicality of paper, pen stroke, and ink. And yet, in terms of style, such a sketch as this is integral to Old Master art. It merely dramatizes the quality that enables Baudelaire to see a Delacroix as nothing but arabesques.

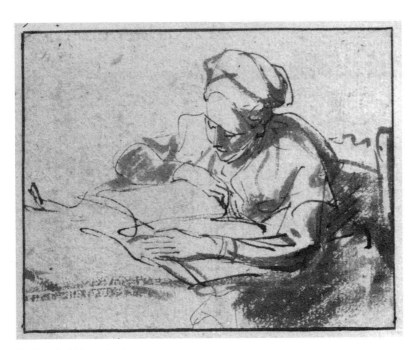

Rembrandt, *A Woman Reading,*
c. 1639–1640. Pen and wash with
luster, 2 ⅝ × 3 ⁷⁄₁₆ in. The Metropolitan
Museum of Art, Rogers Fund, 1926.
(26.208)

And, contrariwise, what if the viewer tends to see modernist paint-
ings as spatial abstractions of landscape? The sculptor Don Judd complains
that New York School paintings of the 1950s keep him intensely aware of
what their flatness contains—"airiness" and "illusionistic space." He said
recently: "Rothko's whole way of working depended on a good deal of il-
lusionism. It's very aerial. The whole thing is about areas floating in space.
Compared to Newman there is distinctly a certain depth. But I finally
thought that all painting was spatially illusionistic."[10]

Where does this leave us? The difference between Old Master and
modernist is not, after all, between illusion and flatness; it turns out that
both are present in each. But if the difference is in the *order* in which these
two presences are perceived, then do the subjective approaches of Baude-
laire and Judd reverse the distinction between historic and modern art?

Greenberg is fully conscious of the airy illusionism observed by Judd
in modernist painting. But though open atmospheric effects, such as are

found in Rothko or Jules Olitski, clearly deny and dissemble the picture's material surface, he nevertheless finds them congruent with painting's self-definition because the illusion conveyed is "visual," rather than tactile or kinesthetic. And visual art should, to conform with Kantian self-criticism and scientific consistency, "confine itself exclusively to what is given in visual experience": "Where the Old Masters created an illusion of space into which one could imagine oneself walking, the illusion created by a Modernist is one into which one can look, can travel through, only with the eye."[11]

The difference, then, reduces itself to distinct *kinds* of spatial illusion, but this last saving distinction is one which defines "modernism" by preindustrial standards of locomotion. How, in what kind of painted space, do you let yourself roam? Greenberg apparently can imagine himself trudging through a Rembrandtesque gloom, but he cannot conceive journeying through an Olitski. Do we need to be reminded that in an age of space travel a pictorial semblance of open void is just as inviting to imaginary penetration as the pictorial semblance of a receding landscape was formerly to a man on foot? Are we now to define modernist painting against a Kantian concept of transportation? Greenberg's theoretical schema keeps breaking down because it insists on defining modern art without acknowledgment of its content, and historical art without recognizing its formal self-consciousness.

All major painting, at least of the last six hundred years, has assiduously "called attention to art." Except for tour de force demonstrations and special effects, and before their tradition collapsed in nineteenth-century academicism, the Old Masters always took pains to neutralize the effect of reality, presenting their make-believe worlds, as it were, between quotation marks. The means they chose were, of course, those of their day, not of ours; and often their careful controls are annulled by our habit of lifting a partial work from its setting—transposing a detached fresco or predella panel into the category of easel painting. But a dramatic narrative painted by Giotto resembles neither a late nineteenth-century easel painting nor a movie screen. When it is not wrenched from its context (as in most art history books), it works within a wall system, each wall supporting multiple scenes set between elaborate framing bands, within which, in turn, other scenes on different scales are descried. You are never allowed to see one illusion, one sky, or one fictive horizon alone. You are shown simultaneous and incompatible systems whose juxtaposition cancels or checks the

illusion. Similarly, the Sistine Ceiling when seen in its entirety: the work is a battleground for local illusion, counterillusion, and emphasized architectural surface—art turning constantly back on itself.

This is a functional multiplicity, and it occurs even in apparently single works. Look at those cornered, diminutive prophets in the fresco on p. 16, leaning out of the picture plane: their eager demonstrative gestures toward the Christ turn the illusionist scene of the Crucifixion back into a picture of it—complete with its own patterned frame. Or take an engraved Baroque portrait (p. 17). The depicted man is a paper paste-up on a dog-eared sheet on a flat wall, and the whole stratigraphy of it is exhibited in the changing density of horizontal striations. The artists here do exactly what Greenberg admires as a significant find in a crucial Cubist picture by Braque: "[Braque] discovered that *trompe-l'oeil* could be used to undeceive as well as to deceive the eye. It could be used, that is, to declare as well as to deny the actual surface."[12]

Where the Old Masters seem to dissolve the picture plane to gain an unambiguous illusion of depth, they usually have a special objective in mind, an objective understood and shared by the viewer. Michelangelo's *Last Judgment,* unlike the Ceiling, obliterates the supporting wall plane so that the vision of a Christ "come to judge the quick and the dead" gives immediate urgency to the words of the Creed. Caravaggio's pictures, whether erotic or religious in their address, were similarly intended to induce a penetrating experience. But their relentless, surface-dissolving illusionism was largely repudiated by the Old Masters. Until the nineteenth century, the kind of painting which utterly broke the consistency of the surface remained a special, even exceptional resource of Old Master art.

The more realistic the art of the Old Masters became, the more they raised internal safeguards against illusion, ensuring at every point that attention would remain focused upon the art.

They did it by radical color economies, or by eerie proportional attenuation; by multiplication of detail, or by preternatural beauty. They did it—as modern films do with spliced footage taken from older movies—by quotations and references to other art; quotation being a surefire means of shunting the ostensible realism of a depicted scene back into art.

They did it by abrupt internal changes of scale; or by shifting reality levels—as when Raphael's *Expulsion of Heliodorus* inserts a group of contemporaries in modern dress as observers of the Biblical scene; or by overlapping reality levels, as when a frescoed battle scene on a Vatican wall curls

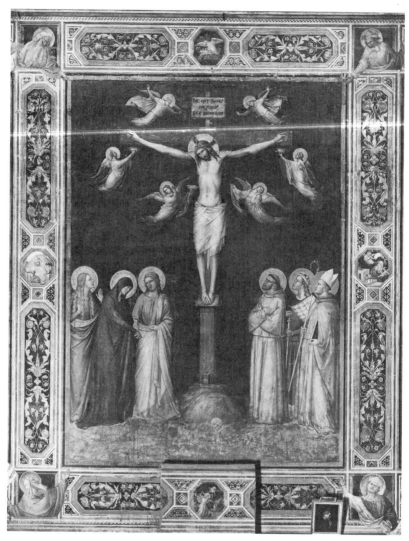

Niccolò di Pietro Gerini (?), *Crucifixion*.
Santa Croce, Florence, Italy. Alinari / Art
Resource, NY.

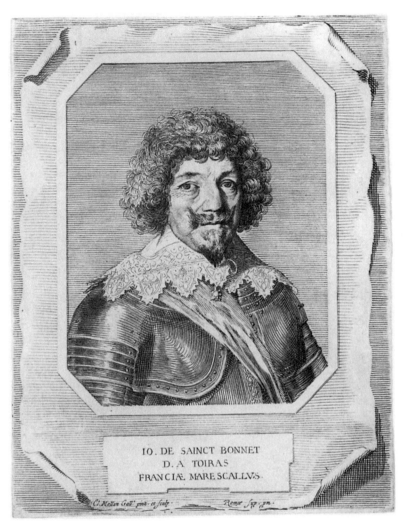

Claude Mellan, *Portrait of Jean de Saint-Bonnet, Seigneur de Toiras*, c. 1636. Engraving, 9 ⅜ × 7 ⅜ in. Jack S. Blanton Museum of Art, The University of Texas at Austin, The Leo Steinberg Collection.

up at the edges to become a fake tapestry—two self-confounding illusions which call both into question and recall both to art.

The "recall to art" may be engineered by the subject matter itself. In a Dutch interior, the backview of a personage who draws a curtain aside to look at a painting on the far wall acts as my alter ego, doing what I am doing and reminding me (in case I missed the point of the picture's immense ebony frame) that I too am looking at a flat object. Better still, such seventeenth-century interiors as Velázquez's *Ladies in Waiting* often juxtapose a doorway or window view with a framed painting, and, next to that, a mirror filled with a reflection. These three kinds of image serve as an inventory of the three possible roles assignable to a picture plane. The window pane or proscenium effect refers to what lies behind it, the looking glass refers to what lies before, while the pigmented surface asserts itself; and all three are paraded in sequence. Such pictures soliloquize about the capacities of the surface and the nature of illusion itself.

Again and again, in so-called illusionist art, it is illusionism that is under discussion, the art "calling attention to art" in perfect self-critical consciousness. And this is why the Old Masters are forever inventing interferences with spatial recession. They do not merely "take account" of the tension between surface and depth, as if for the sake of decorative coherence, while reserving their thrust for the depiction of depth. Rather, they maintain an explicit, controlled, ever-visible dualism. Fifteenth-century perspective was not a surface-denying illusion of space, but the symbolic form of space as an intelligible coordinate surface pattern. Good illusionist painting not only anchors depth to the plane; it is almost never without built-in devices designed to suspend the illusion, and the potency of these devices depends—like the appreciation of counterpoint or of puns—on the spectator's ability to register two things in concert, to receive both the illusion and the means of illusion at once.

Some of the Old Masters overruled the apparent perspective by dispersing identical color patches as an allover carpet spread (Pieter Bruegel, for instance). Some worked with chromatic dissonances to weave a continuous surface shimmer like mother-of-pearl. Many—from Titian onward—insured their art against realism by the obtrusive calligraphy of the brush—laying a welter of brushstrokes upon the surface to call attention to process. Some contrived implausible contradictions within the field, as when the swelling bulk of a foreshortened form is collapsed and denied the spatial ambience to house it. All of them counted on elaborate framing as an integral part of the work ("advertising the literal nature of the

support," as Greenberg says of collage)—so that the picture, no matter how deep its illusionism, turned back into a thing mounted there like a gem. It was Michelangelo himself who designed the frame of the *Doni Madonna,* an element essential to the precious mirror effect of its surface.

Greenberg wants all Old Master and modernist painters to reduce their differences to a single criterion, and that criterion as mechanistic as possible—either illusionistic or flat. But what significant art is that simple? Have you ever asked how deep the thrones of the Sistine Prophets and Sibyls are? Perfectly shallow if you glance across the whole sequence; but, as all the early copies reveal, they run more than ten feet deep as soon as you focus on one alone. Perspective illusionism and anatomic foreshortening sustain a ceaseless optical oscillation.

"The abiding effect is a constant shuttling between surface and depth, in which the depicted flatness is 'infected' by the undepicted. Rather than being deceived, the eye is puzzled; instead of seeing objects in space, it sees nothing more than—a picture."[13] These words, in which Greenberg describes Cubist collage, apply equally well to Michelangelo's Ceiling and to thousands of Old Master works. They describe the effect of a not untypical early fifteenth-century manuscript page: *Missus est Gabriel angelus* (p. 20). Three reality levels oscillate in, and compete for, that capital M: an arcade opening on a bedchamber; a trellis for ivy ornament; and a letter at the head of a word. All three at once. The eye is puzzled; instead of seeing objects in space it sees a picture.[14]

The notion that Old Master paintings in contrast to modern dissemble the medium, conceal the art, deny the surface, deceive the eye, etc., is only true for a viewer who looks at the art like those ex-subscribers to *Life* magazine. The distinction a critic makes between modernist self-analytical and Old Master-representational refers less to the works compared than to his own chosen stance—to be analytic about the one and polemically naive about the other.

It is poor practice, when modern art is under discussion, to present the Old Masters as naively concerned with eye-fooling trickery, while reserving for modern art both the superior honesty of dealing with the flat plane of painting and the maturer intellectual discipline of self-analysis. All important art, at least since the Trecento, is preoccupied with self-criticism. Whatever else it may be about, all art is about art. All original art searches its limits, and the difference between the old and the modernist is not in the fact of self-definition but in the direction which this self-definition takes. This direction being part of the content.

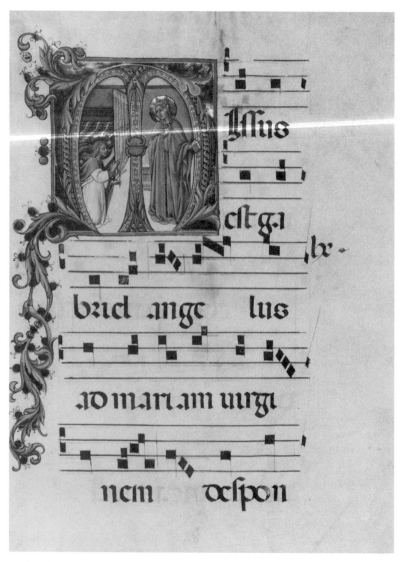

Attributed to Sano de Pietro (Italian,
1406–1481), *The Annunciation* [*Missus
est Gabriel angelus*]. Illuminated manu-
script page; tempera and gold leaf on
vellum, 19 × 15 in. The Speed Art Mu-
seum, Louisville, Kentucky.

At this point Greenberg might answer that self-definition does not deserve its name unless it aims at purity, and that this in turn requires stripping painting down to its irreducible essence, i.e., the coincidence of flattened color with its material support. I reply that this mistakes a special case for a necessity. The process of painting's self-realization can go either way. For Jan van Eyck, for example, the self-realization of painting is not reductive but expansive. He turns to the sculptor and says, "Anything you can do I can do better"; then to the goldsmith—"Anything *you* can do I can do better"; and so to the architect. He redesigns everything in the flat and even banishes metallic gold to create the effect of it—like Manet—in pure color and light. Anything anybody can do, painting does better—and that's where, for van Eyck, painting realizes itself—discovering its autonomy literally in its ability to do without external aid.

Art's perpetual need to redefine the area of its competence by testing its limits takes many forms. Not always does it probe in the same direction. Jacques Louis David's ambition to make art a force of national moral leadership is as surely a challenge to the limits of art as is Matisse's elimination of tonal values. At one historical moment painters get interested in finding out just how much their art can annex, into how much non-art it can venture and still remain art. At other times they explore the opposite end to discover how much they can renounce and still stay in business. What is constant is art's concern with itself, the interest painters have in questioning their operation. It is a provincialism to make the self-critical turn of mind the sufficient distinction of modernism; and once it is understood as not its peculiar distinction, then the specific look of contemporary abstract art—its object quality, its blankness and secrecy, its impersonal or industrial look, its simplicity and tendency to project a stark minimum of decisions, its radiance and power and scale—these become recognizable as a kind of content—expressive, communicative, and eloquent in their own way.

The Corporate Model of Developing Art

It is astonishing how often recent abstract American painting is defined and described almost exclusively in terms of internal problem solving. As though the strength of a particular artist expressed itself only in his choice to conform with a set of existent professional needs and his inventiveness in producing the answers. The dominant formalist critics today tend to treat modern painting as an evolving technology wherein at any one

moment specific tasks require solution—tasks set for the artist as problems are set for researchers in the big corporations. The artist as engineer and research technician becomes important insofar as he comes up with solutions to the right problem. How the choice of that problem coincides with personal impulse, psychological predisposition, or social ideal is immaterial; the solution matters because it answers a problem set forth by a governing technocracy.

In America this corporate model of artistic evolution appears full-blown by the mid-1920s. It inhabits the formalist doctrine that Painting aspires toward an ever-tightening synthesis of its design elements. The theory in its beginnings was fairly simple. Suppose a given painting represents a reclining nude; and suppose the figure outlined with a perceptible contour. Within that contour lies a distinct shape. That shape is of a certain color, and the color—modulated from light to dark or from warm to cool—reflects a specific quantity or kind of light. We have then four formal elements—line, shape, color, and light—which can be experienced and thought of as separate and distinct. Now, it is argued, the test of significantly advanced painting will be the progressive obliteration of these distinctions. The most successful picture will so synthesize the means of design that line will be no longer separable from shape, nor shape from color, nor color from light. A working criterion, easily memorized and applied. It tells you not necessarily which picture is best, but which is in line to promote the overall aspiration of Painting—this alignment being a *sine qua non* of historic importance. By this criterion, the painter of the Sistine Ceiling is, with due respect, relegated to one of the byways of Painting since his inventions, for all their immediate interest, do not ultimately promote the direction in which Painting must go; Michelangelo's forms are "realized in a sculptural rather than a pictorial manner."[15] Indeed, the elements of Michelangelo's depictions are remarkable for separability—specific shapes sharply delineated by bounding lines, tinted by local color, modulated by chiaroscuro. Though Michelangelo will, I am convinced, be emerging within the next several years as one of the most original colorists of all time, by the criteria enunciated above he fails to contribute—as did Titian's coloristic diffusion—to the synthesis of the means of design. For the critic-collector Albert C. Barnes he remains a dead end, whereas the course initiated by Titian leads irresistibly to its culmination in Renoir and William Glackens.

This single criterion for important progressive art, moving as by predestination toward utter homogeneity of the elements of design, is still

with us, now considerably more analytical, more prestigious than ever, and celebrating its latest historical denouement in the triumph of color field painting.

In formalist criticism, the criterion for significant progress remains a kind of design technology subject to one compulsive direction: the treatment of "the whole surface as a single undifferentiated field of interest." The goal is to merge figure with ground, integrate shape and field, eliminate foreground-background discontinuities; to restrict pattern to those elements (horizontals or verticals) that suggest a symbiotic relationship of image and frame; to collapse painting and drawing in a single gesture, and equate design and process (as Pollock's drip paintings do, or Morris Louis's *Veils*); in short, to achieve the synthesis of all separable elements of painting, preferably—but this is a secondary consideration—without that loss of incident or detail which diminishes visual interest.

There is, it seems to me, a more thoroughgoing kind of synthesis involved in this set of descriptions—the leveling of end and means. In the criticism of the relevant paintings there is rarely a hint of expressive purpose, nor recognition that pictures function in human experience. The painter's industry is a closed loop. The search for the holistic design is self-justified and self-perpetuating. Whether this search is still the exalted Kantian process of self-criticism seems questionable; the claim strikes me rather as a remote intellectual analogy. And other analogies suggest themselves, less intellectual, but closer to home. It is probably no chance coincidence that the descriptive terms which have dominated American formalist criticism these past fifty years run parallel to the contemporaneous evolution of the Detroit automobile. Its ever-increasing symbiosis of parts—the ingestion of doors, running boards, wheels, fenders, spare tires, signals, etc., in a one-piece fuselage—suggests, with no need for Kant, a similar drift toward synthesizing its design elements. It is not that the cars look like the paintings. What I am saying here relates less to the pictures themselves than to the critical apparatus that deals with them. Pollock, Louis, and Noland are vastly different from each other; but the reductive terms of discussion that continually run them in series are remarkably close to the ideals that govern the packaging of the all-American engine. It is the critics' criterion far more than the painters' work which is ruled by a streamlined efficiency image.

But the reference to industrial ideals can serve to focus on certain distinctions within art itself. If, for instance, we question the work of the three painters just mentioned from the viewpoint of expressive content,

they immediately separate out. There is obviously no affinity for industrialism in Pollock or Louis, but it does characterize an important aspect of the younger man's work. His thirty-foot-long stripe paintings, consisting of parallel color bands, embody, beyond the subtlety of their color, principles of efficiency, speed, and machine-tooled precision which, in the imagination to which they appeal, tend to associate themselves with the output of industry more than of art. Noland's pictures of the late sixties are the fastest I know.

The painter Vlaminck used to say that he wished to make pictures which would be readable to a motorist speeding by in an automobile. But Vlaminck's belated expressionism could never realize such an ideal. His palette-knifed snowscapes lacked every access to his ostensible goal. They possessed neither the scale, the format, the color radiance, nor even the appropriate subject matter: good motorists look for signals and signs, not at messages from a painter's easel. Vlaminck's statement remains naive because it is essentially idle. But there is nothing naive in Noland's determination to produce, as he put it, "'one-shot' paintings perceptible at a single glance." I quote from a recent article by Barbara Rose, who continues: "To achieve maximum immediacy, Noland was ready to jettison anything interfering with the most instantaneous communication of the image."[16]

Noland's stated objective during the 1960s confirms what his pictures reveal—an idealization of efficient speed and, implicitly, a conception of the humanity at whom his "one-shots" are aimed. The instantaneity which his pictures convey implies a different psychic orientation, a revised relationship with the spectator. Like all art that ostensibly thinks only about itself, it creates its own viewer, projects its peculiar conception of who, what, and where he is.

Is he a man in a hurry? Is he at rest or in motion? Is he one who construes or one who reacts? Is he a man alone—or a crowd? Is he a human being at all—or a function, a specialized function or instrumentality, such as the one to which Rauschenberg's "Chairs" (titled *Soundings*) (1968) reduced the human agent. (A room-size transparent screen whose illumination was electronically activated by sound; the visibility of the chairs which constituted the image depending on the noises made by the spectator—his footsteps when entering, his coughing or speaking voice. One felt reduced to the commodity of a switch.) I suspect that all works of art or stylistic cycles are definable by their built-in idea of the spectator. Thus, returning once more to the Pollock-Louis-Noland procession, the

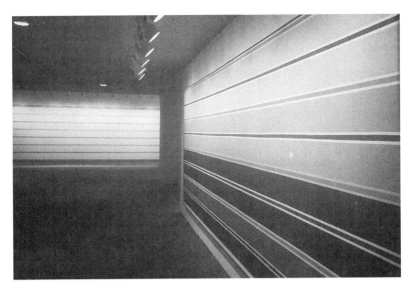

Kenneth Noland, installation view of
Coarse Shadow and *Stria* in the André
Emmerich Gallery, 1967. Courtesy
of the artist. © Kenneth Noland /
Licensed by VAGA, New York, NY.

younger man, who separates himself from his elders by the criterion of industrial affinity, parts from them again by his distinct view of the viewer.

Considerations of "human interest" belong in the criticism of modernist art not because we are incurably sentimental about humanity, but because it is art we are talking about. And it appears to me that even such professional technicalities as "orientation to flatness" yield to other criteria as soon as the picture is questioned not for its internal coherence, but for its orientation to human posture.

What is "pictorial flatness" about? Obviously it does not refer to the zero curvature of the physical plane—a cat walking over pictures by Tiepolo and Barnett Newman gets the same support from each one. What is meant of course is an ideated flatness, the sensation of flatness experienced in imagination. But if that's what is meant, is there anything flatter than the *Olympia* (1950) of Dubuffet (p. 26)? If flatness in painting indicates an imaginative experience, then the pressed-leaf effect, the graffito effect, the scratched-gravel or fossil-impression effect of Dubuffet's image dramatizes the sensation of flatness far beyond the capacity, or the

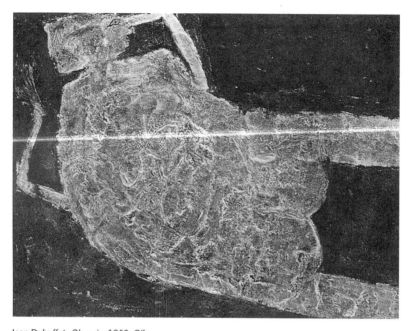

Jean Dubuffet, *Olympia*, 1950. Oil on
canvas, 35 × 45 ⅝ in. © 2001 ARS,
New York / ADAGP, Paris.

intention, of most color field painting. But in fact, these different "flat-
nesses" are not even comparable. And the word "flat" is too stale and re-
mote for the respective sensations touched off by the visionary color *Veils*
of Morris Louis and the bedrock pictographs of Dubuffet. Nor need flat-
ness be an end product at all—as Jasper Johns demonstrated in the mid-
1950s, when his first *Flags* and *Targets* relegated the whole maintenance
problem of flatness to "subject matter." However atmospheric his brush-
work or play of tonalities, the depicted subject ensured that the image
stayed flat. So then one discovers that there are recognizable entities, from
flags even to female nudes, which can actually promote the sensation of
flatness.

 This discovery is still fairly recent, and it is not intelligible in terms of
design technology. It demands consideration of subject and content, and,
above all, of how the artist's pictorial surface tilts into the space of the
viewer's imagination.

The Flatbed Picture Plane

I borrow the term from the flatbed printing press—"a horizontal bed on which a horizontal printing surface rests" (Webster). And I propose to use the word to describe the characteristic picture plane of the 1960s—a pictorial surface whose angulation with respect to the human posture is the precondition of its changed content.

It was suggested earlier that the Old Masters had three ways of interpreting the picture plane. But one axiom was common to all three interpretations, and it remained operative in the succeeding centuries, even through Cubism and Abstract Expressionism: the conception of the picture as representing a world, some sort of worldspace which reads on the picture plane in correspondence with the erect human posture. The top of the picture corresponds to where we hold our heads aloft; while its lower edge gravitates to where we place our feet. Even in Picasso's Cubist collages, where the Renaissance worldspace concept almost breaks down, there is still a harking back to implied acts of vision, to something that was once actually seen.

A picture that harks back to the natural world evokes sense data which are experienced in the normal erect posture. Therefore the Renaissance picture plane affirms verticality as its essential condition. And the concept of the picture plane as an upright surface survives the most drastic changes of style. Pictures by Rothko, Still, Newman, de Kooning, and Kline are still addressed to us head to foot—as are those of Matisse and Miró. They are revelations to which we relate visually as from the top of a columnar body; and this applies no less to Pollock's drip paintings and the poured *Veils* and *Unfurls* of Morris Louis. Pollock indeed poured and dripped his pigment upon canvases laid on the ground, but this was an expedient. After the first color skeins had gone down, he would tack the canvas on to a wall—to get acquainted with it, he used to say, to see where it wanted to go. He lived with the painting in its uprighted state, as with a world confronting his human posture. It is in this sense, I think, that the Abstract Expressionists were still nature painters. Pollock's drip paintings cannot escape being read as thickets; Louis's *Veils* acknowledge the same gravitational force to which our being in nature is subject.[17]

But something happened in painting around 1950—most conspicuously (at least within my experience) in the work of Robert Rauschenberg and Dubuffet. We can still hang their pictures—just as we tack up maps and architectural plans, or nail a horseshoe to the wall for good luck.

Yet these pictures no longer simulate vertical fields but opaque flatbed horizontals. They no more depend on a head-to-toe correspondence with human posture than a newspaper does. The flatbed picture plane makes its symbolic allusion to hard surfaces such as tabletops, studio floors, charts, bulletin boards—any receptor surface on which objects are scattered, on which data is entered, on which information may be received, printed, impressed—whether coherently or in confusion. The pictures of the last fifteen to twenty years insist on a radically new orientation, in which the painted surface is no longer the analogue of a visual experience of nature but of operational processes.

To repeat: it is not the actual physical placement of the image that counts. There is no law against hanging a rug on a wall, or reproducing a narrative picture as a mosaic floor. What I have in mind is the psychic address of the image, its special mode of imaginative confrontation, and I tend to regard the tilt of the picture plane from vertical to horizontal as expressive of the most radical shift in the subject matter of art, the shift from nature to culture.

A shift of such magnitude does not come overnight, nor as the feat of one artist alone. Portents and antecedents become increasingly recognizable in retrospect—Monet's *Nymphéas* or Mondrian's transmutation of sea and sky into signs plus and minus. And the picture planes of a synthetic Cubist still life or a Schwitters collage suggest like-minded reorientations. But these last were small objects; the "thingness" of them was appropriate to their size. Whereas the event of the 1950s was the expansion of the work-surface picture plane to the man-sized environmental scale of Abstract Expressionism. Perhaps Duchamp was the most vital source. His *Large Glass,* begun in 1915, his *Tu m'* of 1918, these are no longer analogues of a world perceived from an upright position, but matrices of information conveniently placed in a vertical situation. And one detects a sense of the significance of a ninety-degree shift in relation to a man's posture even in some of those Duchamp "works" that once seemed no more than provocative gestures: the coat rack nailed to the floor and the famous urinal tilted up like a monument.

But on the New York art scene the great shift came in Rauschenberg's work of the early 1950s. Even as Abstract Expressionism was celebrating its triumphs, he proposed the flatbed or work-surface picture plane as the foundation of an artistic language that would deal with a different order of experience. The earliest work which Rauschenberg admits into his canon—*White Painting with Numbers*—was painted around 1949 in a life

class at the Art Students League, the young painter turning his back on the model. Rauschenberg's picture, with its cryptic meander of lines and numbers, is a work surface that cannot be construed into anything else. Up and down are as subtly confounded as positive-negative space or figure-ground differential. You cannot read it as masonry, nor as a system of chains or quoins, and the written cyphers read every way. Scratched into wet paint, the picture ends up as a verification of its own opaque surface.

In the year following, Rauschenberg began to experiment with objects placed on blueprint paper and exposed to sunlight. Already then he was involved with the physical material of plans; and in the early 1950s used newsprint to prime his canvases—to activate the ground, as he put it—so that his first brushstroke upon it took place in a gray map of words.

In retrospect the most clownish of Rauschenberg's youthful pranks take on a kind of stylistic consistency. Back in the fifties, he was invited to participate in an exhibition on the nostalgic subject of "nature in art"— the organizers hoping perhaps to promote an alternative to the new abstract painting. Rauschenberg's entry was a square patch of growing grass held down with chicken wire, placed in a box suitable for framing and hung on the wall (p. 30). The artist visited the show periodically to water his piece—a transposition from nature to culture through a shift of ninety degrees. When he erased a de Kooning drawing, exhibiting it as "Drawing by Willem de Kooning erased by Robert Rauschenberg," he was making more than a multifaceted psychological gesture; he was changing—for the viewer no less than for himself—the angle of imaginative confrontation; tilting de Kooning's evocation of a worldspace into a thing produced by pressing down on a desk.

The paintings he made toward the end of that decade included intrusive non-art attachments: a pillow suspended horizontally from the lower frame (*Canyon,* 1959); a grounded ladder inserted between the painted panels which made up the picture (*Winter Pool,* 1959; p. 31); a chair standing against a wall but ingrown with the painting behind (*Pilgrim,* 1960). Though they hung on the wall, the pictures kept referring back to the horizontals on which we walk and sit, work and sleep.

When in the early 1960s he worked with photographic transfers, the images—each in itself illusionistic—kept interfering with one another, intimations of spatial meaning forever canceling out to subside in a kind of optical noise. The waste and detritus of communication—like radio transmission with interference; noise and meaning on the same wavelength, visually on the same flatbed plane.

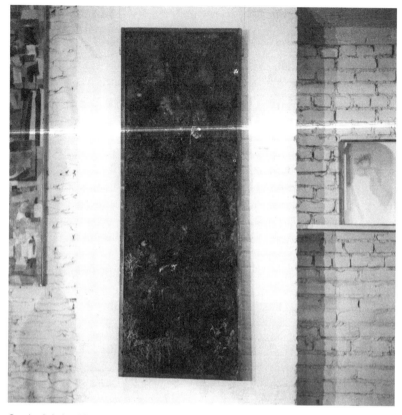

Growing Painting, 1953. Dirt and vege-
tation in wood frame, c. 72 × 25 in.
Lost or destroyed. Photograph by
Robert Rauschenberg.

The picture plane, as in the enormous canvas called *Overdraw* (1963;
p. 32), could look like some garbled conflation of controls system and city-
scape, suggesting the ceaseless flow of urban message, stimulus, and im-
pediment. To hold all this together, Rauschenberg's picture plane had to
become a surface to which anything reachable-thinkable would adhere. It
had to be whatever a billboard or dashboard is, and everything a projection
screen is, with further affinities for anything that is flat and worked over—
palimpsest, canceled plate, printer's proof, trial blank, chart, map, aerial
view. Any flat documentary surface that tabulates information is a relevant
analogue of his picture plane—radically different from the transparent
projection plane with its optical correspondence to man's visual field. And

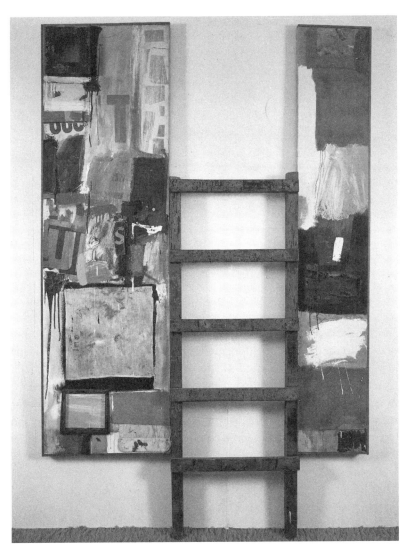

Winter Pool, 1959. Combine painting: oil, paper, fabric, wood, metal, sand-paper, tape, printed paper, printed re-productions, handheld bellows, and found painting, on canvas, with lad-der, 90 × 59 ½ × 4 in. Collection of David Geffen, Los Angeles.

Overdraw, 1963. Oil and silkscreen ink
on canvas, 60 × 120 in. Kunsthaus
Zürich.

it seemed at times that Rauschenberg's work surface stood for the mind it-
self—dump, reservoir, switching center, abundant with concrete refer-
ences freely associated as in an internal monologue—the outward symbol
of the mind as a running transformer of the external world, constantly in-
gesting incoming unprocessed data to be mapped in an overcharged field.

To cope with his symbolic program, the available types of pictorial
surface seemed inadequate; they were too exclusive and too homoge-
neous. Rauschenberg found that his imagery needed bedrock as hard and
tolerant as a workbench. If some collage element, such as a pasted-down
photograph, threatened to evoke a topical illusion of depth, the surface
was casually stained or smeared with paint to recall its irreducible flatness.
The "integrity of the picture plane"—once the accomplishment of good
design—was to become that which is given. The picture's "flatness" was
to be no more of a problem than the flatness of a disordered desk or an
unswept floor. Against Rauschenberg's picture plane you can pin or pro-
ject any image because it will not work as the glimpse of a world, but as a
scrap of printed material. And you can attach any object, so long as it beds
itself down on the work surface. The old clock in Rauschenberg's 1961
Third Time Painting lies with the number 12 on the left, because the clock
face properly uprighted would have illusionized the whole system into a
real vertical plane—like the wall of a room, part of the given world. Or,
in the same picture, the flattened shirt with its sleeves outstretched—not
like wash on a line, but—with paint stains and drips holding it down—

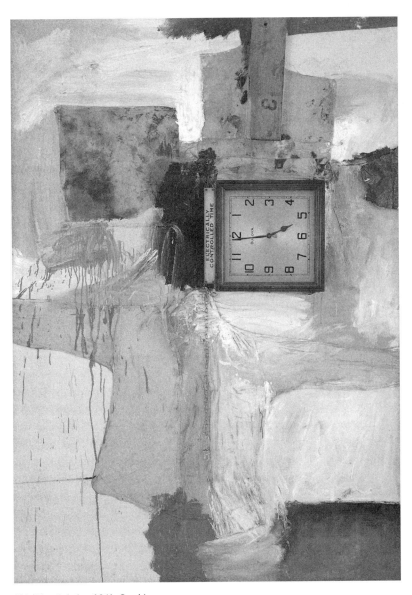

Third Time Painting, 1961. Combine painting: oil, fabric, wood, metal, and clock on canvas, 84 × 60 in. Collection of Thomas M. Lee and Ann Tenenbaum, New York.

like laundry laid out for pressing. The consistent horizontality is called upon to maintain a symbolic continuum of litter, workbench, and data-ingesting mind.

Perhaps Rauschenberg's profoundest symbolic gesture came in 1955 when he seized his own bed, smeared paint on its pillow and quilt coverlet, and uprighted it against the wall. There, in the vertical posture of "art," it continues to work in the imagination as the eternal companion of our other resource, our horizontality, the flat bedding in which we do our begetting, conceiving, and dreaming. The horizontality of the bed relates to "making" as the vertical of the Renaissance picture plane related to seeing.

I once heard Jasper Johns say that Rauschenberg was the man who in this century had invented the most since Picasso. What he invented above all was, I think, a pictorial surface that let the world in again. Not the world of the Renaissance man who looked for his weather clues out of the window; but the world of men who turn knobs to hear a taped message, "precipitation probability ten percent tonight," electronically transmitted from some windowless booth. Rauschenberg's picture plane is for the consciousness immersed in the brain of the city.

The flatbed picture plane lends itself to any content that does not evoke a prior optical event. As a criterion of classification it cuts across the terms "abstract" and "representational," Pop and modernist. Color field painters such as Ken Noland, Frank Stella, and Ellsworth Kelly, whenever their works suggest a reproducible image, seem to work with the flatbed picture plane, i.e., one which is man-made and stops short at the pigmented surface; whereas Pollock's and Louis's pictures remain visionary, and Frankenthaler's abstractions, for all their immediate modernism, are—as Lawrence Alloway recently put it—"a celebration of human pleasure in what is not man-made."[18]

Insofar as the flatbed picture plane accommodates recognizable objects, it presents them as man-made things of universally familiar character. The emblematic images of the early Johns belong in this class; so, I think, does most of Pop art. When Roy Lichtenstein in the early sixties painted an Air Force officer kissing his girl goodbye, the actual subject matter was the mass-produced comic book image; Ben-day dots and stereotyped drawing ensured that the image was understood as a representation of printed matter. The pathetic humanity that populate Dubuffet's pictures are rude man-made graffiti, and their reality derives both from the material density of the surface and from the emotional pressure that

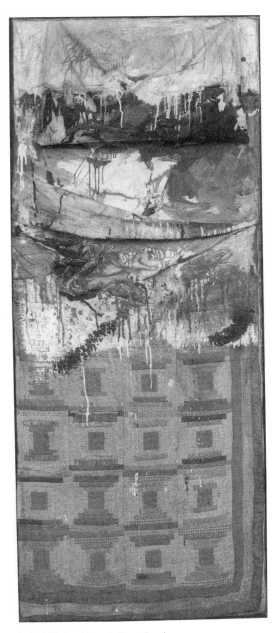

Bed, 1955. Combine painting: oil and pencil on pillow, quilt, and sheet, mounted on wood, 75 ¾ × 31 ½ × 8 in. The Museum of Modern Art, New York. Gift of Leo Castelli in honor of Alfred H. Barr, Jr. Photograph © 2001 The Museum of Modern Art, New York.

guided the hand. Claes Oldenburg's drawing, to quote his own words, "takes on an 'ugliness' which is a mimicry of the scrawls and patterns of street graffiti. It celebrates irrationality, disconnection, violence and stunted expression—the damaged life forces of the city street."[19]

And about Andy Warhol, David Antin once wrote a paragraph which I wish I had written:

> In the Warhol canvases, the image can be said to barely exist. On the one hand this is part of his overriding interest in the "deteriorated image," the consequence of a series of regressions from some initial image of the real world. Here there is actually a series of images of images, beginning from the translation of the light reflectivity of a human face into the precipitation of silver from a photosensitive emulsion, this negative image developed, re-photographed into a positive image with reversal of light and shadow, and consequent blurring, further translated by telegraphy, engraved on a plate and printed through a crude screen with low-grade ink on newsprint, and this final blurring and silkscreening in an imposed lilac color on canvas. What is left? The sense that there is something out there one recognizes and yet can't see. Before the Warhol canvases we are trapped in a ghastly embarrassment. This sense of the arbitrary coloring, the nearly obliterated image and the persistently intrusive feeling. Somewhere in the image there is a proposition. It is unclear.[20]

The picture conceived as the image of an image. It is a conception which guarantees that the presentation will not be directly of a world-space, and that it will nevertheless admit any experience as the matter of representation. And it readmits the artist in the fullness of his human interests, as well as the artist-technician.

The all-purpose picture plane underlying this post-modernist painting has made the course of art once again nonlinear and unpredictable. What I have called the flatbed is more than a surface distinction if it is understood as a change within painting that changed the relationship between artist and image, image and viewer. Yet this internal change is no more than a symptom of changes which go far beyond questions of picture planes, or of painting as such. It is part of a shakeup which contaminates all purified categories. The deepening inroads of art into non-art continue to alienate the connoisseur as art defects and departs into strange territories, leaving the old standby criteria to rule an eroding plain.

Notes

1. Published posthumously (New York: Macmillan, 1939), p. 150.

2. Albert C. Barnes, *The Art in Painting* (Merion, Pa.: Barnes Foundation Press, 1925), p. 408.

3. Clement Greenberg, "Picasso at Seventy-Five," in Greenberg, *Art and Culture* (Boston: Beacon Press, 1961), p. 62.

4. Clement Greenberg, "Modernist Painting," in Gregory Battcock, ed., *The New Art* (New York: Dutton, 1966), pp. 101ff. The essay first appeared in *Art and Literature* (Spring 1965).

5. Clement Greenberg, "Abstract, Representational and So Forth," in *Art and Culture*, p. 136.

6. Betty Friedan, *The Feminine Mystique* (New York: Norton, 1963), p. 37. Cf. her analysis (pp. 29–30) of the ideal American woman as presented in an issue of *McCalls* (July 1960)—"pared down to pure femininity, unadulterated."

7. Greenberg, "Modernist Painting," p. 102.

8. Clement Greenberg, "Cézanne," in *Art and Culture*, p. 53.

9. Greenberg, "Modernist Painting," pp. 103–104.

10. Don Judd, in *Art News* (October 1971), p. 60.

11. Greenberg, "Modernist Painting," p. 107.

12. Clement Greenberg, "Collage," in *Art and Culture*, p. 72.

13. Ibid., pp. 73–74.

14. The deliberate exploitation of surface-to-depth oscillation characterizes all major painting; it is the inexhaustible resource of the art. But the degree to which the resultant duality registers on the viewer's attention depends on the culture and the set of expectancies he brings to his appreciation. He mistakes the goal of the Old Masters if he imagines them aiming for that near absolute dissolution of the picture plane which distinguishes late nineteenth-century academic painting.

To take an outstanding example of illusionist Old Master art—Velázquez's *Menippus:* the heavy impasto that molds the scrolls and books in the foreground tells you explicitly where the paint is. But the jug and bench in the "background," where the raw canvas appears barely stained by a thin wash of pigment, says—"this is where the canvas is." And the palpable mystery of the painting is the old cynic's material presence inserted in the nondimensional film between canvas and paint. No painting was ever more self-defining than this.

15. Barnes, *Art in Painting*, p. 408. For the author's insistence on synthesizing the elements of design, see pp. 55, 61, 67f.

16. Barbara Rose, "Quality in Louis," *Artforum* (October 1971), p. 65.

17. The fact that some Louis paintings may actually hang upside down is immaterial. Their space will still be experienced as gravitational, whether the image suggests falling veils or shooting flames.

18. Lawrence Alloway, "Frankenthaler as Pastoral," *Art News* (November 1971), p. 68.

19. Quoted in Eila Kokkinen's review of *Claes Oldenburg: Drawings and Prints,* in *Arts* (November 1969), p. 12.

20. David Antin, "Warhol: The Silver Tenement," *Art News* (Summer 1966), p. 58.

Hymnal, 1955. Combine painting: oil,
paper, fabric, printed paper, printed
reproductions, and wood on fabric,
with telephone directory, metal, and
string, 64 × 49 ¼ × 7 ¼ in. Sonnabend
Collection, New York.

Rauschenberg and the Materialized Image

Rosalind Krauss

Her reaction several years ago to the essay by Leo Steinberg had been, "Well, I know he may be right in several respects . . . but *Rauschenberg?!*" In her question, italics included, was the unspoken comparison between the course of Steinberg's argument and the kind of misdirected zeal that led Baudelaire to present, as the exemplar of a painter who could capture the "heroism of modern life," Constantin Guys. For Steinberg had been addressing what he saw as a radical change in the aesthetic premises of contemporary art, a change that he called a "shift from nature to culture." Focusing on the kind of orientation that a picture declares itself to have to the upright body of the man who views it, Steinberg had been pointing to something that had occurred in the art of the late 1950s and early 1960s, something that was most conspicuous and thoroughgoing in the art of Robert Rauschenberg.[1]

If pictures before that time, including abstract pictures, had conspired with the viewer's vertical posture, opening up a space, no matter how transformed, that was an extension of his own visual field, and therefore of nature as he experienced it, the work of Rauschenberg countered this conventional orientation with something else. "These pictures," Steinberg wrote, "no longer simulate vertical fields but opaque flatbed horizontals," a condition that he went on to compare with tabletops, studio floors, or "any receptor surface on which objects are scattered, on which data is entered, on which information may be received, printed, impressed— whether coherently or in confusion."[2] And, he asserted, this change in direction had made available to contemporary art an entirely new range of content.

The response of my colleague had not been to whether Steinberg's appraisal of a certain situation was accurate or not, but to her sense that a change of major aesthetic consequence must be proffered in the form of masterpieces, something which, in her eyes, Rauschenberg had not produced. I think of that now, in relation to Jasper Johns's remark that Rauschenberg was the man who in this century had invented the most since Picasso.[3]

The tension between those two positions, between a sense of art's relationship to invention and its status as embedded in the notion of the Masterpiece, is a tension which is not merely circumstantially related to Rauschenberg's work. For part of what informs the stance of that work, as it has come to seem familiar over the last twenty years, part of what is urged by its layered clutter and disarray, is, surely, that the masterpiece as conventionally conceived is a concept which is itself deeply compromised.

Rauschenberg's art developed at precisely the same time that saw the rise of single-image painting as the dominant pictorial mode in this country. Grounded in the work of Jasper Johns and then in that of Frank Stella, the single-image identified itself so completely with the support which bore it that it took on the holistic nature of that support. It was assimilated into the mode of perception by which objects in the world are recognized as unitary, unbroken Gestalts. Rauschenberg himself had produced a pictorial object of this kind. In 1955, the same year that Johns made his first *Flag,* Rauschenberg created *Bed,* a work in which the richness of internal textural divisions and the blatant shifts in attack from one part of the work to another were completely absorbed—rendered nugatory—by the singleness of the work's presence as an object. But in Rauschenberg's career, *Bed* is a more or less isolated instance. In the face of the ascendancy of single-image art, Rauschenberg ran his own work, no matter what the medium, whether painting, printmaking, sculpture, or performance, through the channel of collage. It was, as we shall see, a form of collage that was largely reinvented, such that in Rauschenberg's hands the meaning and function of the collage elements bore little relation to their earlier use in the work of Schwitters or the Cubists. But it was collage nonetheless. And in so being, it forced on the viewer of Rauschenberg's work an undeniable experience of syntax.

In the particular way that Rauschenberg enforced a part-by-part, image-by-image reading of his work, he guaranteed that the experience of it would share with language some of its character of discourse. The encounter with one image after another would, that is, demand an attention

to a kind of temporal unfolding that was like that of hearing or reading a sentence. And though the syntactic connections between Rauschenberg's images never presupposed the grammatical logic of a known language, they implied that the modality of discursiveness was one aspect of the artist's medium. What Rauschenberg was insisting upon was a model for art that was not involved with what might be called the cognitive moment (as in single-image painting) but instead was tied to the *durée*—to the kind of extended temporality that is involved in experiences like memory, reflection, narration, proposition. In lodging his art there—within the *durée*—Rauschenberg went on, year after year, in good work and bad, infusing what he made with a certain stance about the function of art, a stance which at the present time has a special relevance and urgency.

Concern about the function of art, in those who deal with art at all, has largely been left to writers whose thinking has been shaped by Marxism. And whether we are talking about Walter Benjamin, Christopher Caudwell,[4] or Jean-Paul Sartre, shared observations can be found in this literature about the relationship of modern art, as it developed in the nineteenth century, to consumer capitalism. This argument, briefly and unfortunately crudely summarized, runs as follows. The social structure imposed by advanced industrial capitalism acts to transform the relationship between men and men into the kind of proprietary transaction that obtains between men and things. Wage labor enters what is called "the labor market" and is bought and sold like so many objects. Or, in the phrase "goods and services," there is an equation between both those terms which assumes that they are simply two brands of commodity. To this deformation of human relationships Marxism gives the name "commodity-fetishism." And in describing the way this insinuates itself into the art of the nineteenth century, Benjamin speaks of the graphic fantasies of Grandville as having "transmitted commodity-character onto the universe. They modernised it. The ring of Saturn became a cast-iron balcony, upon which the inhabitants of Saturn take the air of an evening."[5]

Relatedly, a preoccupation with fashion signals the way in which each individual within bourgeois society comes to view himself as a species of packaging: as a commodity-fetish.

Fashion prescribed the ritual by which the fetish Commodity wished to be worshipped, and Grandville extended the sway of fashion over the objects of daily use as much as over the cosmos. In pursuing it to its extremes, he revealed its nature. It stands in opposition to the

organic. It prostitutes the living body to the inorganic world. In relation to the living it represents the rights of the corpse. Fetishism, which succumbs to the sex-appeal of the inorganic, is its vital nerve; and the cult of the commodity recruits this to its service.[6]

But Grandville is, of course, a kind of sidelight within the history of nineteenth-century art, the major event of which was the doctrine of *l'art pour l'art*. The Marxist assessment of aestheticism or formalism is that it represents the artist exercising the bourgeois *illusion* of freedom, by an attempt to withdraw his art from the meritriciousness of commercial values.[7] But in this attempt the artist is seen as "succumbing to the form of commodity-fetishism appropriate to his kind,"[8] namely, the creation of the work as Object and the alliance of its function with that of the commodity: with that of something whose meaning is appropriately grasped in the process of acquisition, or collection. This view, which is harsh and unresponsive to the specific aims of various artists within the late nineteenth century, does seem increasingly applicable to certain forms of contemporary modernism. But if it is a view that is intensely critical of formalism, consciousness of that criticism is nowhere to be found in the belief that modernist art is most appropriately related to private collecting, a belief which William Rubin recently rehearsed in the pages of *Artforum*. "The *ideal* place," he said, "—even for a big Pollock—is in a private home. I think that's what most modern painting, given its character, really wants. To me, museums are essentially compromises. They are neither like a really public place, nor are they private—like an apartment."[9]

Now if the analysis just summarized defines a situation which obtains rather markedly for certain works of modern art, it is because in these works aesthetic content is tied to the function of the commodity; it is as if they are about the act of delectation and possession and nothing more. However, the stance of the early Abstract Expressionists was clearly a first wave in an attempt to renounce this function.[10] And the second wave of this attempt is to be found in the work of Rauschenberg and Johns.

In the form that they introduced it and in which it has come to permeate the art of the generation(s) that followed them, this reversal in the function of art produced within bourgeois society depended on the capacity of the work of art to operate as Idea. That is, insofar as the work's content was primarily directed toward a reorientation in thinking, insofar as its energies would have to be seen (on whatever level) as in some sense theoretical, the object's relationship to its audience was that of a form of

address. In the simplest sense, one could say that the experience of a Johns *Target* or *Flag* has everything to do with understanding it, "getting it," seeing its point, and nothing to do with owning it.

On the level of simple production, this is part of what stands behind Johns's choice to employ images devalued by their relation to mass production, and Rauschenberg's use of common junk objects in the Combine paintings or the procedures of mass dissemination of images in the silkscreen paintings. But that decision to draw their imagery from a source that would theoretically undermine the work's stature as a unique object of value is only symptomatic of a more general effort to readjust the sense of art's import. It was as if only by situating the work somehow within what could be seen, or *had* to be seen, as a kind of theoretical or discursive space, could the art object challenge its fate of being absorbed as a commodity only. (It is one of the peculiar ironies of recent art that, while much of Minimal and post-Minimalist work was directed toward internally establishing the primacy of conceptual value over commodity value, the most rarified versions of Conceptual art managed to render Idea itself into a kind of commodity.)

In relation to this whole question of the aesthetic primacy of conception over commodity, Rauschenberg's and Johns's affinities with the work of Duchamp are entirely consistent. This is so even though the specific aspects of Duchamp's art, toward which the two men established a relationship, differed as their own work developed in tangential directions.

The aspect of Duchamp's production that seems most related to the visual quality of Rauschenberg's art is contained in works like *Glider Containing a Water Mill (in Neighboring Metals); To Be Looked at . . . Close To, for Almost an Hour;* and *The Bride Stripped Bare by Her Bachelors, Even*—a genre of painting which Duchamp described as "a delay in glass." In those works, Duchamp's procedure is to sandwich and suspend the depicted image between two transparent panes, and to set those panes either at right angles to the wall or on stanchions which will support them as freestanding within the space of a room. The effect of this treatment is to materialize the image, to make a representation read as though it were a corporeal thing.

From the beginning Rauschenberg, too, had treated images as a species of material. In the upper left and lower right corners of *Charlene* (1954) are swatches of *broderie anglaise* in which a peacock and flowered border are defined by the varying densities of the heavy lace. In the works

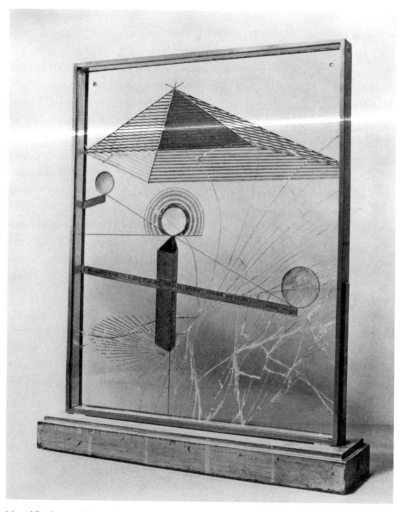

Marcel Duchamp, *To Be Looked at
(from the Other Side of the Glass) with
One Eye, Close To, for Almost an Hour,*
1918. Oil paint, silver leaf, lead wire,
and magnifying lens on glass
(cracked), 19 ½ × 15 ⅜ in.; mounted
between two panes of glass in a stand-
ing metal frame, 20 ⅛ × 16 ¼ × 1 ½
in.; on painted wood base, 1 ⅞ ×
17 ⅞ × 4 ½ in.; overall height, 22 in.
The Museum of Modern Art, New York.
Katherine S. Dreier Bequest. Photo-
graph © 2001 The Museum of Modern
Art, New York. © 2001 Artists Rights
Society (ARS), New York / ADAGP,
Paris / Estate of Marcel Duchamp.

of the next few years there is a consistent use of printed fabrics, paisleys, and embroideries, always enforcing the sense that the images of flowers, fruit, or whatever, are contained by, literally embedded in, a material substance. And consequently that images themselves, within the medium of Rauschenberg's art, *are* material substances. Clearly, when the "images" are actual objects—socks, shirts, washcloths, umbrellas, street signs, and the like—the sense of identification between material objects and "images" is heightened in every way.

The parallel I mentioned before between Rauschenberg's technique and that of Duchamp in the glass paintings rests not simply on the material character that he gives to images, but also on the procedure that follows from their materiality: that they can be physically embedded within the pictorial medium, the way a nail can be driven into the surface of a wall. In the case of printed or embroidered material this quality of an embedded image is natural to the weave of the fabric itself. But Rauschenberg heightens the physical quality of even these images by sandwiching or layering swathes of sheer prints, one over another, as in the paintings *Knee Pad* (1956) and *Hymnal* (1955). And in the case of fabrics into which an image is not already woven—as in the voluptuous passages of rust- and peach-colored silk-velvet that cover the major portions of *Red Interior* (c. 1955)—images are embossed into the fabric by, in the case of *Red Interior*, ironing the velvet over a set of metal signs with raised letters, thereby imprinting the fabric with the impressions of material objects that appear to be submerged within it. Given another class of image—the shirts, socks, ties, etc.—these are still treated as if suspended within the pictorial field, as in the Duchamp works in glass. The items of clothing are embedded into the surface by covering them either by a coating of paint, or by a stretch of semitransparent scrim material so that they are implanted under the continuous spread of the surface like a splinter under the skin. This physical incorporation of the image extends to Rauschenberg's treatment of images of a more conventionally cultural sort. So that snapshots, postcards, news photos, comic strips, or poster fragments are layered into the surface like so much material, suspended within the pictorial matrix like biological specimens floating in fluid under glass.

This practice of materializing images had entered Rauschenberg's art through an earlier experience of materializing color. In the black paintings of 1952 and the first *Red Paintings* of 1953, a collage surface of various types of paper, including strips of newspaper, was impregnated with

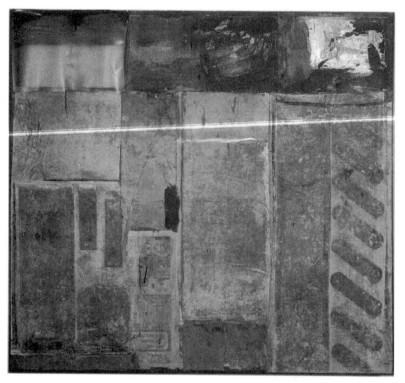

Red Interior, c. 1955. Combine paint-
ing: oil, fabric, and newspaper
on canvas, with plastic, wood,
metal-and-porcelain pulley, pebbles,
and string, 55 ⅜ × 61 × 2 ⅜ in. The
Estate of Victor and Sally Ganz.

pigment—black in the first case and red in the other. The tonal and chro-
matic differences in the color across these surfaces became then a function
of the material to which it was applied, or by which it was absorbed. So
that the impression of color within what was a conventional picture field
was seen to be a function of the color of things. This attitude toward color
prepared for the subsequent attitude toward the image. It was, itself, some-
thing that Rauschenberg did not pursue further, at least in terms of mak-
ing it the subject of an entire work (although it obviously conditions his
subsequent use of paint as a self-evidently colored material and his incor-
poration of spectral colors in the form of sequences of color swatches in
both *Rebus* and *Small Rebus* [1955 and 1956]). It is clear that Johns took it
up in his monochrome pictures, like *Green Target* and *White Flag,* where

Untitled *(Red Painting)*, c. 1953. Oil,
fabric, and newspaper on canvas, with
wood, 79 × 33 ⅛ in. Solomon R.
Guggenheim Museum, New York, Gift
of Walter K. Gutman, 1963.

Rauschenberg and the Materialized Image

color appears as if sandwiched between a coagulated ground of newspaper strips on the one hand, and the waxy surface of encaustic on the other. It is also clear that Stella has been involved with the whole issue of color as a declared function of material in his recent relief paintings.

But Rauschenberg's impulse was to leave off an investigation into the stratified constituents of painting, like "color," and to concern himself with the materialization of images. In the course of this, the paint itself—both in terms of its color and its density, applied in smears, drips, squeezes—came to function within the works as its own kind of specialized "image."[11]

In speaking of a materialized image, I hope it is clear that I am talking about something that is entirely original in Rauschenberg's art, something that separates him off from any use of the surface-related image before him. Because the image, as we have previously known it, was always a case of mapping: of translating a three-dimensional thing onto a two-dimensional field (and doing so in terms of a set of traces which themselves, literally, physically, *had* no dimension). Aside from this change in dimension, the obvious features of this translation were apparent changes in scale from object to image, and in texture from the natural surface to the medium of depiction. But the image was more than just a translation of the object; it was a relocation of it. The image removed the object from the space of the world, installing it in a space of an entirely different order. The new space was in the nature of a projection. And because it was irrevocably separated off from reality, it was understood (with varying degrees of idealization) to transcend reality.

The Cubist use of collage elements did nothing to suspend this situation, but merely intensified it. By making the process of image formation more apparent, they made it seem more paradoxically magical. A bit of newspaper absorbed into the shape of a wineglass can identify itself as a piece of the real world only from within the depths of a whole network of ambiguity. Caught up in the process of mapping, it is on the way to being absorbed, it has already *been* absorbed, into the transformational mesh of the image. It is something that is constantly forced to "read as" something else. The texture of the fine print translates into the broken light of an atmospheric tone, so that it is caught up in the process of rendering the transparency of glass. Its real shape as paper fragment translates into the shape of the object it coincides with, so that it becomes the medium by which the image is drawn. And in every sense there is an absolute tension between the physical irritant of the collage piece and the totally aphysical nature of the image per se. Although in both Schwitters's and Dubuffet's

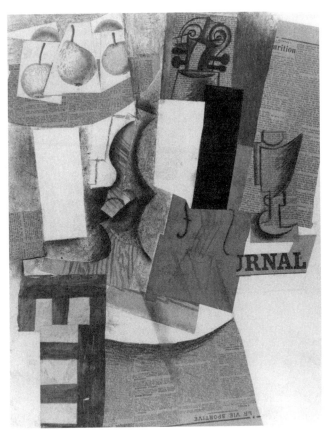

Pablo Picasso, *Bowl with Fruit, Violin,
and Wineglass,* begun after December
2, 1912; completed after January 21,
1913. Pasted paper, gouache, and
charcoal on cardboard, 25 ½ × 19 ½
in. Philadelphia Museum of Art: A. E.
Gallatin Collection. © 2001 Estate of
Pablo Picasso / Artists Rights Society
(ARS), New York.

cases (I am thinking of the *texturologies*) the collage elements were not used to assist in the formation of images, they were employed in such a way as to suspend their materiality between their own identity as objects and a transformation into sheer pictorial design or tone.

In Rauschenberg's work the image is not about an object transformed. It is a matter, rather, of an object transferred. An object is taken out of the space of the world and embedded into the surface of a painting, never at the sacrifice of its density as material. Rather it insists that images themselves are a species of material. And this is true whether the image in question is a shirt or a sock which operates as the image of a shirt or a sock while all the time remaining that thing, or whether the image is a section of cultural space—a postcard bought at the Louvre or a photo clipped from a newspaper—which joins the work as a materialization of the culture from which it sprang.

By never transcending the material world, the image is unambiguously identified with that material world—arising from within it rather than beyond it. Its relocation onto the conventional field of painting does not compromise this. Rather it situates the conventional picture's space at a new angle to that of real space. Steinberg spoke about this new angulation as a reorienting of Rauschenberg's pictorial surface: from that of a traditional vertical to that of a horizontal "flatbed." And, although I am in complete agreement with his characterization, I would like to inflect it in a slightly different way.

The images that collect on those flatbed surfaces, like so much clutter or debris, have an extraordinary range in terms of the type of content they bear. A work like *Small Rebus* (1956) places, one next to another, such disparate types of images as magazine photos of sports events, a map section showing the north central United States, a snapshot of a family, postage stamps, a child's drawing of a clock face, and a reproduction of Titian's *Rape of Europa*. Yet, because each image is given the same level of density as object, one is struck not by their multivalence as signs, but rather by their sameness as things. Within the space of *Small Rebus,* that is, they all seem to take on an equal degree of density. They share an equal thickness in terms of their presence to experience. Thus the viewer of the work is struck by the fact that the surface of this painting is a place, or locale, where this kind of equalization can happen. Further, he is struck by the sensation that this feat of leveling among images does not seem particularly odd.

There is, of course, another space, one to which we all have recourse, in which this kind of experience of leveling occurs. It is a space in which

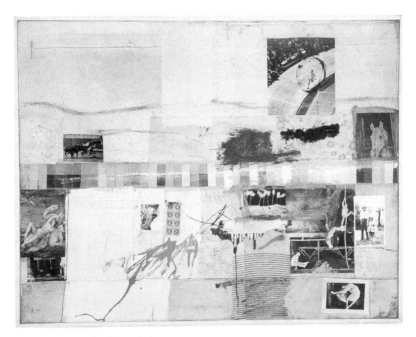

Small Rebus, 1956. Combine painting,
35 × 46 in. The Museum of Contem-
porary Art, Los Angeles. The Panza
Collection.

the image of a painting we have seen in a museum, and the image of an actual event we have witnessed, and the image of one we have merely fantasized or dreamed, all *do* possess an equal degree of density. This is the space of memory. For as one remembers experience, each memory image seems to function for recall in a way that is independent of whether it happened or not, or what degree of denseness it had when we experienced it. The image of a scene from a movie may be equally vivid for memory as the face of an absent friend.

This analogy that *Small Rebus* bears with the space of memory is possible because of the coming together of the various operations that Rauschenberg has performed on images. It is possible because by materializing them he has given them equal weight. Further it is possible because the act of embedding them or layering them into the surface gives to their juxtaposition an astonishing quality of plausibility. And this plausibility is certainly not to be explained by any kind of formal logic that might pertain to them as elements in a design, or any kind of obvious narrative

connection between them. Finally it is possible because of the quality they have of being suspended in a medium—that thing that Duchamp called a "delay in glass." What is most important here in Duchamp's phrase is the term "delay." For by giving to images the property of actual physical resistance that objects or actions have in our ordinary experience, Rauschenberg endows them with a sense of having to be encountered through time. In this way they are returned to an experience that is fully durational, an experience which we said in the beginning was like memory, reflection, narration, proposition. Rauschenberg speaks of the temporality of his work. "Listening happens in time," he said. "Looking also had to happen in time."[12]

In raising this analogy with memory, the question that might come to mind is this: Isn't there something incompatible between a kind of surface in which each image-object remains a physical thing and is therefore an apparent extension of the real space of the external world, and the kind of internal, psychological space which memory presupposes? And also, isn't there an important difference between the shared access that everyone might have to the common objects of everyday life and the very special access that each of us has to memory: to our own memories which reflect the uniqueness and ultimately the privacy of our own experience? So that ultimately wouldn't the procedure of analogizing the two fields—the one of the picture and the one of memory—be enough to remove the picture surface from real space and set it up within the kind of transcendent space which I have been claiming Rauschenberg rejects?

The answer to this lies not in the power of the conventional image to transcend reality, but in the power of Rauschenberg's use of images to transform the space of the convention. For it is exactly the notion of memory, or of any other private experience which paintings might have formerly expressed, that is redefined by these pictures. The field of memory itself is changed from something that is internal to something that is external; from something that is private to something that is collective insofar as it arises from the shared communality of culture. This is not culture with a capital C but rather a profusion of facts, some exalted but most banal, each of which leaves its imprint as it burrows into and forms experience.

On the picture field these physical traces of a set of temporal indexes must be held in simultaneous suspension. But by analogizing the fixed synchrony of the pictorial convention to the field of memory (where things may be synchronously stored but temporally reexperienced), Rauschenberg proposes several crucial reversals to the previous canon of

painting. The first is that the nature of the passage of the object from real space to the space of the picture is not about absorbing the object into a different *kind* of present time from that of the real space of the observer (one that transcends it), but is rather about transferring the object into the simultaneity of past time. The second is that past time, like memory, should be reconceived: from something that is understood as an internal state to something that is felt as a condition of externals.

Rauschenberg's extraordinary repertory of marking or registering the image on the surface, most of them a refusal to use the autographic mark of conventional drawing (because that kind of mark had become compromised as an extension outward of the private, internal space from which it was supposed that the hand was directed), is testimony to his insistence that it is the stuff of experience—the things one bumps into as one moves through the world—that forms experience. The business of ironing the raised lettering and shapes of the metal signs into the velvet of *Red Interior* is only one instance of this substitution of the deposited physical mark of the real thing for the kind of drawn mark that presupposes the pictorial field to be sealed off from the impress of objects. Rauschenberg's endless inventiveness about finding ways of marking from real space onto pictorial space is an obvious precedent for Johns's own use of this as a strategy.

Through the procedure of inventing ways of leaving marks, Rauschenberg stumbled on discoveries of a formal kind which he rarely, if ever, pursued. One of these, the *Tire Print* from 1953, was made by lining up sheets of paper over more than twenty-two feet of road and then directing John Cage to drive a car over them. It was certainly a way of making a mark. But beyond that it was also a way of finding an operational means of producing extension—of accounting procedurally for the way that one piece of the art space relates to the next. For Rauschenberg's work this operational means of accounting for the extent of the work recurs only in the *Rebus* pictures, where the assembly of the spectrum through a lineup of paint samples determines the width of the picture. But in the work of other, later, artists one is reminded—although I am not speaking of "influence"—of this device, for example, in Bochner's use of counting to arrive at the same result.

The transfer drawings—made by taking a rubbing on paper from newsprint soaked with lighter fluid—are another phase in the development of Rauschenberg's repertory of marking. Everything I have said about the earlier images—about their equal density (guaranteed by the equal process of their transfer) and the sense of their being embedded

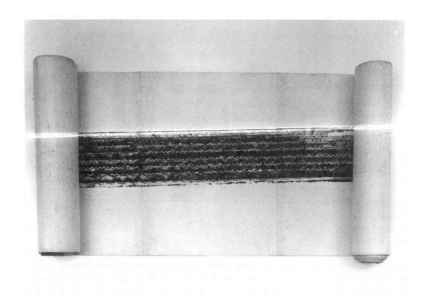

Automobile Tire Print, 1953. Ink on
twenty sheets of paper, mounted on
fabric, 16 ½ × 264 ½ in. Collection of
the artist.

within the surface as a species of object—applies to these drawings. As does the sense that they are suspended within a temporal matrix for which the model might be that of personal history. In 1965 Rauschenberg said of this type of drawing, which he was then making, "But everyday, by doing consistently what you do with the attitude you have, if you have strong feelings, these things are expressed over a period of time as opposed to, say, one *Guernica.*"[13] Yet the personal history and the strong feelings are composed by images which are external to the artist. In most instances the badge of their externality is their extreme banality. Even when they are incorporated into the space of his art they remain external. By insisting on their own external character, they suggest that the nature of his feelings, and the space of his art, and his personal history, are the product of the material world.

At the same time, by being absorbed into his world, by being "delayed" there as an incorporated part of his experience, the objects themselves are registered as images. By being deposited onto the pictorial field of experience, they are redeemed from a fate of functioning solely as commodity. And the work, as Rauschenberg conceives it, shares in—by inventing—this redemption.

Notes

1. Leo Steinberg, "Reflections on the State of Criticism," *Artforum* (March 1972), pp. 37–49; reprinted in this volume.

2. Ibid. (in this volume, p. 28).

3. These are words Steinberg uses to transcribe Johns's remark. Ibid., p. 34.

4. Caudwell's most important book, *Illusion and Reality,* was published in 1937 in England. For a recent study of his work, see Francis Mulhern, "The Marxist Aesthetic of Christopher Caudwell," *New Left Review* (May-June 1974), pp. 37–60.

5. Walter Benjamin, "Paris—Capital of the Nineteenth Century," *New Left Review* (March-April 1968), p. 82.

6. Ibid.

7. The sense in which the absorption in fashion, and the conscious attempt to withdraw the work of art from the commercial world of which fashion is a symptom, are two aspects of the same cultural situation is caught by Mallarmé. In his essay "Art for All" he cautions poets to preserve the mystery of their work by withdrawing it into the preserve of rare and expensive editions, thus saving it from the popular press and the mass audience. Yet at the same time he was editing and writing a review called *The Latest Fashion* dedicated to a discussion of dresses, jewels, furniture, even theater programs and dinner menus. As he wrote later to Verlaine, "The eight or ten numbers [of the review] which actually appeared still set me to dreaming whenever I get them out and dust them off."

8. Mulhern, "Marxist Aesthetic of Christopher Caudwell," p. 50.

9. "Talking with William Rubin," *Artforum* (October 1974), p. 53.

10. Max Kozloff discusses this in an article which addresses the function of art. See Kozloff, "American Painting during the Cold War," *Artforum* (May 1973), pp. 44–45.

11. The recent works made of corrugated cardboard and the *Pyramid Series* (1974) involve a partial return to the black paintings and *Red Paintings,* in that they involve the embedding or the finding (by tearing away the outer layer of the cardboard) of an image of a far less figurative kind than in the Combine or screen paintings. The image-content of those series works in a way that is closest to the attitude toward color in the earliest paintings. However, in my view, there is not an equal return to the level of quality of these earlier works.

12. In G. R. Swenson, "Rauschenbert Paints a Picture," *Art News* 62 (April 1963), p. 45.

13. In Dorothy Seckler, "The Artist Speaks: Robert Rauschenberg," *Art in America* (May 1966), p. 84.

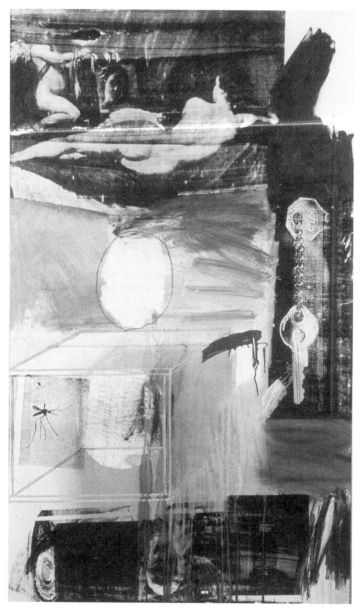

Exile, 1962. Oil and silkscreen ink on
canvas, 60 × 36 in. Collection of
Robin Trust. Photograph courtesy Leo
Castelli Gallery.

On the Museum's Ruins

Douglas Crimp

The German word *museal* [museumlike] has unpleasant overtones. It describes objects to which the observer no longer has a vital relationship and which are in the process of dying. They owe their preservation more to historical respect than to the needs of the present. Museum and mausoleum are connected by more than phonetic association. Museums are the family sepulchers of works of art.

—Theodor W. Adorno, "Valéry Proust Museum"

Reviewing the installation of nineteenth-century art in the Metropolitan Museum's new André Meyer Galleries, Hilton Kramer derided the inclusion of salon painting. Characterizing that painting as silly, sentimental, and impotent, Kramer went on to assert that, had the reinstallation been done a generation earlier, such pictures would have remained in the museum's storerooms, to which they had once so justly been consigned:

It is the destiny of corpses, after all, to remain buried, and salon painting was found to be very dead indeed.

But nowadays there is no art so dead that an art historian cannot be found to detect some simulacrum of life in its moldering remains. In the last decade, there has, in fact, arisen in the scholarly world a powerful subprofession that specializes in these lugubrious disinterments.[1]

Kramer's metaphors of death and decay in the museum recall Adorno's essay, in which the opposite but complementary experiences of Valéry and Proust at the Louvre are analyzed, except that Adorno insists

upon this *museal* mortality as a necessary effect of an institution caught in the contradictions of its culture and therefore extending to every object contained there.[2] In contrast, Kramer, retaining his faith in the eternal life of masterpieces, ascribes the conditions of life and death not to the museum or the particular history of which it is an instrument but to the artworks themselves, their autonomous quality threatened only by the distortions that a particular misguided installation might impose. He therefore wishes to explain "this curious turnabout that places a meretricious little picture like Gérôme's *Pygmalion and Galatea* under the same roof with masterpieces on the order of Goya's *Pepito* and Manet's *Woman with a Parrot*. What kind of taste is it—or what standard of values—that can so easily accommodate such glaring opposites?"

> The answer is to be found in that much-discussed phenomenon—the death of modernism. So long as the modernist movement was understood to be thriving, there could be no question about the revival of painters like Gérôme or Bouguereau. Modernism exerted a moral as well as an aesthetic authority that precluded such a development. But the demise of modernism has left us with few, if any, defenses against the incursions of debased taste. Under the new post-modernist dispensation, anything goes. . . .
>
> It is as an expression of this post-modernist ethos . . . that the new installation of 19th-century art at the Met needs . . . to be understood. What we are given in the beautiful André Meyer Galleries is the first comprehensive account of the 19th century from a postmodernist point of view in one of our major museums.[3]

We have here an example of Kramer's moralizing cultural conservatism disguised as progressive modernism. But we also have an interesting estimation of the museum's discursive practice during the period of modernism and its present transformation. Kramer's analysis fails, however, to take into account the extent to which the museum's claims to represent art coherently have already been opened to question by the practices of contemporary—postmodernist—art.

One of the first applications of the term *postmodernism* to the visual arts occurs in Leo Steinberg's "Other Criteria" in the course of a discussion of Robert Rauschenberg's transformation of the picture surface into what Steinberg calls a "flatbed," referring, significantly, to a printing press.[4]

This flatbed picture plane is an altogether new kind of picture surface, one that effects, according to Steinberg, "the most radical shift in the subject matter of art, the shift from nature to culture."[5] That is to say, the flatbed is a surface that can receive a vast and heterogeneous array of cultural images and artifacts that had not been compatible with the pictorial field of either premodernist or modernist painting. (A modernist painting, in Steinberg's view, retains a "natural" orientation to the spectator's vision, which the postmodernist picture abandons.) Although Steinberg, writing in 1968, did not have a precise notion of the far-reaching implications of the term *postmodernism,* his reading of the revolution implicit in Rauschenberg's art can be both focused and extended by taking his designation seriously.

Steinberg's essay suggests important parallels with the "archaeological" enterprise of Michel Foucault. Not only does the term *postmodernism* imply the foreclosure of what Foucault would call the episteme, or archive, of modernism, but even more specifically, by insisting on the radically different kinds of picture surfaces upon which different kinds of data can be accumulated and organized, Steinberg selects the very figure that Foucault employed to represent the incompatibility of historical periods: the tables on which their knowledge is formulated. Foucault's archaeology involved the replacement of such unities of historicist thought as tradition, influence, development, evolution, source, and origin with concepts such as discontinuity, rupture, threshold, limit, and transformation. Thus, in Foucauldian terms, if the surface of a Rauschenberg painting truly involves the kind of transformation Steinberg claims it does, then it cannot be said to evolve from or in any way be continuous with a modernist painting surface.[6] And if Rauschenberg's flatbed pictures are experienced as producing such a rupture or discontinuity with the modernist past, as I believe they do and as I think do the works of many other artists of the present, then perhaps we are indeed experiencing one of those transformations in the epistemological field that Foucault describes. But it is not, of course, only the organization of knowledge that is unrecognizably transformed at certain moments in history. New institutions of power as well as new discourses arise; indeed, the two are interdependent. Foucault analyzed modern institutions of confinement—the asylum, the clinic, and the prison—and their respective discursive formations—madness, illness, and criminality. There is another such institution of confinement awaiting archaeological analysis—the museum—and another discipline—art

history. They are the preconditions for the discourse that we know as modern art. And Foucault himself suggested the way to begin thinking about this analysis.

The beginning of modernism is often located in Manet's work of the early 1860s, in which painting's relationship to its art-historical precedents was made shamelessly obvious. Titian's *Venus of Urbino* is meant to be as recognizable a vehicle for the picture of a modern courtesan in Manet's *Olympia* as is the unmodeled pink paint that composes her body. Just one hundred years after Manet thus rendered painting's relationship to its sources self-consciously problematic,[7] Rauschenberg made a series of pictures using images of Velázquez's *Rokeby Venus* and Rubens's *Venus at Her Toilet*. But Rauschenberg's references to Old Master paintings are effected entirely differently from Manet's; whereas Manet duplicated the pose, composition, and certain details of the original in a painted transformation, Rauschenberg simply silkscreened photographic reproductions of the originals onto surfaces that might also contain such images as trucks and helicopters. If trucks and helicopters did not find their way onto the surface of *Olympia,* it was obviously not only because such products of the modern age had not yet been invented; it was also because the structural coherence that made an image-bearing surface legible as a picture at the threshold of modernism differs radically from the pictorial logic that obtains at the beginning of postmodernism. Just what it is that constitutes the particular logic of a Manet painting is suggested by Foucault in an essay about Flaubert's *Temptation of St. Anthony:*

> *Déjeuner sur l'Herbe* and *Olympia* were perhaps the first "museum" paintings, the first paintings in European art that were less a response to the achievement of Giorgione, Raphael and Velázquez than an acknowledgment (supported by this singular and obvious connection, using this legible reference to cloak its operation) of the new and substantial relationship of painting to itself, as a manifestation of the existence of museums and the particular reality and interdependence that paintings acquire in museums. In the same period, *The Temptation* was the first literary work to comprehend the greenish institutions where books are accumulated and where the slow and incontrovertible vegetation of learning quietly proliferates. Flaubert is to the library what Manet is to the museum. They both produced works in a self-conscious relationship to earlier paintings or texts—or

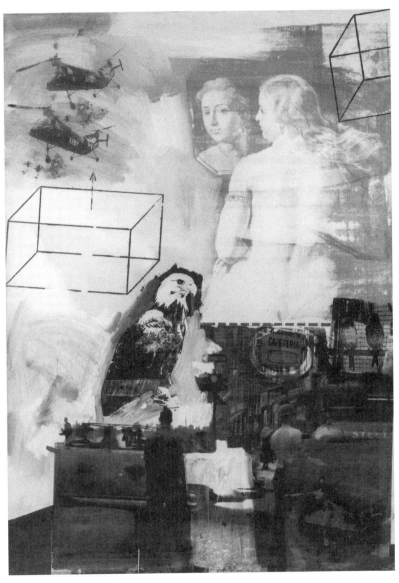

Tracer, 1963. Oil and silkscreen ink on
canvas, 84 × 60 in. The Nelson-Atkins
Museum of Art, Kansas City, Missouri
(Purchase) F84-70.

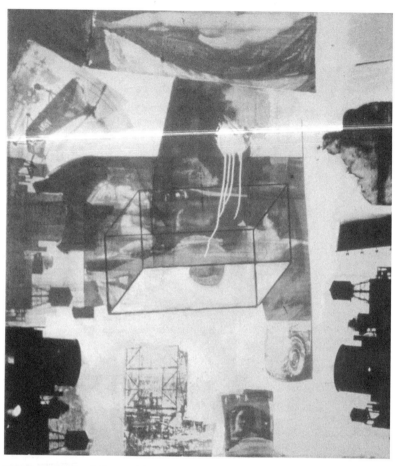

Transom, 1963. Oil and silkscreen ink
on canvas, 56 × 50 in. Private collec-
tion. Photograph courtesy Leo Castelli
Gallery.

rather to the aspect in painting or writing that remains indefinitely open. They erect their art within the archive. They were not meant to foster the lamentations—the lost youth, the absence of vigor, and the decline of inventiveness—through which we reproach our Alexandrian age, but to unearth an essential aspect of our culture: every painting now belongs within the massive surface of painting and all literary works are confined to the indefinite murmur of writing.[8]

At a later point in the essay, Foucault says that "*Saint Anthony* seems to summon *Bouvard and Pécuchet*, at least to the extent that the latter stands as its grotesque shadow." If *The Temptation* points to the library as the generator of modern literature, then *Bouvard and Pécuchet* fingers it as the dumping ground of an irredeemable classical culture. *Bouvard and Pécuchet* is a novel that systematically parodies the inconsistencies, the irrelevancies, the foolishness of received ideas in the mid-nineteenth century. Indeed, a "Dictionary of Received Ideas" was to make up part of a second volume of Flaubert's last, unfinished novel.

Bouvard and Pécuchet is the narrative of two loony Parisian bachelors who, at a chance meeting, discover between themselves a profound sympathy and also learn that they are both copy clerks. They share a distaste for city life and particularly for their fate of sitting behind desks all day. When Bouvard inherits a small fortune, the two buy a farm in Normandy to which they retire, expecting there to meet head-on the reality that was denied them in the half-life of their Parisian offices. They begin with the notion that they will farm their farm, at which they fail miserably. From agriculture they move to the more specialized field of arboriculture. Failing that, they decide on garden architecture. To prepare themselves for each new profession, they consult various manuals and treatises, in which they are perplexed to find contradictions and misinformation of all kinds. The advice they read is either confusing or utterly inapplicable; theory and practice never coincide. Undaunted by their successive failures, however, they move on inexorably to the next activity, only to find that it too is incommensurate with the texts that purport to represent it. They try chemistry, physiology, anatomy, geology, archaeology—the list goes on. When they finally succumb to the fact that the knowledge they've relied on is a mass of haphazard contradictions quite disjunct from the reality they'd sought to confront, they revert to their initial task of copying. Here is one of Flaubert's scenarios for the end of the novel:

They copy papers haphazardly, everything they find, tobacco pouches, newspapers, posters, torn books, etc. (real items and their imitations. Typical of each category).

Then, they feel the need for a taxonomy, they make tables, antithetical oppositions such as "crimes of the kings and crimes of the people."—blessings of religion, crimes of religion. Beauties of history, etc.; sometimes, however, they have real problems putting each thing in its proper place and suffer great anxieties about it.

—Onward! Enough speculation! Keep on copying! The page must be filled. Everything is equal, the good and the evil. The farcical and the sublime—the beautiful and the ugly—the insignificant and the typical, they all become an exaltation of the statistical. There are nothing but facts—and phenomena.

Final bliss.[9]

In an essay about *Bouvard and Pécuchet,* Eugenio Donato argues persuasively that the emblem for the series of heterogeneous activities of the two bachelors is not, as Foucault and others have claimed, the library-encyclopedia, but rather the museum. This is not only because the museum is a privileged term in the novel itself but also because of the absolute heterogeneity the museum gathers together. It contains everything the library contains, and it contains the library as well:

If Bouvard and Pécuchet never assemble what can amount to a library, they nevertheless manage to constitute for themselves a private museum. The museum, in fact, occupies a central position in the novel; it is connected to the characters' interest in archeology, geology, and history and it is thus through the *Museum* that questions of origin, causality, representation, and symbolization are most clearly stated. The *Museum,* as well as the questions it tries to answer, depends upon an archeological epistemology. Its representational and historical pretensions are based upon a number of metaphysical assumptions about origins—archeology intends, after all, to be a science of the *archēs.* Archeological origins are important in two ways: each archeological artifact has to be an original artifact, and these original artifacts must in turn explain the "meaning" of a subsequent larger history. Thus, in Flaubert's caricatural example, the baptismal font that Bouvard and Pécuchet discover has to be a Celtic sacrificial stone, and Celtic culture has in turn to act as an original master pattern for cultural history.[10]

Bouvard and Pécuchet derive from the few stones that remain from the Celtic past not only all of Western culture but the "meaning" of that culture as well. Those menhirs lead them to construct the phallic wing of their museum:

> In former times, towers, pyramids, candles, milestones and even trees had a phallic significance, and for Bouvard and Pécuchet everything became phallic. They collected swing-poles of carriages, chair-legs, cellar bolts, pharmacists' pestles. When people came to see them they would ask: "What do you think that looks like?" then confide the mystery, and if there were objections, they shrugged their shoulders pityingly.[11]

Even in this subcategory of phallic objects, Flaubert maintains the heterogeneity of the museum's artifacts, a heterogeneity that defies the systematization and homogenization that knowledge demanded.

> The set of objects the *Museum* displays is sustained only by the fiction that they somehow constitute a coherent representational universe. The fiction is that a repeated metonymic displacement of fragment for totality, object to label, series of objects to series of labels, can still produce a representation which is somehow adequate to a nonlinguistic universe. Such a fiction is a result of an uncritical belief in the notion that ordering and classifying, that is to say, the spatial juxtaposition of fragments, can produce a representational understanding of the world. Should the fiction disappear, there is nothing left of the *Museum* but "bric-a-brac," a heap of meaningless and valueless fragments of objects which are incapable of substituting themselves either metonymically for the original objects or metaphorically for their representations.[12]

This view of the museum is what Flaubert figures through the comedy of *Bouvard and Pécuchet.* Founded on the disciplines of archaeology and natural history, both inherited from the classical age, the museum was a discredited institution from its very inception. And the history of museology is a history of the various attempts to deny the heterogeneity of the museum, to reduce it to a homogeneous system or series. The faith in the possibility of ordering the museum's "bric-a-brac," echoing that of Bouvard and Pécuchet, persists until today. Reinstallations such as that of the

Metropolitan's nineteenth-century collection in the André Meyer Galleries, particularly numerous throughout the 1970s and the 1980s, are testimonies to that faith. What so alarmed Hilton Kramer is that the criterion for determining the order of aesthetic objects in the museum throughout the era of modernism—the "self-evident" quality of masterpieces—has been abandoned, and as a result "anything goes." Nothing could testify more eloquently to the fragility of the museum's claims to represent anything coherent at all.

In the period following World War II, the greatest monument to the museum's mission is André Malraux's *Museum without Walls.* If *Bouvard and Pécuchet* is a parody of received ideas in the mid-nineteenth century, the *Museum without Walls* is the hyperbolic expression of such ideas in the mid-twentieth. The claims that Malraux exaggerates are those of "art history as a humanistic discipline."[13] For Malraux finds in the notion of style the ultimate homogenizing principle, indeed the essence of art, hypostatized, interestingly enough, through the medium of photography. Any work of art that can be photographed can take its place in Malraux's supermuseum. But photography not only secures the admittance of various objects, fragments of objects, details of objects to the museum, it is also the organizing device: it reduces the now even vaster heterogeneity to a single perfect similitude. Through photographic reproduction a cameo takes up residence on the page next to a painted tondo or a sculpted relief; a detail of a Rubens in Antwerp is compared to that of a Michelangelo in Rome. The art historian's slide lecture and the art history student's slide comparison exam inhabit the museum without walls. In a recent example provided by one of our eminent art historians, the oil sketch for a small detail of a cobblestone street in *Paris—A Rainy Day,* painted in the 1870s by Gustave Caillebotte, occupies the left-hand screen while a painting by Robert Ryman from the *Winsor* series of 1966 occupies the right, and presto! they are revealed to be one and the same.[14] But precisely what kind of knowledge is it that this artistic essence, style, can provide? Here is Malraux:

> In our Museum Without Walls, picture, fresco, miniature, and stained-glass window seem of one and the same family. For all alike—miniatures, frescoes, stained glass, tapestries, Scynthian plaques, pictures, Greek vase paintings, "details" and even statuary—have become "color-plates." In the process they have lost their properties as *objects;* but, by the same token, they have gained something: the utmost signifi-

André Malraux with the photographic
plates for *The Museum without Walls.*
Photograph *Paris Match* / Jarnoux.

cance as to *style* that they can possibly acquire. It is hard for us clearly
to realize the gulf between the performance of an Aeschylean tragedy,
with the instant Persian threat and Salamis looming across the Bay, and
the effect we get from reading it; yet, dimly albeit, we feel the differ-
ence. All that remains of Aeschylus is his genius. It is the same with
figures that in reproduction lose both their original significance as ob-
jects and their function (religious or other); we see them only as works
of art and they bring home to us only their makers' talent. We might
almost call them not "works" but "moments" of art. Yet diverse as they
are, all these objects . . . speak for the same endeavor; it is as though
an unseen presence, the spirit of art, were urging all on the same

quest. . . . Thus it is that, thanks to the rather specious unity imposed by photographic reproduction on a multiplicity of objects, ranging from the statue to the bas-relief, from bas-reliefs to seal-impressions, and from these to the plaques of the nomads, a "Babylonian style" seems to emerge as a real entity, not a mere classification—as something resembling, rather, the life-story of a great creator. Nothing conveys more vividly and compellingly the notion of a destiny shaping human ends than do the great styles, whose evolutions and transformations seem like long scars that Fate has left, in passing, on the face of the earth.[15]

All of the works that we call art, or at least all of them that can be submitted to the process of photographic reproduction, can take their place in the great superoeuvre, art as ontology, created not by men and women in their historical contingencies but by Man in his very being. This is the comforting "knowledge" to which the *Museum without Walls* gives testimony. And concomitantly, it is the deception to which art history is most deeply, if often unconsciously, committed.

But Malraux makes a fatal error near the end of his *Museum:* he admits within its pages the very thing that had constituted its homogeneity; that thing is, of course, photography. So long as photography was merely a *vehicle* by which art objects entered the imaginary museum, a certain coherence obtained. But once photography itself enters, an object among others, heterogeneity is reestablished at the heart of the museum; its pretensions to knowledge are doomed. For even photography cannot hypostatize style from a photograph.

In Flaubert's "Dictionary of Received Ideas" the entry under "Photography" reads, "Will make painting obsolete. (See Daguerreotype.)" And the entry for "Daguerreotype" reads, in turn, "Will take the place of painting. (See Photography.)"[16] No one took seriously the possibility that photography might usurp painting. Less than half a century after photography's invention such a notion was one of those received ideas to be parodied. In our century, until recently, only Walter Benjamin gave credence to the notion, claiming that inevitably photography would have a truly profound effect on art, even to the extent that the art of painting might disappear, having lost its all-important aura through mechanical reproduction.[17] A denial of this power of photography to transform art contin-

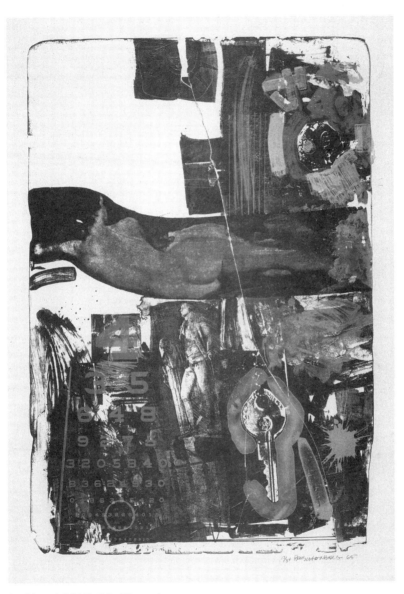

Breakthrough II, 1965. Color lithograph
on paper, 48 ⅜ × 33 ¹⁵⁄₁₆ in. From an
edition of thirty-four published by
Universal Limited Art Editions. Co-
copyright Robert Rauschenberg
and ULAE / Licensed by VAGA, New
York, NY.

ued to energize modernist painting through the immediate postwar pe-
riod in America. But then in the work of Rauschenberg photography
began to conspire with painting in its own destruction.

Although it is only with slight discomfort that Rauschenberg was
called a painter throughout the first decade of his career, when he system-
atically embraced photographic images in the early 1960s it became less and
less possible to think of his work as painting. It was instead a hybrid form
of *printing*. Rauschenberg had moved definitively from techniques of *pro-
duction* (Combines, assemblages) to techniques of *reproduction* (silkscreens,
transfer drawings). And this move requires us to think of Rauschenberg's
art as postmodernist. Through reproductive technology, postmodernist art
dispenses with the aura. The fiction of the creating subject gives way to a
frank confiscation, quotation, excerptation, accumulation, and repetition
of already existing images.[18] Notions of originality, authenticity, and pres-
ence, essential to the ordered discourse of the museum, are undermined.
Rauschenberg steals the *Rokeby Venus* and screens her onto the surface of
Crocus, which also contains pictures of mosquitoes and a truck, as well as a
reduplicated Cupid with a mirror. She appears again, twice, in *Transom,*
now in the company of a helicopter and repeated images of water towers
on Manhattan rooftops. In *Bicycle* she appears with the truck of *Crocus* and
the helicopter of *Transom,* but now also with a sailboat, a cloud, and an
eagle. She reclines just above three Merce Cunningham dancers in *Overcast
III* and atop a statue of George Washington and a car key in *Breakthrough.*
The absolute heterogeneity that is the purview of photography, and
through photography, the museum, is spread across the surface of Rausch-
enberg's work. Moreover, it spreads from work to work.

Malraux was enraptured by the endless possibilities of his Museum, by
the proliferation of discourses it could set in motion, establishing ever new
stylistic series simply by reshuffling the photographs. That proliferation is
enacted by Rauschenberg: Malraux's dream has become Rauschenberg's
joke. But, of course, not everyone gets the joke, least of all Rauschenberg
himself, judging from the proclamation he composed for the Metropoli-
tan Museum's *Centennial Certificate* in 1969:

> Treasury of the conscience of man.
> Masterworks collected, protected and
> celebrated commonly. Timeless in
> concept the museum amasses to
> concertise a moment of pride

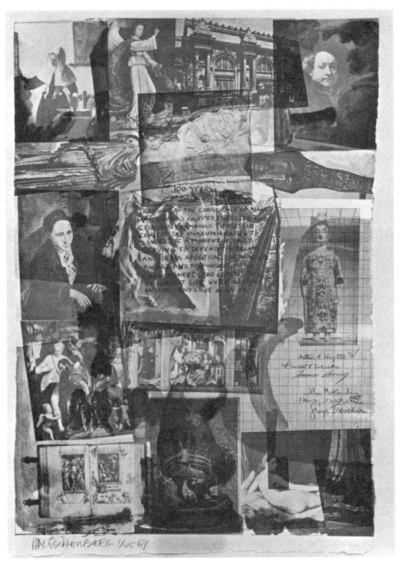

Centennial Certificate, Metropolitan Museum of Art, 1969. Lithograph from two stones and two plates on specially made Angoumois à la Main paper, 35 ¼ × 25 ¼ in. From an edition of forty-five published by Telamon Editions. Co-copyright Robert Rauschenberg and ULAE / Licensed by VAGA, New York, NY.

serving to defend the dreams
and ideals apolitically of mankind
aware and responsive to the
changes, needs and complexities
of current life while keeping
history and love alive.

This certificate, containing photographic reproductions of masterpieces of art—without the intrusion of anything else—was signed by the Metropolitan Museum officials.

Notes

1. Hilton Kramer, "Does Gérôme Belong with Goya and Monet?" *New York Times,* 13 April 1980, sec. 2, p. 35.

2. Theodor W. Adorno, "Valéry Proust Museum," in *Prisms,* trans. Samuel and Shierry Weber (London: Neville Spearman, 1967), pp. 173–186.

3. Kramer, "Does Gérôme Belong," p. 35.

4. Leo Steinberg, "Other Criteria," in *Other Criteria* (New York: Oxford University Press, 1972), pp. 55–91; partially reprinted in this volume as "Reflections on the State of Criticism." This essay is based on a lecture presented at the Museum of Modern Art, New York, in March 1968.

5. Ibid., p. 84; reprinted in this volume, p. 28.

6. See Rosalind Krauss's discussion of the radical difference between the Cubist collage and Rauschenberg's "reinvented" collage in "Rauschenberg and the Materialized Image," *Artforum* 13, no. 4 (December 1974), pp. 36–43; reprinted in this volume.

7. Not all art historians would agree that Manet made the relationship of painting to its sources problematic. That is, however, the initial assumption of Michael Fried's "Manet's Sources: Aspects of His Art, 1859–1865" (*Artforum* 7, no. 7 [March 1969], pp. 28–82), whose opening sentences read, "If a single question is guiding for our understanding of Manet's art during the first half of the 1860s, it is this: What are we to make of the numerous references in his paintings of those years to the work of the great painters of the past?" (p. 28). In part, Fried's presupposition that Manet's references to earlier art were *different,* in their "literalness and obviousness," from the ways in which Western painting had previously used sources led Theodore Reff to attack Fried's essay, saying, for example, "When Reynolds portrays his sitters in attitudes borrowed from famous pictures by Holbein, Michelangelo and Annibale Carracci, wittily playing on their relevance to his own subject; when Ingres deliberately refers in his religious compositions to those of Raphael, and in his portraits to familiar examples of Greek sculpture or Roman painting, do they not reveal the same historical consciousness that informs Manet's early work?" (Theodore Reff, "'Manet's Sources': A Critical Evaluation," *Artforum* 8, no. 1 [September 1969], p. 40). As a result of this denial of difference, Reff is able to continue applying to modernism art-historical methodologies devised to explain past art, for example that which explains the very particular relationship of Italian Renaissance art to the art of classical antiquity.

It was a parodic example of such blind application of art-historical methodology to the art of Rauschenberg that occasioned this essay: in a lecture by the critic Robert Pincus-Witten, the source of Rauschenberg's *Monogram* (an assemblage that employs a stuffed angora goat) was said to be William Holman Hunt's *Scapegoat!*

8. Michel Foucault, "Fantasia of the Library," in *Language, Counter-Memory, Practice,* trans. Donald F. Bouchard and Sherry Simon (Ithaca: Cornell University Press, 1977), pp. 92–93.

9. Quoted in Eugenio Donato, "The Museum's Furnace: Notes toward a Contextual Reading of *Bouvard and Pécuchet,*" in Josué V. Hararu, ed., *Textual Strategies: Perspectives in Post-Structuralist Criticism* (Ithaca: Cornell University Press, 1979), p. 214.

10. Ibid., p. 220. The apparent continuity between Foucault's and Donato's essays here is misleading, inasmuch as Donato is explicitly engaged in a critique of Foucault's archaeological methodology, claiming that it implicates Foucault in a return to a metaphysics of origins. Foucault himself moved beyond his "archaeology" as soon as he had codified it in *The Archaeology of Knowledge* (1969; New York: Pantheon Books, 1972).

11. Gustave Flaubert, *Bouvard and Pécuchet,* trans. A. J. Krailsheimer (New York: Penguin Books, 1976), pp. 114–115.

12. Donato, "The Museum's Furnace," p. 223.

13. The phrase is Erwin Panofsky's; see his article "The History of Art as a Humanistic Discipline," in *Meaning in the Visual Arts: Papers in and on Art History* (Garden City, N.Y.: Doubleday Anchor Books, 1955), pp. 1–25.

14. This comparison was first presented by Robert Rosenblum in a symposium entitled "Modern Art and the Modern City: From Caillebotte and the Impressionists to the Present Day," held in conjunction with the Gustave Caillebotte exhibition at the Brooklyn Museum in March 1977. Rosenblum published a version of his lecture, although only works by Caillebotte were illustrated. The following excerpt will suffice to give an impression of the comparisons Rosenblum drew: "Caillebotte's art seems equally in tune with some of the structural innovations of recent nonfigurative painting and sculpture. His embracing, in the 1870s, of the new experience of modern Paris . . . involves fresh ways of seeing that are surprisingly close to our own decade. For one, he seems to have polarized more than any of his Impressionist contemporaries the extremities of the random and the ordered, usually juxtaposing these contrary modes in the same work. Parisians in city and country come and go in open spaces, but within their leisurely movements are grids of arithmetic, technological regularity. Crisscrossing or parallel patterns of steel girders move with an A-A-A-A beat along the railing of a bridge. Checkerboards of square pavement stones map out the repetitive grid systems we see in Warhol or early Stella, Ryman or Andre. Clean stripes, as in Daniel Buren, suddenly impose a cheerful, primary aesthetic order upon urban flux and scatter" (Robert Rosenblum, "Gustave Caillebotte: The 1970s and the 1870s," *Artforum* 15, no. 7 [March 1977], p. 52). When Rosenblum again presented the Ryman-Caillebotte slide comparison in a symposium on modernism at Hunter College in March 1980, he admitted that it was perhaps what Panofsky would have called a pseudomorphism.

15. André Malraux, *The Voices of Silence,* trans. Stuart Gilbert, Bollingen Series, no. 24 (Princeton: Princeton University Press, 1978), pp. 44, 46.

16. Flaubert, *Bouvard and Pécuchet,* pp. 321, 300.

17. See Walter Benjamin, "The Work of Art in the Age of Mechanical Reproduction," in *Illuminations,* trans. Harry Zohn (New York: Schocken Books, 1969), pp. 217–251.

18. For an earlier discussion of these postmodernist techniques pervasive in recent art, see Douglas Crimp, "Pictures," *October* 8 (Spring 1979), pp. 75–88.

Untitled [black painting with grid
forms], 1952, 1953. Oil and news-
paper on canvas, 72 × 54 in. Collec-
tion of Denise and Andrew Saul.

Like the smell of a barn: when I see only the bust of the sitters (Hendrijke, in the Berlin Museum) or only the head, I cannot refrain from imagining them standing on manure. The chests breathe. The hands are warm. Bony, knotted, and warm. The table in *The Syndics* rests on straw, the five men smell of cow dung. Under Hendrijke's skirts, under the fur-edged coats, under the painter's extravagant robe, the bodies are performing their functions: they digest, they are warm, they are heavy, they smell, they shit. However delicate her face and serious her expression, *The Jewish Bride* has an ass. You can tell. She can raise her skirts at any moment. She can sit down, she has what it takes.

—Jean Genet, "What Remains of a Rembrandt Torn in Four Equal Pieces, and Flushed Down the Toilet . . ."

The *White Paintings:* simple, rectangular canvases, painted a flat, strokeless white and hung side by side, their edges butting tightly up against one another. Robert Rauschenberg made them in 1951 during his second sojourn at Black Mountain College. They were painted after a prolific summer during which he completed the *Night Blooming* series (c. 1951): large canvases six by eight feet that Rauschenberg took outside, saturated with wet oil paint, and pressed into the ground, where they picked up the heavy gravel from the road. Night blooming in North Carolina . . . jasmine, honeysuckle, sweet gardenia.

John Cage once said, "The white paintings caught whatever fell on them; why did I not look at them with my magnifying glass?"[1] They hung

on the wall ready for viewers to cast their shadows upon them. Cage's question was incomplete, for dust played second fiddle to shadows. The completion of the *White Paintings* demanded the mark of a bodily form— why else would they have needed to be so large? so smooth? so supplicant? so available? Ultimately shadows would not be enough, not because they were too arbitrary but rather because they were too ephemeral. They lacked the full texture and the heady smell of the night bloomers. The first black painting, made at Black Mountain in 1951, mimicked its white counterparts: black matte paint applied to the canvas with a roller. Rauschenberg knew an uninteresting failure when he saw one. He quickly returned to texture for a sense of touch, an excitation of the senses. The problem emerged: how to create a texture more bodily in nature than gravel, to register the body more concretely than a shadow?

First produced at Black Mountain between 1951 and 1952 and then, after a nine-month hiatus, in 1953, the black paintings are patterned canvases with dense, crackling surfaces, laboriously made by tearing sheets of newspaper, dipping them in glue, and affixing them to the canvas in a random fashion, where they would be covered by several hues of viscous black paint.[2] In the earliest paintings the newspaper remains hidden under thick paint, resulting in an ambiguous surface texture. Untitled [matte black painting with *Asheville Citizen*] (c. 1952) was the first work to expose the newspaper. Rotating the sports and classified pages of the local paper 180 degrees, Rauschenberg spread the full sheets across two joined canvases and painted matte black around their edges. Revealing the newspaper opened a whole new register of meaning for the paintings. For the newspaper is a paradigm of an economy of endless repetition marked by daily consumption and disposability, perhaps best explicated by the popular expression "same shit, different day." Its disposability ensures its dailiness, repetition, and regularity. In the *Asheville Citizen* painting, Rauschenberg exaggerates these aspects of the newspaper by using the sports and classified sections, perhaps the most daily parts of the newspaper (they contain information pertinent only to the immediate present). The black paintings became quite repetitious in both appearance and production,[3] mirroring the structure of their ground. Given the number of the paintings, the shadowy newspaper datelines, which almost always remain legible, impart a diaristic quality to the works, linking the paintings even more directly to the dailiness and repetition of the newspaper.

Simultaneously, Rauschenberg assiduously photographed the progress of the black paintings. The photograph's ability to repeat endlessly and

Untitled [matte black painting with
Asheville Citizen], c. 1952. Oil and
newspaper on canvas, 72 ¼ × 28 ½ in.
Collection of the artist.

the need to repeat the painting through a photograph of it, as well as the indexical capability of the photograph to record the specificity of time and place, has a parallel relation to the newspaper's signification of dailiness. For this purpose, Rauschenberg continually framed the black paintings in doorways and doorframes. "More than simple scaling devices," Walter Hopps has remarked, "they suggest human presence and establish a literal conjunction of abstract art and the physical factum of everyday life."[4] Is the "physical factum of everyday life" merely newspaper and doorways? Or do those traces stand in for dailiness and "human presence" in another form?

It is hard for me to overlook the way the paintings' textures and colors resonate with fecal matter: the smeared quality of the paint, the varying degrees of viscosity, and the color—shit brown and black. After all, repetition and cycles of consumption and disposal have as much to do with anality as they do with newspapers. And the relation between the two is not so far-fetched. Ernest Jones's landmark essay "Anal-Erotic Character Traits" discusses the various objects that can signify excrement in unconscious life, with newspapers prominent among them (think of those black smudges left on your hands). "Books and other printed matter are a curious symbol of feces," he writes, "presumably through the association with paper and the idea of pressing (smearing, imprinting)."[5] The dirtiness and dailiness, the visual similitude, and the compulsive documenting of the paintings against heavily textured brick walls suggest an "excremental reading" of these works.

In this essay I give an account of Rauschenberg's early work that engages the uneasiness and disgust that accompany the intense visual pleasure of these paintings. I will also attempt to recapture the profound sense of experimentation with which these works were undertaken. Furthermore I hope to challenge the codification of several standard formalist/biographical/descriptive/iconographical readings of Rauschenberg.[6] My intention is not to psychoanalyze Rauschenberg or to conflate anality with his sexuality. On the contrary, I feel that "the body" is presented in Rauschenberg's oeuvre as polymorphously perverse. In this regard, my reading engages certain questions concerning the body and the anxieties, fantasies, and problems it raises (arouses), especially in the work of artists during the 1950s.[7] Despite the dearth of literature on the topic,[8] Rauschenberg was not alone in this exploration; the problem of registering the body was shared by (at least) two other key figures at Black Mountain, John Cage and Charles Olson.[9]

"The white paintings came first," Cage once said, "My silent piece came later."[10] Yet the exact chronology is not as important as the concern with how to mediate and discuss the body within artistic production. In this regard Cage's recollection of his discovery of silence in a soundproof chamber at Harvard University is striking:

> I entered one at Harvard University several years ago and heard two sounds, one high and one low. When I described them to the engineer in charge, he informed me that the high one was my nervous system in operation, the low one my blood in circulation. Until I die there will be sounds. And they will continue following my death. One need not fear about the future of music.[11]

This revelation locates Cage's most generative musical, artistic, and compositional idea within the body itself—more importantly, within the interior of the body, the nervous and circulatory systems, realms of bodily experience of which we are usually not aware. Cage's silence is both located within and driven by the desire to know the body more intimately, to listen to its interior.

Charles Olson takes up the question of the body in a prose poem titled "Proprioception" (1959).[12] The text has fanciful moments when Olson longs to (re)attribute specific organs' emotional characteristics, such as desire to the heart, sympathy to the bowels. Speculating on the possibility of the unconscious being situated in the "cavity of the body, in which the organs are slung," as opposed to the brain, the poem puzzles over the meanings that our bodies present to us. The viscosity of the poem turns violent at times when it explores the possibility (and perhaps the ramifications) of gathering information from the body:

> Violence:
> knives/anything, to get the body in.
> To which the data of depth sensibility/the 'body' of us as
> PROPRIOCEPTION: object which spontaneously or of its own order
> produces experience of, 'depth' Viz
> SENSIBILITY WITHIN THE ORGANISM
> BY MOVEMENT OF ITS OWN TISSUES[13]

Here the body is a source of experience. Similar to Cage's work, the external surface of the body is less important than its hidden interior, an

interior that is marvelous as it both produces and stores experience as information.

It is within this historical milieu that the black paintings were first exhibited at the Stable Gallery in New York in 1953, where Dore Ashton's review saw them as "black as beasts . . . they stir up vaguely primordial sensations, and anxiety. But that is all."[14] A decade later the Jewish Museum gave Rauschenberg his first retrospective. In the catalogue essay Alan Solomon discussed the paintings' use of color: "It supplies an enigmatic field, at once opaque and deep to the furthest reach of space. Shadowed and secretive, it proposes all and discloses nothing, and it became the plasma out of which his present style was formed."[15] The excremental look of these paintings lay barely beneath the surface of these sensual and tentative descriptions of the "deep" and the "primordial"—but the "anxiety" that it produces is dismissed (Ashton's "But that is all"; Solomon's it "discloses nothing").

Rauschenberg's anxiety took a rather different form. Telling an interviewer he went to Black Mountain to be disciplined by Albers, he says:

> I could have gone on just painting with my hands, I think, and making messes forever because I really loved painting. I guess the physicality of my personality was emerging, and so I had to paint with my hands. I couldn't stand a brush coming between me and the canvas. Naturally, I cleaned my "brushes," which were my hands, on my clothes.[16]

Rauschenberg does not want to be in the painting—as in Jackson Pollock's famous pronouncement that he could "literally be *in* the painting"[17]—as much as he wants to have the painting be on his body and, conversely, to have his physicality be on the canvas.

Excremental Fantasies

In Dennis Cooper's novel *Frisk* (1991) the main character (also named Dennis) finds his ultimate sexual pleasure in the murder of other young men. Or so it would seem, for in *Frisk* it is all a fantasy, elaborated through letter writing, the great literary form of self-disclosure. Beyond the trope of sex and death (better known as "sex 'n meth" in certain punk film quarters) there lies a deeper probing in this novel. The title gives it all away: what Dennis wants is knowledge. Sitting in a hotel room with hooker/

porn star Pierre, Dennis combs every inch of his body with his mouth, gathering minute pieces of information: tastes, smells, changes in skin texture. He is logging them for future reference. Dennis requests that Pierre shit and not flush; this too is information he desires.

> "I'm not being abject," I say. "It's not, 'Ooh, shit, piss, how wicked,' or anything. It's, like I said, information." Pierre nods. "Then what are you going to do with it?" he asks. "I don't mean with my shit, I mean with the information." My face scrunches up. "Uh, create a mental world . . . uh, wait. Or a situation where I could kill you and understand . . ."[18]

Yet Cooper is fully cognizant as to how such information refuses to add up; certainly in the novel it never equals a satisfactory situation for murder. But what drives *Frisk*'s main character is the fantasy of knowing another person so thoroughly that one would be intimate with the interior of that body. "I'm sure I've idealized brutality, murder, dismemberment, etc.," Dennis says to Pierre during their second hotel meeting, "But even slicked up, there's an unknowableness there that's so profound or whatever, especially when I combine it with sex."[19] Sex, that fantasy moment where two bodies merge as one, is an idealized form of the desire to know the inside, or to be inside someone else's body. The act is the idealized form of gathering knowledge about the other. But murder offers another version of "getting to know you"; it offers the "real" stuff, the secret hidden stuff that no one else knows, not even its subject. An existentialist novel, *Frisk* is about the aching desire to know the self and the ultimate impossibility of self-knowledge. No amount of nausea, it seems, reduces the foreignness of one's own body. What is in there, what is it doing, what relation does it have to me and I to it?

For Freud, desire for knowledge awakens when the child asks: Where do babies come from?[20] Initially these "infantile sexual researches" center on the mother's body, with the child assuming that babies are born from her bowels. Yet, Freud argues, the child has a vague notion of birth's sexual component, although the child is unable to understand it fully. The problem of information exceeding comprehension continues throughout adult life (accounting, he adds, for the brooding of many intellectuals); but it is reactivated most importantly for Freud in the Oedipal conflict.[21]

Perhaps the experience of representing the body through excrement in the black paintings (both for the viewer and the maker) problematizes

the speed with which Freud passes over the child's relation to the interior of the mother's body in his rush to get to the genital and Oedipal configurations of the subject. Melanie Klein, however, lingers and elaborates upon the young child's fantasies regarding the interior of the mother's body. For Klein, the child's earliest relationship to the mother is one of "sucking and scooping" at the breast, voiding the mother of her interior substances. Soon the child begins to take pleasure in its ability to master the process of defecation, a pleasure derived from the interior of its own body. When the child learns that it came out of the mother's body, the initial fascination with the mother's interior becomes interwoven with the child's pleasurable sense of its own. Hence, the child equates itself and excrement as products of the mother's body. "In the imagination of the small child these multiple objects are situated inside his mother's body and this place is also the chief objective of his destructive and libidinal tendencies and also of his awakening *epistemophilic* impulses."[22]

The child's desire to explore the interior of the mother's body, a desire that extends to the child's relationship to his or her own body and its products, is the awakening of *epistemophilic impulses*. It is on this crucial point that Freud and Klein diverge. For Klein sees the activation of the desire for knowledge as intensely and intrinsically related to the body and the question of its interior and its by-products. Freud does not engage the child's relation to its own or the mother's body outside of the realm of the genitalia. The interior of the body and the mystery that surrounds it, both for the child and the adult, are never quite broached.

For Western civilization, however, the body ultimately is an obstacle to be overcome. Civilization, as Freud has noted, requires the control of bodily functions and the sublimation of instinctual drives. In *Civilization and Its Discontents* he writes: "The diminution of the olfactory stimuli seems itself to be a consequence of man's raising himself from the ground, of his assumption of an upright gait."[23] By pulling his nose away from the ground, Freud argues, man lifts his senses away from the smells of excrement and genitalia, divorcing his senses from his body. Likewise, children are taught to repress their initial means of gathering information: groping, sucking, smearing. Subsequently, the drive for knowledge that prompts the questions "Where do babies come from? Where do I come from?" will need to be sublimated.

But if we read the black paintings as excremental, as the daily expulsion from the body's interior, can the implications of this instance of *de*sublimation, an instance of a body not successfully overcome, transform

the question "Where do I come from?" into "What is inside of me?" They manifest the desire to explore the interior body through what might be called "bodily knowledge"—the knowledge, pleasure, curiosity, and disgust surrounding that primary bodily product—shit.

Rauschenberg has indeed attempted to turn himself inside out to mark his own body on the canvas.[24] His immersion in an indexical art practice can be well documented by surveying his investment in imprinting the corporeal senses onto the artistic surface. Placing a nude body directly onto light-sensitive paper, Rauschenberg and Susan Weil made the blueprints (1950–1951). Taking the wet paintings outside and pressing them in the dirt, he made the *Night Blooming* series. But the questions the black paintings ask are: What kind of knowledge do our bodies produce about ourselves? Can knowledge be desublimated and "returned" to its origin? These are the questions that the black paintings end up sharing with *Frisk*. The black paintings mark the canvas with the body in the basest of ways. "The body begins to exist where it *repugnates,* repulses, yet wants to devour what disgusts it and exploits that taste for distaste . . . "[25] The paintings enact the body liberated through excretion. They are a narcissistic fantasy of self-birth; they give way to the delirium of the body producing its own knowledge.

The Stain

A *macchiato* is an Italian espresso, preferably quite strong. The black coffee is tinged by dark brown that rims the cup; a dollop of light airy foam from steamed milk floats on top. *Macchiato* comes from the Italian word *macchia,* which means stain. (See antonym: *immacolato,* meaning immaculate, as in the Conception.)

At the end of a summer of black paintings at Black Mountain, Rauschenberg and Cy Twombly left together for Rome. During the seven-month trip, which included a stay in North Africa, Rauschenberg made Cornell-like boxes, fetishes that he threw into the Arno River, and a series of collages that he packed up and didn't exhibit for more than twenty years. These delicate collages (all are untitled and dated to c. 1952) fall between the two periods of the black paintings. Repetitive in size, structure, and material, the collages pull back from the initial viscous explosion onto the canvas of Rauschenberg's interior. The mottled paperboards were collected from the insides of shirts as they were freshly returned from the cleaners: the very support for these collages is bodily

Robert Rauschenberg and Susan Weil,
Female Figure, c. 1950. Monoprint:
exposed blueprint paper, 105 × 36 in.
Collection of the artist, on loan to the
National Gallery of Art, Washington.
Photograph © Board of Trustees,
National Gallery of Art, Washington.

through contact and scale. The cardboard is preciously torn, rough edges insisting upon the hand that ripped it; each is topped by a sheet of fluttering paper. Engraved images culled from old books that Rauschenberg found at the local flea markets are pasted on top, the lumpy glue creasing the fine paper, or staining the thin cardboard. The images are decidedly "scientific," an eccentric dictionary of various animals, body parts, and microorganisms. The scientific dissections are brief glimpses into biological interiors: interiors devoid of any fluids, interiors that are dry and empty, interiors where the space between skin and bones is discreetly marked off as a void—as nonpresence. Yet the glue stains on the cardboard are an indexical moment of the artist's hand smearing and pressing in the act of collage. Ernest Jones postulates that the sublimation of the smearing impulse leads to the "impulse to stain or contaminate." The stain implies uncleanliness: sweat, semen, mucus, the remains of sex on linen or clothing.

With regard to the Shroud of Turin, Georges Didi-Huberman has argued that it is through "the absence of figuration therefore [that the stain] serves as proof of existence. Contact having occurred, figuration would appear false."[26] The use of the stain as an index, Didi-Huberman insists, affirms the place of contact as a place of origin. These simple early collages are, in this sense, a pedantic object lesson. The origin of the work of art is the artist's body—in the pressing and the smearing, in the dailiness of bodily functions, in the question "What kinds of marks can I make?" If, as Didi-Huberman argues, collage is indexical, then, for Rauschenberg, the absence that the collage signifies is the body of its maker.

Toward *Bed*

The intolerance for disorder is closely related to another trait, the intolerance for waste. This has more than one source. It represents a dislike of anything being thrown away (really from the person)— a manifestation of the retaining tendency under consideration—and also a dislike of the waste product because it represents refuse—i.e., dirt—so that every effort is made to make use of it. Such people are always pleased at discovering or hearing of new processes for converting waste products into useful material, in sewage farms, coal-tar manufactories and the like.

—Ernest Jones, "Anal-Erotic Character Traits"

Untitled [frog and turtle], c. 1952.
Engravings, pencil, and glue on paper,
mounted on paperboard, 14 × 5 in.
Sonnabend Collection, New York.

Untitled [palm of hand], c. 1952.
Engravings, pencil, and glue on paper,
mounted on paperboard, 14 × 5 ¼ in.
Lost or destroyed.

The *Red Paintings* (1953–1954) begin Rauschenberg's lifelong investment in found objects. Moving beyond printed matter, the paintings incorporate a large array of fabrics, found wood, and trinkets. When asked why he used the color red, Rauschenberg replied, "I was trying to move away from the black and white. . . . So I picked the most difficult color for me to work in. If you're not careful, red turns black when you're dealing with it."[27]

The Latin root of scrutiny is *scruta,* meaning rags or trash. Originally, to scrutinize an area meant to investigate so thoroughly as to search through the rags. The domestic nature of the use of fabrics such as lace and brocade in the *Red Paintings* has been noted by several critics. That these traditional emblems of femininity should be so inundated within the bloody surface of these paintings gives pause in light of this text. If the black paintings are an attempt to know the interior through the autoerotic pleasures of shit, then the *Red Paintings* are the horror of the body exploded, dispersed, and flowing over the surfaces of everything. The extreme agitation of the *Red Paintings* is perversely heightened by the attempts to modulate their "bloodiness." Their grounds are built up from cartoons and comic strips. The playful polka-dot fabric in *Yoicks* (1954) or the three childlike hearts drawn into the surface of *Red Import* (c. 1954) seem to make the violence more macabre. Their viscosity oozes even beyond that of the black paintings, and their incorporation of found objects blurs any clear distinction of interior/exterior, found object/painting. As Andrew Forge has put it, "The frames and battens of *Charlene* (1954) articulate the *inside* of the picture; they also throw its boundaries far and wide."[28] This struggle over boundaries is what is continued so persuasively in the Combines, and perhaps *Bed* (1955) is the ultimate moment of blissful and terrifying confusion.

Anality is less a matter of actual feces than of the fantasies surrounding them—their production and disposal.[29] If one of sublimation's definitions is the displacement of the low functions of the body onto its higher faculties, then Rauschenberg radically reinserts the lower body into art. He desublimates the hand of the artist, allowing it to smear and rub, press and glue, privileging tactility over sight. Rauschenberg's work cataloged the body through its products—shit, stain, blood—but ultimately the body produces a limited amount of knowledge about itself. Rauschenberg even told Billy Klüver that the black paintings interested him "in their complexity without their revealing anything—the fact that there was a lot to see but not much showing."[30]

"Sublimation is a search in the outside world for the lost body of childhood," Norman O. Brown has written. Rauschenberg's art is this search. And yet this body is not reconstituted until the advent of the *Red Paintings.* They start to participate in "the totality of the disorder in the human body."[31] For anality is never isolated; it too is being continually displaced onto other sites in the body. The body's entire sexual organization is one of displacement from one region and/or function to another.[32] In this regard the *Red Paintings,* and subsequently the Combines, come closer than the black paintings to "knowing" the body, by enacting its nonhierarchical displacement onto a conglomerate of heterogeneous objects. Inasmuch as they achieve this, they simulate the fantasy space that surrounds the body's functions, desires, and organization. For it is there, in the realm of fantasies which surround the interior body, that "body knowledge" is actually constructed.

Brown argues that culture functions dualistically: as a denial of the body, and as a projection of that repressed body into things. Despite this, "the child knows consciously, and the adult unconsciously, that we are nothing but body" and that "all values are bodily values."[33] Rauschenberg's radical inclusion of "things" in the *Red Paintings* allows the body to be reconstituted at its *limit,* in the space of fantastic disorganization. Perhaps the *Red Paintings* are best described by a passage from Roland Barthes: "Collages are not decorative, they do not juxtapose, they conglomerate . . . their truth is etymological, they take literally the *colle,* the glue at the origin of their name; what they produce is the glutinous, alimentary paste, luxuriant and nauseating."[34]

A Dream

I dreamt that after reading in bed I fell asleep, book across my chest. My lover came to bed and woke me. He seduced me and entered me from behind. Never having had intercourse this way before, I was surprised. Afterwards I felt elation, lightness; for by having this sex my lover had voided me of all my interior substances. He had emptied me, and I drifted off into a sleep more peaceful than any I had ever known.

Notes

Special acknowledgements must be made to the invaluable comments and criticisms of Roddy Bogawa and Miwon Kwon.

1. John Cage, *Silence* (Middletown, Conn.: Wesleyan University Press, 1961), p. 108.

2. Calvin Tomkins, *Off the Wall: Robert Rauschenberg and the Art World of Our Time* (Garden City, N.Y.: Doubleday, 1980), p. 71. Tomkins claims that Rauschenberg would randomly drop glue-soaked newspaper onto the canvas, implying that the canvas was horizontal, but no other scholarship makes that assertion.

3. Rauschenberg made at least nine black paintings during 1952 while at Black Mountain and at least seven at his Fulton Street studio in New York during the spring and summer of 1953.

4. Walter Hopps, *Robert Rauschenberg: The Early 1950s* (Houston: Houston Fine Arts Press, 1991), p. 62.

5. Ernest Jones, *Papers on Psycho-Analysis* (New York: William Wood and Company, 1918), p. 676.

6. Two examples are Roni Feinstein's "Random Order: The First Fifteen Years of Robert Rauschenberg's Art, 1949–1964" (Ph.D. diss., New York University, 1990), as primarily descriptive; and Mary Lynn Kotz's monograph *Rauschenberg: Art and Life* (New York: Harry N. Abrams, 1990), as biographical.

7. The importance of the desire to mark bodily form in 1950s art practice is an idea that had its genesis in the context of Rosalind Krauss's seminar "The Transgressive '50s" at the CUNY Graduate Center. Krauss's work on Jackson Pollock and Pam Lee's work on Cy Twombly created the space out of which this article grew.

8. The exception is Jonathan Weinberg's "It's in the Can: Jasper Johns and the Anal Society," *Genders* 1 (Spring 1988).

9. The relationship between Rauschenberg and John Cage has been well documented. See Calvin Tomkins, *The Bride and the Bachelors* (London: Penguin, 1976). The relationship between Rauschenberg and Olson is much less clear. They were both, however, part of *Theater Piece No. 1,* a multimedia event that is often referred to as the first performance-art piece. Among many other activities, Olson read poetry, and Rauschenberg's *White Painting* was included.

10. Cage, *Silence,* p. 98.

11. Ibid., p. 8.

12. I must thank Charles Molesworth, who brought this text to my attention and who initially suggested the link between the concerns of Olson and Rauschenberg.

13. Charles Olson, *Additional Prose,* ed. George F. Butterick (Berkeley: Four Seasons Foundation/Book People, 1974), p. 17.

14. Dore Ashton, "Robert Rauschenberg," *Art Digest* (September 1953), pp. 20 and 25.

15. Alan Solomon, *Robert Rauschenberg* (New York: Jewish Museum, 1963), n.p.

16. Barbara Rose, *Robert Rauschenberg* (New York: Vintage Books, 1987), p. 23.

17. Ellen Johnson, ed., *American Artists on Art from 1940 to 1980* (New York: Harper and Row, 1982), p. 4.

18. Dennis Cooper, *Frisk* (New York: Grove Weidenfeld, 1991), p. 69.

19. Ibid., p. 78.

20. See Sigmund Freud, *Leonardo da Vinci and a Memory of His Childhood,* trans. Alan Tyson (New York: Norton, 1989), and "On the Sexual Theories of Children," in *The Standard Edition of the Complete Psychological Works of Sigmund Freud,* vol. 9, trans. and ed. James Strachey (London: Hogarth Press, 1959).

21. See Jean Laplanche, "To Situate Sublimation," trans. Richard Miller, *October* 28 (Spring 1984), pp. 7–26.

22. Melanie Klein, *The Psycho-Analysis of Children* (London: Hogarth Press, 1963), p. 208 (emphasis added).

23. Sigmund Freud, *Civilization and Its Discontents,* trans. James Strachey (New York: Norton, 1961), p. 54. In the same passage Freud notes that despite sublimation we are rarely repulsed by our own excrement.

24. Roland Barthes, *The Responsibility of Forms,* trans. Richard Howard (Berkeley: University of California Press, 1985), p. 207. Barthes establishes this idea of turning oneself inside out to discuss the work of the French painter Requichot.

25. Ibid., pp. 210–211.

26. Georges Didi-Huberman, "The Index of the Absent Wound (Monograph on a Stain)," trans. Thomas Repensek, *October* 29 (Summer 1984), p. 68.

27. Rose, *Robert Rauschenberg,* pp. 52–53.

28. Andrew Forge, *Robert Rauschenberg* (Amsterdam: Stedelijk Museum, 1968), p. 65.

29. Norman O. Brown, *Life against Death* (Middletown, Conn.: Wesleyan University Press, 1959). Brown makes a distinction between the neo-Freudian definition of anality as "an attitude in interpersonal relationships" and orthodox Freudians who relate it directly to toilet training. He argues that anality is a function of fantasy life connected to the anal zone, of fantasies that are subsequently projected onto the world.

30. Forge, *Robert Rauschenberg,* p. 64.

31. Brown, *Life against Death,* p. 289.

32. See Sandor Ferenczi, *Further Contributions to the Theory and Technique of Psycho-Analysis* (New York: Brunner/Mazel, 1980), especially "Composite Formations of Erotic and Character Traits."

33. Brown, *Life against Death,* p. 293.

34. Barthes, *The Responsibility of Forms,* p. 211.

Robert Rauschenberg looking through
the archive of the *Miami Herald,* 1979.

I went in for my interview for this fantastic job. . . . The job had a
great name—I might use it for a painting—"Perpetual Inventory."

—Rauschenberg to Barbara Rose

1. Here are three disconcerting remarks and one document:

The first settles out from a discussion of the various strategies Robert
Rauschenberg found to defamiliarize perception, so that, in Brian O'Do-
herty's terms, "the city dweller's rapid scan" would now displace old habits
of seeing and "the art audience's stare" would yield to "the vernacular
glance."[1] With its voraciousness, its lack of discrimination, its wandering
attention, and its equal horror of meaning and of emptiness, this leveling
form of perception, he wrote, not only accepts everything—every piece
of urban detritus, every homey object, every outré image—into the per-
ceptual situation, but its logic decrees that the magnet for all these ele-
ments will be the picture surface, itself now defined as the antimuseum.[2]

This conceptual context, made newly precise by O'Doherty in 1974
but nonetheless familiar by that time to Rauschenberg's audience, does
not prepare us for O'Doherty's additional avowal that there is "something
that, for all his apparent clowning, he [Rauschenberg] believes in pro-
foundly: the integrity of the picture plane."[3] Coming as it does from the
aesthetic vocabulary that Rauschenberg's project would seem to have
made defunct, this notion of the picture plane and its integrity, coupled
with the idea that they inspire "belief," sounds very strange indeed. For
this vocabulary, linked to a definition of the pictorial itself as irreducibly

illusionistic—an illusionism that was thought by such critics as Clement Greenberg to be residual within even the most abstract and flattened painting[4]—evokes a plane whose integrity is constantly breached and just as continually resecured.

If by the mid-1960s the picture plane was something to which Donald Judd was eager to say good riddance, declaring the canvas field as nothing more than one side of a "specific object,"[5] that experience of the impenetrability, the literalness, of the two-dimensional surface had been made possible largely by Rauschenberg's work itself. The stuffed goat that stands astride the floor-bound picture field in *Monogram* (1955–1959), placidly bearing witness to the transformation of visual surface into—as Rauschenberg put it—"pasture," or the eagle that projects from the solidly wall-like *Canyon* (1959), had in Judd's eyes written "finis" to centuries of pictorial illusionism with its little dance of opening and closing, its performance of a kind of transcendental two-step.

The art history that Rauschenberg, as well as O'Doherty, knew only too well, the lessons that Josef Albers had after all drilled at Black Mountain College, turned on the yield of *meaning* to be harvested from that fertility of the picture plane. Although still schematically present in the reversible geometries of Albers's squares, the model of this field as the ground of meaning is perhaps most clearly demonstrated in the kind of Renaissance painting in which a tunnel of deep perspective—an allée of trees, say—is just about to arrive at its destination in the horizon's vanishing point, when something at the very forefront of the picture—the lily the angel of the Annunciation is handing to the Virgin, for example—blocks that whoosh into depth. All the pressure of the painting now converges on this object, since it must "hold" the surface, preventing its "violation" by an unimpeded spatial rush. Because this "holding" is perforce of a two-dimensional, emblematic kind, it stands in utmost contrast to the illusionistic vista's offer of a real stage on which imaginatively to project real bodies. But then such "holding" becomes a way of holding up two conflicting modes of being for comparison—real versus ideal, secular versus sacred, physical versus iconic, deep versus flat—all the while performing the magic trick of turning the one into the other, since it is the deep space that is the illusion, and the flattened wafer of the surface-bound icon that is touchably real. It is in this mystery of transposition, in this crossover between flesh and idea, that the meaning of a picture plane that has sealed over its spatial puncture, thus reasserting its "integrity," announces itself as both the source and expression of "belief."

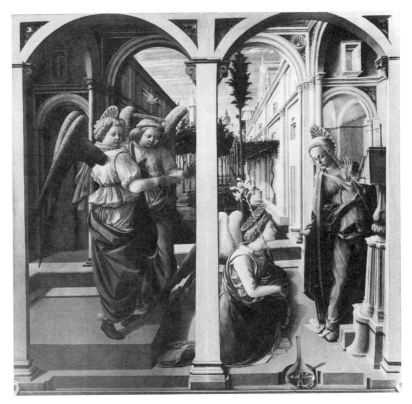

Fra Filippo Lippi, *Annunciation,*
c. 1440. Oil on panel, 69 × 72 in.
San Lorenzo, Florence. Alinari /
Art Resource, NY.

All this seems worlds away, of course, from the goat calmly grazing the pasture of *Monogram,* or the tread marks asserting twenty-two feet of unmitigated literalness in *Automobile Tire Print* (1953), the point of which seems to be that along this stretch of road there is no break that would allow the old-time metaphysics of tension and release to occur. Where is there a place in this work for humanist painting's notions of "belief" suspended and refound in a reconfirmed "integrity"?[6] And yet O'Doherty was not just a consummately intelligent critic but also someone who engaged personally with Rauschenberg, both at those places where they would have intersected in the 1960s art world and in the "morgue" of the *New York Times,* where the two examined old photoengraving plates together for Rauschenberg's 1962 initial foray into printmaking.[7]

2. My second example is not, perhaps, as counterintuitive as the first, but it nonetheless strikes the same kind of discordant note from within Susan Sontag's "One Culture and the New Sensibility," her report from the front lines of the 1960s.[8] Taking issue with C. P. Snow's notorious two-culture argument, in which science and humanism have drifted into two separate worlds, with the occupants of the one regarding the occupants of the other as a set of unrecognizable, nearly inhuman mutants, Sontag claimed a single "advanced" culture for both science and art, with their common enemy now in literature. If electronic music is the model for this "one culture," she argued, so is the practice of a kind of painting and sculpture made collectively on the principles of industrial fabrication (Minimalism, Pop), as is the understanding shared by both science and art that their high degree of specialization (the twelve-tone row, abstraction) will demand a certain period of apprenticeship on the part of their audiences.

It is in such a context that Sontag then drew up a list of textual sources that she saw as basic to this new nonliterary culture: Antonin Artaud, Roland Barthes, André Breton, Norman O. Brown, John Cage, R. Buckminster Fuller, Sigfried Giedion, Claude Lévi-Strauss, Marshall McLuhan, Friedrich Wilhelm Nietzsche, and Ludwig Wittgenstein.[9] Most of the names—the obvious phalanx of 1960s intellectual realignments—are expected, of course. Breton's is somehow aberrant, however, striking one as it does as lying at an oblique angle to the line that connects Artaud to Nietzsche or Fuller to Lévi-Strauss. Breton's commitment to poetry, his insistent literariness, and the fastidiousness of his tastes all seem to drive a wedge between him and this company. Even though Barthes's 1967 enunciation of "The Death of the Author" includes the Surrealists' attacks on meaning and the collective nature of their practice as important steps along the path leading away from the writer as the focus of meaning to the reader as its new locus of unity,[10] Breton's allegiance to psychoanalysis seems to put him specifically out of play.

For the psychoanalytic seems not only to cling to the importance of the source of emission (the writer) but also to privilege chains of association that, in their dependence on further associations to decode them, continue to assert the private depths of experience underwriting these connections. Furthermore, it is the very nature of such connections as metaphoric that makes them alien to the "new sensibility" Sontag invoked. The ideas of literalness, of deadpan, of the ruthless "cool" that led Frank Stella to declare, "My painting is based on the fact that what can be seen there *is* there. . . . What you see is what you see,"[11] seems to join the

whole post-Abstract Expressionist cohort in its rejection of psychological depth and emotiveness.

Rauschenberg's own distaste for such qualities can be summed up in his frequently repeated instance of "the sad cup of coffee," his emblem for the endless psychologizing of the artist's means and hence the promiscuous spread of metaphor within the older (Surrealist-influenced) generation. Speaking of the talk at the Cedar Bar or the Club, he complained, "They even assigned seriousness to certain colors," and then, turning to the way the New York artists had infected Beat poetry: "I used to think of that line in Allen Ginsberg's *Howl,* about 'the sad cup of coffee.' I've had cold coffee and hot coffee, good coffee and lousy coffee, but I've never had a sad cup of coffee."[12]

Indeed, Rauschenberg had been very troubled by the reception of his black paintings (1951–1953), which critics and viewers alike assumed were to be understood at that emotive level. "They couldn't see black as pigment," he complained. "They moved immediately into association with 'burned-out,' 'tearing,' 'nihilism' and 'destruction.' . . . I'm never sure what the impulse is psychologically, I don't mess around with my subconscious." For good measure, he added, "If I see any superficial subconscious relationships that I'm familiar with—clichés of association—I change the picture."[13]

3. This brings me to my third example, dropped by Rauschenberg himself when speaking of his silkscreen practice in the early 1960s. He was addressing a painting that juxtaposes photoreproductions of an army truck, mosquitoes, and, in a somber banner along the midsection, Diego Velázquez's *Venus and Cupid (Rokeby Venus)* (1650), an aggressive X-mark thickly painted in white over a part of it. Explaining why he called the picture *Crocus* (1962), he said, "Because the white X emerges from a gray area in a rather dark painting, like a new season."[14]

"Like a new season" comes strangely from the lips of someone who cannot imagine a "sad cup of coffee." But then by the early 1960s, Rauschenberg was also the artist who quite astonishingly had already decided to devote a good part of two and a half years of his life to the canto-by-canto illustration of Dante's *Inferno,* a work whose very fabric is woven from the rich strands of multiple associations, one famous branch of which invokes just this figure of renewal: "In the turning season of the youthful year when the sun is warming his rays beneath Aquarius/and the days and nights already begin to near their perfect balance; the hoar-frost copies/then the

Crocus, 1962. Oil and silkscreen ink on
canvas, 60 × 36 in. Collection of Linda
and Harry Macklowe, New York.

image of his white sister on the ground." Rauschenberg's astonishingly aqueous transfer drawing devoted to Canto XXIV responds to this image, Dore Ashton tells us, by way of "a compartment, sealed away from the snakes and electric eels below, to house a tender painting of the hoar-frosted trees."[15]

That Dante's text served as a motivating force behind the X metaphorically fecundating *Crocus* is likely but not necessary. The same allegorical use of the seasons stretches from one end of English poetry to another, from Geoffrey Chaucer's evocation of the showers of April piercing the droughts of March, to T. S. Eliot's "April is the cruellest month, breeding/Lilacs out of the dead land. . . ." *Crocus* is quite a metaphoric thought for someone who does not want to accept the connotations spun off from the color black.

4. The document I want to insert here comes from around the time when Rauschenberg was making *Crocus,* for it includes a reproduction of *Renascence* (1962), another of the very first works in the black-and-white silkscreen series he began early in the fall of 1962. Called "Random Order," it is part manifesto, part diary, part poem. It consists of five pages in the first issue of the magazine *Location,* published in spring 1963, but probably handed in to the editors, Thomas B. Hess and Harold Rosenberg, in late winter. The "cover page" (p. 27) gives the title and reproduces *Sundog* (1962). The next two sheets (pp. 28–29) show an assortment of photographs taken by Rauschenberg and affixed with masking tape to a paper support to present a messy grid of vignettes between which Rauschenberg's dyslexic lettering meanders in a complex of affirmations. These are followed by two almost full-page images: the painting *Renascence* on the left (p. 30), and a Rauschenberg photograph captioned "View from the artist's studio" on the right (p. 31). Representing two very different notions of seeing through a window, these pages juxtapose Leone Battista Alberti's model of perspective, signaled by *Renascence*'s volumetric cube (if a picture is like a window through which we look at what is painted, the viewed material is itself tightly contained on the stage of the pictorial construction),[16] with the photographed windowpane as surrogate for the camera's aperture in what seems to invoke the indiscriminate appetite of the "vernacular glance."

If I have called this document a manifesto, this is because it made its appearance at the time Rauschenberg's work was undergoing a shift, one that marked all his immediately succeeding work and the vast majority of

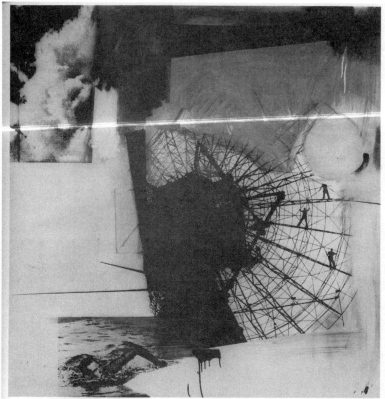

Rauschenberg, **Sun Dog**, oil, 60″ by 60″, 1962 (Collection Mr. and Mrs. William Janss)

Random Order
by ROBERT RAUSCHENBERG

27

"Random Order," *Location* 1, no. 1
(Spring 1963), p. 27.

what he went on to do in the following years. This was a shift to photography not only as the image bank on which his pictorial practice would then rely—whether in the form of the silkscreened paintings of the early 1960s, or their renewed version in the veil-like *Hoarfrosts* (1974–1976), or in the guise of audience-activated works, such as *Soundings* (1968) and *Revolvers* (1967)—but as a new conception of the pictorial itself.[17] The ground for this shift was obviously prepared in Rauschenberg's long apprenticeship to the media image via the Dante drawings. But since the sol-

WITH SOUND SCALE AND INSISTENCY. TRUCKS
MOBILIZE WORDS, AND BROADSIDE OUR CULTURE BY A
COMBINATION OF LAW AND LOCAL
MOTIVATION WHICH PRODUCES AN
EXTREMLY
COMPLEX
RANDOM
ORDER THAT
CAN NOT BE
DESCRIBED
AS ACCIDENTAL

EVERY STEP
IS CHANGE.

STAIRS IS A SCULPTURAL MASTERPIECE
CLEARLY, ECONOMICALLY AND
DRAMATICALLY DEFINING SPACE. AN AIR FILLED SENSE OF VOLUME
CAN BE HAD BY LOOKING OUT ONE
WINDOW THROUGH THE SPACE
TO ANOTHER WINDOW AND INTO
IT. THIS CAN BE AMPLIFIED
BY REALIZING THE SOURCE
OF THIS VISION IS AT A
DIFFERENT TEMPERATURE,
BRIGHTNESS AND WILL BE
SUBJECT TO CHANGE AS IT
MOVES ON. AIR VOLUME
CAN BE COMPRESSED AND
FLATTENED TO THE EXTENT
THAT A BRUSH LOAD OF PAINT
CAN HOLD IT TO A
PICTURE SURFACE.

A DIRTY OR FOGGY
WINDOW MAKES WHAT
IS OUTSIDE APPEAR
TO BE PROJECTED
ON TO THE WINDOW
PLANE.

LOOKING AGAIN?

28

"Random Order," p. 28.

vent transfer technique of those drawings maintains the actual scale of their original media sources, photographic information could not be married to the greatly increased size and mode of address of Rauschenberg's painterly practice until he gained access to the photomechanical silkscreen process. This, then, provided the possibility both of greatly enlarging the scale of his source material and of making that material's photographic nature far more obvious than it had been in the Dante series, where, due to the vagaries of the transfer technique, it had largely been muted by the veil-like character of the image. Furthermore, Rauschenberg seems to have wanted the continuity of the mirrorlike photographic surface to

"A LIGHT BULB IN THE DARK CAN NOT SHOW ITS SELF WITHOUT SHOWING YOU SOMETHING ELSE TOO.

EVERY NIGHT, FROM MINUTE TO MINUTE THE SKYLINE, THAT IN DAY REMAINS MORE OR LESS AS WE KNOW IT, CHANGES AND REDEFINES THE SPACE DISTORTING OUR COMMON SENSE VEIW. THIS IS ACCOMPLISHED BY THE COMBINED INVOLUNTARY ACTIONS NECESSARY IN DOING SOMETHING ELSE.

THE INTIMIDATING CLARITY OF ... PLUMBING AS AN IMAGE, OCCURS BECAUSE OF ITS UN-ORNAMENTED STRUCTURAL RIGIDITY. THIS UNYIELDING QUALITY MAKES IT A DIFFICULT SUBJECT FOR SENTIMENTAL THOUGHTS. (THE IMAGE REMAINS MORE KEEN AND COMMUNICABLE WITH LITTLE ROOM FOR ESTHETIC DISAGREEMENT.)

ALLEGORY"

29

"Random Order," p. 29.

stamp its character on his newly revised sense of his medium, thereby re-placing the collage condition of his Combines with the seamlessness of the photographic print.

This was the departure, at the opening of the 1960s, that seemed to call for some kind of acknowledgment. If "Random Order" is such a dec-laration of Rauschenberg's newly "photographic" medium, contrasting it and (Renaissance) painting would seem entirely in order, so that its con-tingency could be compared to painting's compositional program, and its frame, a chance cut from the ongoing fabric of the whole world, could be set against painting's contraction around a gravitational center.

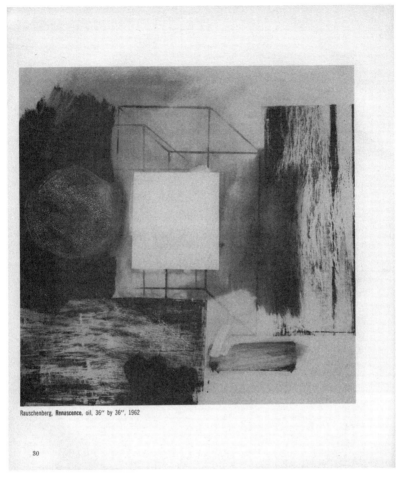

Rauschenberg, **Renascence**, oil, 36" by 36", 1962

30

"Random Order," p. 30.

But, as we will see, of the various oppositions set up within "Random Order," the obvious one between photography and painting, or rather between photography and Renaissance painting, does not seem to apply. Instead, one of the major oppositions seems to be between the aural and the visual, with sound annexing itself to language and thus yielding a further opposition between speech and vision.

This occurs with the two-page spread's first textual grouping, which is written above and along the side of its opening photograph—a truck seen head-on, looming out of the night. In it we read: "With sound scale and insistency trucks mobilize words, and broadside our culture by a

View from the artist's studio

31

"Random Order," p. 31.

combination of law and local motivation which produces an extremely
complex random order that cannot be described as accidental."[18] In the
context of all the other images—the two views out the window to facing
buildings and a roofscape; the kitchen area with a glimpse of paintings ly-
ing on the studio floor beyond; the toilet; the stairs; a potted plant[19]—
which continually place us inside Rauschenberg's Broadway loft, this idea
that the truck delivers both noise and words sets up another opposition:
that between exterior and interior, public and private. Even if we had not

read Calvin Tomkins's description of Rauschenberg's loft—"Tall, grimy windows let in the distinctively white light of downtown New York—also the roar of trucks on Broadway"[20]—we would feel the intimacy and interiority of the space of these pages, which only the auditory aggression of the truck as signifier of the outside violates.

If this sense of privacy promotes the conditions of a diary, they are invoked even more by the associative progression of the text itself, as one thought seems to suggest the next, without any authorial plan or argument having been established beforehand. To have pronounced "random order" next to the truck seems to have provoked Rauschenberg to write on the opposite side: "Every step is change," which in turn called for close-ups of stairs and their risers. That, then, brought on a comment about the volumetric quality of a stairwell—"a sculptural masterpiece clearly, economically and dramatically defining space"—which then moved the author's thoughts to other spatial volumes. And the one that came immediately to his mind, provided in turn with its own photograph, an out-the-window view, is the following:

> An air-filled sense of volume can be had by looking out one window, through the space, to another window and into it. This can be amplified by realizing the source of this vision is at a different temperature, brightness and will be subject to change as it moves on. Air volume can be compressed and flattened to the extent that a brushload of paint can hold it to a picture surface.

The frame, the piercing vista, and the "integrity" of the original surface restored by a brushload of paint have landed us, then, in the midst of the very "picture plane" in which O'Doherty would so counterintuitively claim that Rauschenberg believes. And when Rauschenberg's statement itself yields in turn to the photographic metaphor written on the other flank of the image—"A dirty or foggy window makes what is outside appear to be projected on to the window plane"—what we have is not the opposition between the indexically produced image (the photograph, onto the surface of which things fall like cast shadows) and the iconically constructed one (the painting), but, somehow, magically, their conflation. And what remains as well is the opposition announced at the very outset of the text: the difference between the delicately silent visual spaces and the brassily verbal one of the flow of words.

5. It is this opposition between silence and sound, vision and speech, that this essay is, I suppose, circling around. For the silence of the visual was what Rauschenberg had been insisting on in his resistance to the metaphoric expansion of the color black, that is to say the transformation of it from a physical and unarticulated material ("they couldn't see black as a pigment") to an invisible network of language. It is also this silence that connects the understanding of the *White Paintings* (1951) as screens on which to "trap" (no matter how ephemerally) the shadows of passersby to the underlying notion for the later silkscreens, which Rauschenberg thought of as functioning something like "photographic sensitized" surfaces that register the flitting of information passing through the space in front of them.[21] [Rauschenberg himself has emphasized the continuity between his *White Paintings* and his desire to work on photosensitized grounds. *Rauschenberg: "The first photo drawings were done in Cuba in 1952 during a working vacation from Black Mountain, where I was studying with Albers (he never saw them). Silkscreen was [later] a way not to be victimized and limited in scale and color, but still have access to current worldwide information. I did not [then] know about the commercial process of silkscreen and had tried to photosensitize grounds to work on."*][22]

The bridge from the barest monochrome canvas to the most richly photographic concatenation is built, then, on the concept of the index, namely, a type of mark made *causally,* so that it must be conceived as the physical trace of its referent. In structural terms, this is what links the cast shadow to the footprint, or the broken branch to the medical symptom, or the photograph to the wind sock. But, as if in punishment for their utmost degree of truth value, these witnesses to what is passing or has passed are struck dumb; for the index, although a sign, is uncoded and is thus deprived of speech.

It is in this matrix of connections between shadow and photography, on the one hand, and index and silence, on the other, that Rauschenberg was effortlessly enacting the semiotic analysis that was only explicitly theorized in the early 1960s, when Barthes began to publish on photography. That important texts by Barthes bracket Rauschenberg's turn to silkscreen is convenient but fortuitous. Not much art-historical weather can be made from the fact that "The Photographic Message" appeared in 1961, the year before Rauschenberg found the photomechanical silkscreen medium— through the example of Andy Warhol, who had begun using it in August 1962—(although news photographs had already been serving as his source for the transfer drawings over the preceding few years), and "Rhetoric of

the Image" was published in 1964, the year Rauschenberg's success with the silkscreens led to his winning the Grand Prize at the Venice Biennale, which he celebrated by telephoning to New York to have all his screens (about 150 of them) cut from their frames and burned, thereby definitively ending the series. About all that can be said about this chronological convergence is that the media saturation of daily life had made the ubiquity of the photographic a subject of some urgency, whether for theory or for making art.

And yet what interests me is both the way these parallel practices turn on the index's muteness, what Barthes characterized as the scandal of its constituting a "message without a code," and the growing realization that in its photographic form this muteness is nonetheless abuzz with connotations, so that, yes, Virginia, there is always and everywhere (and especially once photographed) a potentially "sad cup of coffee."

6. Barthes sets out from the photograph's status as pure denotation, as analogon, in "The Photographic Message." Stenciled off the world itself, it appears to have only one message to convey, which is identical to the reality from which it was taken. The photographic message seems to reduce itself to the brute gesture of pointing to something in physical space and pronouncing the single syllable "this." But behind such a mythic condition as objective, neutral, and all but silent lies a whole variety of connotational dimensions, which, though they cannot code the photograph in the manner of digital languages, can open up its visual continuity, partitioning it into a scatter of signifieds or meanings. Some of these result from how the photograph is produced (its cropping, lighting, exposure, printing); others arise from the cultural meanings invested in certain gestures, such as the pose a subject is directed to, or caught in the act of taking, or again the cultural knowledge summoned by clothing styles or the typography on signs included within the image. This constant, covertly performed segmentation means that "the photographic 'language' ['*langage*'] is not unlike certain ideographic languages which mix analogical and specifying units, the difference being," Barthes stressed, "that the ideogram is experienced as a sign whereas the photographic 'copy' is taken as the pure and simple denotation of reality."[23]

So strong is the experience of pure continuity, uninterrupted like the flow of reality itself, that the photograph has the power to subsume even the coded, linguistic nature of its own caption into this blank, denotational status: "It is not the image which comes to elucidate or 'realize' the text,"

as in older forms of illustration, "but the latter which comes to sublimate, patheticize or rationalize the image." For, parasitic as it is on the photograph, "the text is only a kind of secondary vibration, almost without consequence" in relationship to an "objective (denoted) message," and "connotation is now experienced only as the natural resonance of the fundamental denotation constituted by the photographic analogy."[24]

Beginning in 1961, then, the structural paradox Barthes was exploring was that of a connotational system hiding behind the seemingly unbroken facade of denotation's objectivity, its naturalness, its "innocence." In "Rhetoric of the Image," he went even further in developing an analysis of the way connotation striates the image, allowing himself to do so by confining his demonstration to a specific photograph used as an advertising image, the various connotative "messages" of which could reasonably be understood as intentional. Always returning to the way the denotative "fact" of the photograph closes over these readings to naturalize them—"the discontinuous connotators are connected, actualized, 'spoken' through the syntagm of the denotation, the discontinuous world of symbols plunges into the story of the denoted scene as though into a lustral bath of innocence"[25]— he tried nonetheless to systematize the connotational swarms.

The system, he suggested, always moves from the particular to the general, from the green, yellow, and red found in the Panzani advertising photo, for example, to the connotator "Italianicity," itself generalized onto a certain axis, that of nationalities, which can in turn be seen as part of a structurally oppositional network that organizes a whole associative field. This common domain was identified by Barthes as that of ideology, which "speaks" itself through a rhetoric, no matter in what medium the speech is conducted, whether in image, articulated sound, or gesture. These different supports for the "speech" affect the substance of the signifiers, he said, but they do not affect its *form,* by which he meant the functional organization of the signifieds in relationship to each other. And if rhetorics, that is, the set of connotators, have form, Barthes speculated, "it is even probable that there exists a single rhetorical *form,* common for instance to dream, literature and image."[26] For the psyche, structured like a language, also seems to move from the specific (as in the daily residue from which dream images are in part fabricated) to the general (the dream's highly repetitive "kernel"), such that "the further one 'descends' into the psychic depths of an individual, the more rarified and the more classifiable the signs become. What could be more systematic," Barthes finally asked, "than the readings of Rorschach tests?"[27]

7. Which brings us back to Breton, the focus of my second counterintuitive example, and, more specifically, to the Breton who, like Rauschenberg in "Random Order," insisted on inserting the supposedly silent testimony of documentary photographs into the pages of his diarylike novels *Nadja* (1928) and *L'Amour fou* (*Mad Love*, 1937).[28] Thus in *Nadja*, no sooner does Breton tell us that he is sitting in the Manoir d'Ango in August 1927, writing the account of his relationship with the quixotic, clairvoyant, mad Nadja, than we have a photograph of the manor house, with its dovecote and courtyard onto which a dead pigeon falls, announcing the closure of the story in the past (Nadja's) and the opening onto a future Breton has yet to live, much less to record. (That future will enter the book's final pages.) The account itself continues with diary entries and photographic documents, the entries turning on the "predictive" nature of Nadja's relation to future events (and Breton's to her), something Breton understood as the working of Surrealism's concept of objective chance.

Among the usual explanations as to why Breton would have proceeded in this curious way are that he was using photographs as a means to dispense with the descriptions that litter naturalistic novels, as Breton himself claimed at one point, and to authenticate the nonfictional status of his narratives. ("Provide me with the real names," Breton famously wrote, "prove to me that you in no way had free reign over your heroes.")[29] These have been swept aside by Denis Hollier, who has argued that the heart of the matter lies in the two forms of the index converging in these pages: (1) the photograph, which can only be a precipitate of the real, and (2) the diaristic, first-person narrator, whose verbal position is equally (deictically) dependent on reality, in this case upon the actual, existential conditions of saying "I." So what is at stake in a work like *Nadja* "is not a change in the referent, a passage from imaginary to real characters as one would do by leaving the novel for historiography. Rather it is a change in the mode of enunciation; the passage to the real must be inferred not by a change of object as much as by the entry onto the stage of the subject and its index."[30] And what this means is that the writer leaves the backstage of the novel to go sit in the theater with the rest of the audience. Placing himself on the same side of the page as his reader, the writer not only casts his own shadow onto the field of the book, but allows the events unfolding in a future he cannot foresee to cast theirs onto the same space. If, for the plastic arts, the indexical principle had meant that "a real shadow, falling onto Miró's *Spanish Dancer*, opens the internal space of the work to the

context of its reception, mixing it with that of its beholder," then "in the same way, what [Michel] Leiris called the literary equivalent of the shadow of the bull's horn should propel the autobiographical text in the shared space of history."[31] What is crucial about this space is that it is open; if Breton calls *Nadja* a book that is like a door left ajar, he means that when he began to write it he knew no more than did his reader, who by book's end would walk through that door. "The one who writes has no privilege," Hollier writes, "no advance over the one who reads. He doesn't know any more about it than the other."[32]

Leaving things "open" has been Rauschenberg's most frequently used expression in describing his artistic stance; whatever happens, he must always conspire to leave the situation open, so that, like Breton, he will be surprised.[33] This, he has stressed, is different from chance, since chance is programmed ahead of time, which is exactly what Rauschenberg has insisted upon avoiding.[34] Instead, if he has continually referred to his process as a collaboration with objects and materials, it is because he never wants it said that he in any way has, as Breton would put it, "had free reign over his heroes."

In Breton's case, openness is equally a matter of diaristic, autobiographical writing and "psychic automatism," or a kind of automatic writing intended to register unconscious thoughts. But since both forms—the diary as a demonstration of the "psychopathology of everyday life" (read: objective chance), and automatic writing as an unconscious precipitate— are viewed as being in collaboration with the unconscious, in their attempt to register this psychic dimension they are equally indexical. They both share in the index's "mode of enunciation." Hollier points out:

> The specific feature of Surrealist writing, whether it be autobiographical or automatic, is, in fact, less the lack of knowledge of its final destination as such than the identical position into which this lack places both the reader and the author in the face of a text whose unfolding neither the one nor the other controls, and about which both of them know neither the future nor the ending.[35]

The *Nadja*-like quality of "Random Order"—in its unfolding that feels both aleatory and associative, in its mixture of intimacy and veracity, and in the dreamlike quality of what impresses one as a nocturnal atmosphere no matter if some of the photographs were taken in daylight—puts Breton back in the interpretative picture. Not in any direct, historical way,

of course, but as a means of flagging the experience of a certain kind of field: full of associations, metaphors, connotations.

This was a field Rauschenberg had expressly courted in the *Inferno* drawings. *[Rauschenberg: "Dante was sought and completed to have the adventure of what, and if, I could apply my abstract sensibility to a classical restrictive assignment. A one-on-one handling and no embarrassment to either. Illustration with compulsive respect."]*

8. There are causal questions that are extremely hard to answer. For example, why would Rauschenberg have chosen the Dante project, not only selecting it but doggedly deciding as well to continue it, necessitating intermittent work over two and a half years, and, toward the end, six months of isolation in Florida in order to bring it to completion? Rauschenberg has given several different explanations. As he told Dorothy Gees Seckler in 1966, he wanted the figurative project demanded by illustration: "The problem when I started the Dante illustrations was to see if I was working abstractly because I couldn't work any other way or whether I was doing it by choice. So I insisted on the challenge of being restricted by a particular subject where it meant that I'd have to be involved in symbolism."[36] Earlier, however, he had told Tomkins that he was simply trying to find a way of solving the problem that his drawings did not follow one from the other the way his paintings did: "I really wanted to make a whole lot of drawings, though, so I began looking around for a vehicle, something to keep them going."[37] If this was his explanation in 1964, however, it had become far more generalized by the time Tomkins wrote *Off the Wall: Robert Rauschenberg and the Art World of Our Time* (published in 1980), which quotes Rauschenberg's pretext as simply wanting to be taken more seriously as an artist.[38] *[Rauschenberg: "It is mentioned why I spent such a long period of time on this work. (1) I was not going to leave it undone. (2) I became extremely irritated by the self-servicing of the text disguised as righteousness. Attempting Dante was a private exercise in my growth and self-exploration to face my weaknesses. A test. By doing it I had equal opportunity to alienate or to ally."]*

If Rauschenberg was forcing himself to engage with "symbolism," was this because his Combine paintings had been truly abstract, as he claimed? Or was it because they had already been invoking connotational fields, particularly in the matrices set up between objects, words, and photographic reproductions on the surfaces of works like *Rebus* (1955), *Talisman* (1958), or *Trophy I (for Merce Cunningham)* (1959)? *[Rauschenberg: "In the canto . . . the space allowed for each image was a measure made by the space*

*Canto IV: Limbo, Circle One, The Virtu-
ous Pagans,* 1958. Solvent transfer on
paper, with cut-and-pasted paper,
pencil, gouache, and watercolor,
14 ½ × 11 ½ in. The Museum of Mod-
ern Art, New York. Given anony-
mously. Photograph © 2001 The
Museum of Modern Art, New York.

occupied by the author's words, literally. (Not to exaggerate or edit.) I was the reporter."] And was the figurative nature of the new project both a way of acknowledging this and of extending it? Further, in the three-way connection set up in these drawings between the figurative, the symbolic, and the photographic, which element is primary?[39] Does the avowed desire to break with abstraction promote figuration, which then leads to the allegorical requirement of a master text (in this case the *Inferno*) and the subsequent need for a (photographic) image bank from which to draw? Or do the photographic forces already assembling on the surfaces of the Combine paintings, themselves releasing uncontainable networks of association, simultaneously demand the figurative and its textual support?

Whatever the first, originary term in this departure, the *Inferno* certainly plunged Rauschenberg into the domain of the connotational, in which messages overlay one another in a pileup of substitutions and metaphors. From the kind of visual symbols used for smells (Canto VI's "putrid slush" is metaphorized as a stinking fish in Rauschenberg's illustration), for sounds (Canto IV's "roar and trembling of Hell" becomes a racing car), and for tactile sensations (Canto XXXII's icy wilderness, where tears freeze the eyes shut, is visualized by a transparent cube with an eye inside it),[40] to those for conceptual conditions (Canto XX's idea of fortune-tellers and diviners is rendered by a large head of Sigmund Freud and by the fact that all the bodies have their heads on backward), the drawings explore the allegorical dimension of the image. But whatever the specific symbolic associations released may be, their interconnections could not pass from one part of the drawing to another without another dimension. That aspect is the technical one, in which rubbing, veiling, and liquidity not only open vignettes of space within the surface of the pages but, by reaffirming that surface, convert it into the vehicle that allows one such space to flow into another.

In creating a unified stroke as the medium of all the images in the series, the act of rubbing necessary to Rauschenberg's solvent transfer process (in which a magazine or newsprint page is soaked with lighter fluid or some other solvent, laid face down on top of the drawing sheet, and then rubbed with a blunt instrument to force the ink of the printed page onto the underlying sheet) serves as the matrix of slippage between one image and the next, which the spills and flows of watercolor and gouache merely heighten.[41] But the rubbing also produces two more effects. Since a rubbing most often takes the form of a rectangular unit capturing a given

figure or object along with a patch of its background, the first is that individual images are framed, something heightened not only by the many found, internal frames within individual images (such as the astronaut's visored helmet in Canto XXX) but by the numerous rectangular elements collaged to the pages. The second is that the rubbing's visual blur promotes the sensation that the images are "veiled."

It is this combination of framing and veiling that paradoxically restores these drawings to the very dimension that Leo Steinberg was to call the "diaphane," in distinguishing it (and the whole tradition of picture making before Rauschenberg) from the very "flatbed picture plane" that he saw Rauschenberg's Combines as inaugurating. The sense of the visual field falling in a transparent but decidedly vertical veil before the viewer's upright body connects the "diaphanic" with a dimension of nature that Steinberg went on to contrast explicitly to Rauschenberg's exploitation of the "post-modern" dimension of culture, understood now, in the Combines, as a horizontal "receptor surface on which objects are scattered, on which data is entered, on which information may be received, printed, impressed."[42] To return to the veil, and thereby to the diaphane—or to the frame, and hence to the window model of the picture plane—was, then, to arise from this flatbed, in which Rauschenberg's originality as an artist had been invested.

But the return to this vertical axis in the Dante drawings seems to have been motivated less by a need to connect to nature (or landscape) than to what we would have to call an "image logic," which is to say that, whether stored within the imaginary spaces of our dreams, fantasies, or memories, or observed in the external world, images are vertically oriented, with heads at the top, feet at the bottom. If Rauschenberg was exploring the associational field of those chains of connotations that, as Barthes had noted, make up the rhetorical form "common for instance to dream, literature and image," he had no choice but to seek the image logic's vector, which is vertical. This is the reason why it is hard to see which was foremost in Rauschenberg's set of choices in 1958: the condition of the symbol; its existence as figurative; or the support of the photograph. This is also why there is no break between the image logic exploited in the Dante drawings and the oneiric feeling of "Random Order." The mental spaces of dream, of memory, and of the imagination are equally upright.

9. Heads contained by frames appear throughout the Dante drawings, either because Rauschenberg encased faces within framing rectangles (as in

Canto XXX: Circle Eight, Bolgia 10, The Falsifiers: The Evil Impersonators, Counterfeiters, and False Witnesses, 1959–1960. Solvent transfer on paper, with watercolor, gouache, and pencil, 14 ½ × 11 ½ in. The Museum of Modern Art, New York. Given anonymously. Photograph © 2001 The Museum of Modern Art, New York.

Cantos X and XXXI) or because he found such framing in the borrowed images themselves (the diver's helmet in Canto XX, the astronaut's in Canto XXX). This resource is carried over into the silkscreened paintings. In *Transom* (1963), *Flush* (1964), and *Trapeze* (1964), for example, mirrors from both the *Rokeby Venus* and Peter Paul Rubens's *The Toilet of Venus* (c. 1613–1614) isolate the female faces and are themselves further isolated by the painting's field, and in *Retroactive II* (1963) and *Press* (1964), John F. Kennedy's head is tightly framed. Enclosing the head and face, the frame seems to organize an image of the mental, or of thought, meditation, or reflection.

Steinberg had indeed spoken of the flatbed of Rauschenberg's Combine paintings as a turning away from the optical toward the mental. "It seemed at times," he wrote, "that Rauschenberg's work surface stood for the mind itself—dump, reservoir, switching center, abundant with concrete references freely associated as in an internal monologue—the outward symbol of the mind as a running transformer of the external world, constantly ingesting incoming unprocessed data to be mapped in an overcharged field."[43] And building on that suggestion, plus the sense that the wildly diverse elements "dumped" onto this surface were nonetheless physically embedded within it in such a way as to produce a peculiar homogeneity among the varied elements, and between them and that surface, I myself tried to develop the particular dimension of the mental space suggested by the Combines, namely memory.[44]

If, from the Combines to the Dante drawings to the silkscreens via "Random Order," the assortment of material objects gives way to the framed image—a two-dimensional element whose substance is now truly at one with its planar support and whose medium is consistently photographic—this experience of a mnemonic space becomes ever more specific. For not only does the verticality of the image become pervasive, but now, as assertively presented in the manifestolike "Random Order," the formula for the entire silkscreen series is to be a loose grid of enframed photographic spaces that seems to present one with nothing so much as a visual archive: the storage and retrieval matrix of the organized miscellany of images, which presents the memory as a kind of filing cabinet of the mind.

10. The photographic archive was not wholly foreign to Rauschenberg's Identikit. He is fond of saying that he almost became a photographer, and the project he imagined embarking on, inspired by the presence at Black

Robert Frank, *View from Hotel Window—Butte, Montana,* 1956. Gelatin-silver print, 9 × 13 ½ in. From *The Americans* by Robert Frank, courtesy Pace/MacGill Gallery, New York.

Mountain College of Harry Callahan and Aaron Siskind, was, WPA-like, to photograph America, foot by foot, "in actual size."[45]

Given Rauschenberg's generation, the WPA characterization is surprising. We would sooner expect him to share a sensibility with someone like Robert Frank. We would predict that Rauschenberg's handling of photography would give us the sense of our connection to a place that is only possible through the intensity of our experience of separation from it, the sense that to see it directly is so painful that the image must somehow be mediated by the presence of a veil. This is true of Frank's famous *Barber Shop through Screen Door—McClellanville, South Carolina* (1955) and his *Fourth of July—Jay, New York* (1954), in which the mesh of screening that paradoxically serves as both focusing device and barrier in the former and the American flag dropping a vertical curtain through the space of the latter produce the simultaneous connection and distance that is the heart of Frank's ambivalence. Whether we are looking at *View from Hotel Window—Butte, Montana* (1956) or *Elevator—Miami Beach* (1955), there is always the effect of a veil, created either by the literal means of photographed fabric or by the technical means of blur, flare, or pulled focus.

N.Y.C. Midtown, 1979. Gelatin-silver
print, 16 × 20 in. Collection of the
artist.

Veils do function in Rauschenberg's treatment of found photographs
within his Combines, famously so in the gauze that falls over a group of
photos in *Rebus* and over the reproduction of the stag in *Curfew* (1958). In
these instances, the veils can be seen as working to create a balance be-
tween the assumed transparency of the photographic image's relation to
reality and the opaque presence of the other objects piled onto the Com-
bine. The skin of paint that often scabs over these objects, marrying them
to the flatbed surface, is thus mimicked by the veil that is dropped in front
of the occasional photographic image.

However, in Rauschenberg's own photography, we see something far
more in tune with the example of Walker Evans's works: the frontality; the
relentless focus; the quality of light falling on textured surfaces (clapboard
siding, for example, or brick) acting as a kind of graphic, or drawn, stroke;
and the fascination with two-dimensional "fronts" (billboards, torn posters,
shop windows) standing in for the deep space of the "real," which they
effectively block. It is these qualities, combined with the survey mentality
expressed by the photographic project Rauschenberg initially imagined,
that make the connection to the idea of an archive, a photographic corpus
through which reality is somehow ingested, organized, catalogued, and
retrieved. Indeed, beginning with the silkscreens—Rauschenberg's sys-

tematic turn to photography as the basis for his paintings—this procedure of the survey has marked his approach in various ways.

One of them is the amassing of the archive on the basis of certain preconceived categories. A precedent can be found in the notorious "shooting scripts" handed out by Roy Stryker in 1936 to his WPA cameramen, including Evans, who were directed to record certain kinds of settings, social types, and accoutrements. In collecting his own material for the silkscreen series and for subsequent works, Rauschenberg has also looked for certain types of subjects in his media sources. As he and his assistants scour these sources, they arrange this material in prescribed categories—athletes, space travel, animals, domestic objects, transport, and American emblems, among others—in piles on the worktables in his Captiva studio.[46]

But the most important aspect of the archival is the idea of the standardized format, which allows for its informational space to be mapped. This is where Rauschenberg's two choices—his employment of the loose grid as a structure and the conveyance of the image in its frame, so clearly enunciated in "Random Order" and so faithfully followed in the silkscreens—become important. *[Rauschenberg: "Re the archives: I also arrange my other colors and materials in such a way to keep them in my reach. Everything I can organize I do, so I am free to work in chaos, spontaneity, and the not yet done."]*

11. The archive is a documentary project, a public act of collective memory; or at least that is its ideal form, the one projected by various prewar archival surveys, like the WPA's in America, or August Sander's *Das Antlitz der Zeit* (*The Face of Time,* 1929) in Germany. Benjamin Buchloh has written about the peculiar relation of postwar avant-garde artists to these earlier demonstrations of a belief not only in the transparency of the photographic medium but in the common-sense assumption of the transparency of the reality itself onto which the camera was focused. Gerhard Richter, as his complex project *Atlas* (1962–present) reflects, is peculiarly adamant about the impossibility of any such transparency and the need to puncture its mythological status. If the archival project is founded on memory, Richter's own example seems to say, it must be based as well on a notion of subjectivity for which (or for whom) coherent memory is possible. But what *Atlas* questions, over the meander of its burgeoning but hapless categorical spaces, is just this option at a historical point at which, to use Buchloh's terms, "anomie" has taken over in such a way as to eclipse the subject, to produce that subject as the basis of mnemonic activity no longer.[47]

In Buchloh's reconstruction of Richter's development, Richter's experience of seeing Rauschenberg's work in the 1959 exhibition *Documenta*

II: Kunst nach 1945 in Kassel was crucial to his embrace of modernism and the redirection of his own project, which *Atlas* inaugurated.[48] It is therefore fortuitous that by 1962 Rauschenberg himself had embarked on a series not unrelated to *Atlas* in various aspects: the use of "amateur-type" photos (here supplied by Rauschenberg, taking them with his Roloflex camera) combined with images culled from magazines and newspapers; the exploitation of serialization and repetition; the coordination of the framed photographic image with the geometrically patterned layout of the grid; and the ultimate quarry, which is the now highly problematic space of memory.

12. The last word of the two-page spread in "Random Order" is "allegory," which is penciled by itself under the layered interior space of Rauschenberg's loft, stove and sink lined up parallel to the surface plane in the image's foreground, countertop repeating this parallel in the middle ground, and floor-bound works in progress in the background. This image shows interior space as organized by the language of perspective, which makes the order of the asserted "allegory" not exactly what we would have expected.

 If "allegory" has been applied as a term of critical appraisal to Rauschenberg's work, this has been to align it with a variety of deployments, including fragmentation, appropriation, and indeterminacy of reading, that characterize certain postmodern practices.[49] It has also been to annex it to Walter Benjamin's use of Baroque systems of allegory to address the reified status of the human subject within a culture of the commodity.[50] In my consideration of "Random Order," however, I would like to do something both more limited and more precise. If allegory begins with the doubling of one text (or image) by another, Rauschenberg is clearly placing photography and (Renaissance) painting into such a reciprocal relationship. Not only has he told us what he thinks Renaissance painting is (the volume that can be flattened "to the extent that a brushload of paint can hold it to a picture surface"), but he has made an emblem of this bellowslike opening and closing every bit as graphic as Albers's reversible squares. The opaque, two-dimensional plane, or square, in *Renascence* is suspended within the schematic, perspectival rendering of the cube as one of its dimensions now "holding volume to the surface"; the cube is a figure that will reappear persistently throughout the silkscreen series in works such as *Exile, New Painting, Payload,* and *Vault* (all 1962); *Die Hard* (1963); *Bicycle, Stop Gap,* and *Transom* (all 1963); and *Press, Stunt,* and *Trap* (all 1964).

Stop Gap, 1963. Oil and silkscreen ink
on canvas, 58 × 40 in. Collection of
Hara Museum of Contemporary Art,
Tokyo.

But in "Random Order," what Rauschenberg has also said is that the photographic mark is not just an imprint falling onto the emulsion of the light-sensitive surface from the space in front of the camera (as in the example of the *White Paintings,* which catch cast shadows), but that the mark seems to be welling up from within the camera itself, as in the case of a foggy or dirty pane, where "what is outside appear[s] to be projected onto the window plane." In the artist's description, the photograph is neither considered the "transparent" access to reality that is part of the ideology of the document, nor conceived of as the indexically opaque mark of the cast shadow. Rather, it is understood—on the model of the Renaissance picture, which stands as its allegory—as layered: a depth and a surface forced into some kind of contact.

The model of that contact is not the *same* as the Renaissance picture; if it were, we would not be speaking of an allegory. Rather, this relationship, or contact, between surface and depth is made—hence the "integrity of the picture plane"—and then broken—the allegorical condition. The figure that comes to mind in this regard is Freud's model of memory, the "Mystic Writing-Pad." How, he asked, can we conceive of the storage of information necessary to memory occurring in the very same neurological system that provides the perpetually virgin fields of impression requisite for new, incoming perceptions?[51] In thinking about the relationship between two systems of neurons—those of permanent impression (that is, storage) and those of perception—Freud turned to a child's toy, the Wunderblock, which is comprised of a plastic sheet layered over a wax tablet. The pressure of drawing on the sheet with a stylus makes the sheet stick to the tablet, producing a graphic outline. But this configuration can be made to disappear simply by lifting the plastic sheet, thereby pulling it away from the tablet to which it had been temporarily attached. The sheet is then virgin once more, and, like the perceptual system, ready to accept fresh data. The tablet has nonetheless retained the marks of the stylus's impression and, like memory, bears a permanent network of traces in the part of the apparatus that lies below.

If "Random Order" is an allegory, it is one that attempts to triangulate memory, photography, and text, with the allegorical exemplar being the oscillating space of painting in which inside and outside, virtual and actual, depth and surface are bound and parted only to be bound and parted again. If there was a "belief" in the early 1960s that these could have something to do with one another, it would surely not have been along the lines of the prewar archive. Rather, although there is no immediate

historical connection, the relationships are on the order of Barthes's discussion in "Rhetoric of the Image," in which connotational chains, anarchic and metastatic, open a kind of echo chamber of unstable meanings ricocheting around the archival structure that Barthes later called the "stereophonic space" of the endlessly multiple associational codes.

By 1964, at the height of his silkscreen production, it was clear to Rauschenberg that these chains were both what he was confronting and what he could never control. Accordingly, he said to David Sylvester,

> We have ideas about bricks. A brick just isn't a physical mass of a certain dimension that one builds houses or chimneys with. The whole world of associations, all the information that we have—the fact that it's made of dirt, that it's been through a kiln, romantic ideas about little brick cottages, or the chimney which is so romantic, or labor— you have to deal with as many of the things as you know about. Because if you don't, I think you start working more like an eccentric, or primitive, which, you know, who can be anymore, or the insane, which is very obsessive.[52]

Another instance he provided Sylvester was the image of a glass of water, which entered into the silkscreen repertory by means of his own photograph. Not only was it a purely physical or functional object—"the fact that it's this big, this high, that it might topple over, that it evaporates and has to be refilled, that it picks up reflections"—but, he admitted, adhering to it were "all the psychological implications of a glass of water." Speaking of the glass that appears in *Persimmon* (1964), he gave an example of one such implication, an interesting demonstration for the person who insisted that there was no such thing as a sad cup of coffee:

> In most cases, my manipulation of the psychological is to try to avoid the ones that I know about. I had trouble in one painting. . . . I was silkscreening a glass of water and I put it over green and that whole painting had to change to destroy the look of poison, which is just simply an association that one has with a glass of green, I think.[53]

The year before this conversation, Rauschenberg had written "Note on Painting,"[54] in which he returned to his rejection of the connotational as the "clichés" that psychological common sense annexes to certain objects ("If I see any superficial subconscious relationship that I'm familiar

Persimmon, 1964. Oil and silkscreen
ink on canvas, 66 × 50 in. Collection
of Jean Christophe Castelli, New York.

with—clichés of association—I change the picture").[55] In "Note on Paint-ing," he wrote, "The work then has a chance to *electric service* become its own cliché," with the interjection of "electric service" into the sentence functioning somewhat in the manner of the insertions of photographs into the flow of "Random Order." Indeed, these strange interruptions in "Note on Painting"—"open 24 hrs.," "heated pool," "Denver 39"—have the quality of textual fragments lifted from advertising, journalism, or any of a number of other sources for those words that "broadside our culture," which the trucks of "Random Order" are pictured as delivering. It's just that the word "cliché," which in Rauschenberg's usage curiously joins the psychological—"clichés of association"—and the material—the words that "broadside our culture"—sets up a relationship between the external source of the image and the internal space of its reception.

Because Rauschenberg has repeatedly said, "I always wanted my works—whatever happened in the studio—to look more like what was going on outside the window,"[56] we are not surprised that with the advent of the silkscreen series he should have identified that outside with photo-graphic media: "I was bombarded with TV sets and magazines by the ex-cess of the world. I thought an honest work should incorporate all of these elements, which were and are a reality."[57] What is more surprising is that he should have conceived of "whatever happened in the studio" as "its own cliché," now considered as a positive quality.

This cliché, a precipitate of his characterization of the media image as "the complex interlocking of disparate visual facts *heated pool* that have no respect for grammar,"[58] is nonetheless the stuff of the "subconscious." It is like the kernel of the dream, or the repetitively simple wish, encircled by the elaborate disjuncture of its imagery, much of which is fabricated from the "daily residue" of one's recent waking life. This relationship between the *form* of a rhetoric and its wildly proliferating, manifest content is what Barthes had been getting at as well when he spoke about the endless lexes into which images of reality can be divided (the idiolects); however, as one *descends* toward the "psychic depths of an individual . . . the more classifi-able the signs become. What could be more systematic than the readings of Rorschach tests?"

The allegory of inside and outside, of front and back, of the photo-graphic striking the subject from the outside but welling up in a different *form* (the grammar of the cliché) from within, emblematized by a revers-ible cube, is the message of "Random Order." As allegories go, it is both simple and moving, evincing a particular faith in the renewability of paint-ing, capable of emerging "like a new season."[59]

Notes

1. Brian O'Doherty, *American Masters: The Voice and the Myth* (New York: Random House, 1974), p. 198. An excerpt of this text was published earlier as O'Doherty, "Rauschenberg and the Vernacular Glance," *Art in America* 61, no. 5 (September-October 1973), pp. 82–89.

2. O'Doherty, *American Masters*, pp. 188–225.

3. Ibid., p. 204.

4. See, for example, Clement Greenberg's statement, "The first mark made on a canvas destroys its literal and utter flatness, and the result of the marks made on it by an artist like Mondrian is still a kind of illusion that suggests a kind of third dimension" (Greenberg, "Modernist Painting" [1960], in Greenberg, *The Collected Essays and Criticism,* ed. John O'Brian, vol. 4, *Modernism with a Vengeance, 1957–1969* [Chicago: University of Chicago Press, 1993], p. 90).

5. Donald Judd, "Specific Objects," *Arts Yearbook* 8 (1965), pp. 74–82.

6. In his extremely important essay "Other Criteria," Leo Steinberg quoted Greenberg in taking issue with his prejudicial contrast between Old Master art—"Realistic, illusionist art had dissembled the medium, using art to conceal art"—and the modernist alternative, which "used art to call attention to art." Insisting that any art, Old Master and modernist alike, uses "art to call attention to art" and thereby preserves the integrity of the picture plane, Steinberg called for a taxonomy of spaces opened up within that plane by different types of painting. His text then develops the oppositions between nature and culture (or optical and mental) and, in relation to the latter, the characterization of the flatbed picture plane in Rauschenberg's work for which the essay is so widely known. But in this association of the terms "flatbed" and "picture plane," it is important to see that the flatbed does not preserve the old metaphysical implications of "integrity": "If some collage element, such as a pasted-down photograph, threatened to evoke a topical illusion of depth, the surface was casually stained or smeared with paint to recall its irreducible flatness. The 'integrity of the picture plane'—once the accomplishment of good design—was to become that which is given. The picture's 'flatness' was to be no more of a problem than the flatness of a disordered desk or an unswept floor. Against Rauschenberg's picture plane you can pin or project any image because it will not work as the glimpse of a world, but as a scrap of printed material" (Steinberg, "Other Criteria," in *Other Criteria: Confrontations with Twentieth-Century Art* [New York: Oxford University Press, 1972], pp. 55–91; partially reprinted in this volume as "Reflections on the State of Criticism," quoted material from pp. 11, 32).

7. Brian O'Doherty, *Object and Idea: An Art Critic's Journal 1961–1967* (New York: Simon and Schuster, 1967), p. 115.

8. Susan Sontag, "One Culture and the New Sensibility," in Sontag, *Against Interpretation* (New York: Farrar, Straus and Giroux, 1966), pp. 293–304.

9. Ibid., p. 298.

10. Roland Barthes, "The Death of the Author" (1967), in Barthes, *Image, Music, Text,* trans. Stephen Heath (New York: Hill and Wang, 1977), p. 144. This text was first published in *Aspen Magazine*, nos. 5–6 (Fall-Winter 1967), an issue edited by O'Doherty.

11. Bruce Glaser, "Questions to Stella and Judd," ed. Lucy R. Lippard, in Gregory Battcock, ed., *Minimal Art: A Critical Anthology* (New York: E. P. Dutton, 1968), p. 158. Reprinted from *Artnews* 65, no. 5 (September 1966), pp. 55–61.

12. Quoted in Calvin Tomkins, *Off the Wall: Robert Rauschenberg and the Art World of Our Time* (Garden City, N.Y.: Doubleday, 1980), p. 89.

13. Quoted in Dorothy Gees Seckler, "The Artist Speaks: Robert Rauschenberg," *Art in America* 54, no. 3 (May–June 1966), p. 76.

14. Quoted in Tomkins, *Off the Wall*, p. 201.

15. Dore Ashton, "Rauschenberg's Thirty-four Illustrations for Dante's Inferno," *Metro* (Milan) 2 (May 1961), p. 58. In preparing to write an extended commentary for the deluxe edition of the drawings, published by Harry N. Abrams, Ashton spent "hours and hours . . . in his [Rauschenberg's] studio reading over John Ciardi's translation and gazing at the drawings. . . . Rauschenberg and I read the poem together, speaking about Dante's ineffable pride, his sly witticisms, his digs at his artistic rivals . . . his lyrical abandon, his extraordinary feeling for the particular, his forthright language, and above all, his great artistic inconsistencies." Quoted in Dore Ashton, "Art: The Collaboration Wheel: A Comment on Robert Rauschenberg's Comment on Dante," *Arts and Architecture* 80, no. 12 (December 1963), pp. 10, 37.

16. The analysis of Leone Battista Alberti's and Piero della Francesca's model of perspective conceived as a closed, volumetric box, constructed with its sides as absolute limits and specifically foreclosing anything that could be thought of as "off-stage" space, is made in Hubert Damisch, *The Origin of Perspective,* trans. John Goodman (Cambridge: MIT Press, 1994), pp. 350–352.

17. Setting aside the fact that Rauschenberg had begun a serious practice of photography itself in the late 1940s and would continue to make photographs throughout his career, a reconsideration of the medium of painting as "photographic" involves a particular leap, which this essay is involved in exploring. Rauschenberg's few blueprint photographic works of 1950–1951 might seem to have performed this leap, and, indeed, the great interest in them might elicit the response that he was not starting out in a new direction at the outset of the 1960s but rather returning to one he had initiated early in his career. I should say here that the status of these works in Rauschenberg's oeuvre is not clear to me. They do signal the kind of reorientation of the work to the horizontality that Steinberg named "the flatbed picture plane"; thus, they team up with *Bed* (1955), *Erased de Kooning Drawing* (1953), and *Automobile Tire Print*. And like the latter two works, or, for that matter, the *White Paintings,* they signal (or maybe initiated) Rauschenberg's pursuit of the index as a way of marking. But Rauschenberg did not return to the photogram technique as a strategy for fusing the photographic index with painting's scale and pictorial logic, perhaps for the very fact that he made these collaborative works together with Susan Weil, then his wife.

18. This head-on shot of the truck made its way into at least two of the black-and-white silkscreens: *Buffalo I* and *Overcast II* (both 1962). (The spelling in all quotes from "Random Order" is Rauschenberg's.)

19. Of these images, two were made into screens. The roofscape with water tanks appears in *Almanac, Overcast I,* and *Overcast II* (all 1962), and *Barge* (1962–1963), *Die Hard, Shaftway, Transom,* and *Windward* (all 1963). The potted plant can be seen in *Almanac*. Speaking with Barbara Rose, Rauschenberg said of these photographs: "I needed some very simple images, like perhaps a glass of water, or a piece of string, or the bathroom floor with a roll of toilet paper on it. They didn't need to have any immediate emotional content. I needed them to dull the social implications, to neutralize the calamities that were going on in the outside world" (Rose, *Rauschenberg* [New York: Vintage Books, 1987], p. 74).

20. Tomkins, *Off the Wall*, p. 211.

21. Rauschenberg suggested that his ultimate project along these lines would be "a project that I have in mind where the walls will absorb whatever images appear in that room" (Rose, *Rauschenberg,* p. 77). In an essay on Rauschenberg, John Cage emphasized that "the white

paintings caught whatever fell on them," calling them "airports for the lights, shadows, and particles" (Cage, "On Robert Rauschenberg, Artist, and His Work," in *Silence* [Middletown, Conn.: Wesleyan University Press, 1961], pp. 108, 102, respectively; reprinted from *Metro* [Milan] 2 [May 1961], pp. 36–51).

22. During the editing process of this essay, Rauschenberg read it and on April 1, 1997, sent me several comments that function as expansions on or associations to the text. The present remark was elicited by this section and relates not only to the continuity of his own connection to the index, but to the issue of Warhol's priority in the use of the commercial silkscreen process, frequently repeated in the literature on the subject. Rauschenberg's other comments appear in brackets within this essay.

23. Barthes, "The Photographic Message," in *Image, Music, Text*, p. 28.

24. Ibid., pp. 25–26.

25. Barthes, "Rhetoric of the Image," in *Image, Music, Text*, p. 51.

26. Ibid., p. 49.

27. Ibid., p. 47.

28. During a conversation with Yve-Alain Bois, in which we were discussing the enigmatic yet suggestive character of "Random Order" as a manifesto, he said that these sheets somehow reminded him of *Nadja*, a comment for which, as will be obvious, I am extremely grateful.

29. André Breton, "Introduction to the Discourse on the Paucity of Reality," trans. Richard Sieburth and Jennifer Gordon, *October* 69 (Summer 1994), p. 134. Previously published as "Introduction au discours sur le peu de réalité" (1924) in Breton, *Point du jour* (Paris: Editions Gallimard, 1970).

30. Denis Hollier, "Surrealist Precipitates: Shadows Don't Cast Shadows," trans. Rosalind Krauss, *October* 69 (Summer 1994), p. 126.

31. Ibid., p. 124.

32. Ibid., p. 129.

33. In her summary of Rauschenberg's aesthetic stance, Seckler introduced her long interview with him by saying that although Rauschenberg "does not recall having paid much attention to abstract expressionism's philosophical premises in existentialism and Zen, he apparently took seriously that part of its moral position which emphasized risk and openness and keeping the artist's activity—with all its precarious balancing—clearly in view." In the interview itself, Rauschenberg stated this by saying, "This insistence on the piece operating in the time situation it was observed in is another one of the ways of trying to put off the death of the work" (Seckler, "The Artist Speaks," pp. 74, 84). Cage also quoted a typical expression of Rauschenberg's drive for openness: "I am trying to check my habits of seeing, to counter them for the sake of greater freshness. I am trying to be unfamiliar with what I'm doing" (Cage, "On Robert Rauschenberg, Artist, and His Work," p. 106). Or again, Rauschenberg said several times to Philip Smith that he wanted to be open to events in order to create an art that would not "tell you something that you already know" (Smith, "To and about Robert Rauschenberg," *Arts Magazine* 51, no. 7 [March 1977], p. 121). The most frequently repeated version is Rauschenberg's refrain about his "collaboration with materials" (see Calvin Tomkins, *The Bride and the Bachelors: The Heretical Courtship in Modern Art* [New York: Viking Press, 1965], pp. 204, 232), which he enunciated to John Gruen as "I put my trust in the materials that confront me, because they put me in touch with the unknown" (Gruen, "Robert Rauschenberg: An Audience of One," *Artnews* 76, no. 2 [February 1977], p. 48).

34. Rauschenberg said, "I was interested in many of John Cage's chance operations and I liked the sense of experimentation he is involved in, but painting is just a different ground for activities. I could never figure out an interesting way to use any kind of programmed activity—and even though chance deals with the unexpected and unplanned, it still has to be organized. Working with chance, I would end up with something that was quite geometric: I felt as though I were carrying out an idea rather than witnessing an unknown idea taking shape" (quoted in Seckler, "The Artist Speaks," p. 81).

35. Hollier, "Surrealist Precipitates," p. 129.

36. Quoted in Seckler, "The Artist Speaks," p. 84.

37. Quoted in Tomkins, *The Bride and the Bachelors,* p. 224.

38. Tomkins, *Off the Wall,* p. 157. That Rauschenberg continues to be defensive about the early characterization of himself as an unserious jokester (in a January 1956 review, Steinberg had written "Eulenspiegel is abroad again") is witnessed by the many interviews in which, referring to his reception in the 1950s, he made remarks like "I was considered a clown." See Leo Steinberg, "Month in Review: Contemporary Group at Stable Gallery," *Arts* 30, no. 4 (January 1956), p. 47, and Paul Taylor, "Robert Rauschenberg," *Interview* 20, no. 12 (December 1990), p. 147.

39. I am using "symbolic" here in a rather loose way, to gather together the idea of images symbolizing other sensory data or specific textual ideas, and thus the drive toward the textual or the linguistic ("symbol" in the semiological sense). In this usage, symbol overlaps with the idea of the allegorical emblem, rather than opposing it, as it does in Walter Benjamin's analysis of the fragmentary and disunified nature of allegory contrasted to the organic character of the work understood as symbol. See Benjamin, *The Origin of German Tragic Drama,* trans. John Osborne (London: New Left Books, 1977).

40. These have been pointed out in Ashton, "Rauschenberg's Thirty-four Illustrations," pp. 57, 61. For another reading of the drawings' relations to the text of *Inferno,* see Bitite Vinklers, "Why Not Dante? A Study of Rauschenberg's Drawings for the *Inferno,*" *Art International* (Lugano) 12, no. 6 (Summer 1968), pp. 99–106.

41. A precedent for the use of rubbing to promote associative readings and slippage is, of course, Max Ernst's frottage technique, which I do not think is connected historically to Rauschenberg's method. Far more likely is the connection between the parallel strokes of the rubbing and Jasper Johns's drawing technique of using parallel hatching to open up pockets of shallow space.

42. Steinberg, "Other Criteria," in this volume as "Reflections on the State of Criticism," p. 28.

43. Ibid., p. 32.

44. See my "Rauschenberg and the Materialized Image," *Artforum* 13, no. 4 (December 1974), pp. 41–43; reprinted in this volume.

45. Quoted in Rose, *Rauschenberg,* p. 75. In 1979, Rauschenberg undertook a project of this nature, *In + Out City Limits.*

46. This was described to me by Nan Rosenthal, who was struck by it on her first visit to Captiva in 1983.

47. Benjamin H. D. Buchloh, "L'Archive anomique de Gerhard Richter," a chapter of his seminal study of Richter, *Gerhard Richter,* exh. cat., vol. 2, *La Peinture à la fin du sujet* (Paris: Musée d'Art Moderne de la Ville de Paris, 1993), pp. 7–17. See also Buchloh's essay "Gerhard Richter's *Atlas:* The Anomic Archive," *October* 88 (Spring 1999), pp. 117–145.

48. Ibid., p. 13. The Rauschenberg works that Richter saw at the 1959 *Documenta* were *Bed, Kickback* (1959), and *Thaw* (1958).

49. See Craig Owens, "The Allegorical Impulse: Toward a Theory of Postmodernism," *October* 12 (Spring 1980), pp. 67–86; and *October* 13 (Summer 1980), pp. 59–80.

50. See Benjamin H. D. Buchloh, "Allegorical Procedures: Appropriation and Montage in Contemporary Art," *Artforum* 21, no. 1 (September 1982), pp. 44, 46–47.

51. Sigmund Freud, "A Note upon the 'Mystic Writing-Pad'" (1924), in *The Standard Edition of the Complete Psychological Works of Sigmund Freud,* ed. James Strachey, vol. 19 (London: Hogarth Press and the Institute for Psycho-analysis, 1961), pp. 227–232.

52. Quoted in Roni Feinstein, *Robert Rauschenberg: The Silkscreen Paintings, 1962–64* (New York: Whitney Museum of American Art; Boston: Little, Brown, 1990), p. 25, from David Sylvester, interview with Rauschenberg, BBC, August 1964, audiotape in Chelsea School of Art Library, London.

53. Quoted in ibid.

54. The handwritten text, dated October 31–November 2, 1963, is reproduced as Robert Rauschenberg, "Note on Painting," in John Russell and Suzi Gablik, *Pop Art Redefined* (New York: Frederick A. Praeger, 1969), pp. 101–102.

55. This particular quotation is taken from the Seckler interview, which took place two years after "Note on Painting" was written. But at the time he made his black paintings, Rauschenberg's hostility to associations was expressed in his distress about the connotations critics wanted to annex to what he considered a simple material.

56. Quoted in Taylor, "Robert Rauschenberg," p. 146.

57. Quoted in Mary Lynn Kotz, *Robert Rauschenberg: Art and Life* (New York: Harry N. Abrams, 1990), p. 99.

58. Rauschenberg, "Note on Painting," p. 101. Italics added.

59. I would like to address in this last footnote the pressure that has been exerted on Rauschenberg's work in attempts to read it as the encoding of a coherent message and in some cases to use the conventional procedures of iconography to decode that message. This began with Charles F. Stuckey's self-proclaimed deciphering of the rebus in *Rebus* ("Reading Rauschenberg," *Art in America* 65, no. 2 [March-April 1977], pp. 74–84) and has continued in the kind of thematic readings developed by Roni Feinstein, where, among other things, she sees certain of the silkscreened paintings as allegories of Marcel Duchamp's *The Bride Stripped Bare by Her Bachelors, Even* (*Large Glass*) (1915–1923); see Feinstein, *Robert Rauschenberg,* pp. 75–90. More recently the iconography has been understood as encrypting themes of gay subculture, whether through allusions to myths resonant within gay sensibility (the Ganymede myth in *Canyon,* discussed in Kenneth Bendiner, "Robert Rauschenberg's *Canyon,*" *Arts Magazine* 56, no. 10 [June 1982], pp. 57–59) or, in the case of the entire Dante drawings project, through hidden references to bathhouse culture and the media support for homoerotic displays of male bodies (Jonathan Katz, "The Art of Code: Jasper Johns and Robert Rauschenberg," in Whitney Chadwick and Isabelle de Courtivron, eds., *Significant Others: Creativity and Intimate Partnership* [London: Thames and Hudson, 1993], pp. 188–207; and Laura Auricchio, "Lifting the Veil: Robert Rauschenberg's *Thirty-four Drawings for Dante's Inferno* and the Commercial Homoerotic Imagery of 1950s America," in Thomas Foster, Carol Siegel, and Ellen E. Berry, eds., *The Gay '90s: Disciplinary and Interdisciplinary Formation in Queer Studies,* Genders, vol. 26 [New York: New York University Press, 1997], pp. 119–154). This idea of the iconographic as the encoding of a relatively coherent text that underlies and explains the images is, of course, miles away

from the complex theories of allegory put in place by Walter Benjamin and then used by other authors, from Paul de Man for literature to Benjamin Buchloh and Craig Owens for the visual arts. In those theories, Baroque allegory is brought forward to demonstrate what in twentieth-century experience is not readable through the iconographic model of a stable relation between two texts. It is precisely the message of uncertainty, of slippage, of unreadability and fragmentation that allegory not only conveys but also, in a necessary act of redoubling, itself becomes. The subject of allegory is thus precisely not the subject of iconography. This would seem to me to be clear from Rauschenberg's own allegory of the subject of media. But, then, the convinced iconographer is almost impossible to dissuade.

Untitled, 1964. Oil and silkscreen ink
on canvas, 58 × 50 in. Private collec-
tion, France. Photograph by Rudolf
Burckhardt.

A Duplication Containing Duplications

Branden W. Joseph

"What's a pure medium?"

—Robert Rauschenberg, "The Art of Assemblage: A Symposium" (1961)

In the fall of 1960, Robert Rauschenberg secluded himself in Treasure Island, Florida, to complete the cycle of Dante drawings he had begun two years earlier. On November 8, however, he interrupted his work to produce *Election,* the only transfer drawing outside the series to feature Rauschenberg's everyman Dante, an image of a nondescript, towel-clad figure appropriated from an advertisement in *Sports Illustrated.* Sitting before the television as the results of the Kennedy-Nixon presidential contest were being broadcast, Rauschenberg employed his signature technique of soaking magazine images in solvent and rubbing them on the back to transfer their ghostly, flickering shadows onto the paper. Alongside Dante, clearly identified in this instance by a large D, *Election* features a smiling image of Jacqueline Kennedy and, above her, oriented inversely, an even larger, more stately image of a smiling JFK. In contrast to the prominent, media-friendly faces of the Kennedys, Pat and Richard Nixon are shown on a much smaller scale, waving, but barely visible, in the drawing's upper right-hand corner. The presence of the American eagle, the head of a Greek statue, and the countenance of George Washington, as Rauschenberg explained in a letter accompanying the work's donation to the first family the following April, "reiterates that the content of the drawing is art and politics."[1] Yet, even though unrepresented, the circumstances of *Election*'s production—its association with a specific

Election, 1960. Solvent transfer on
paper, with pencil and watercolor,
23 × 29 in. Private collection.

broadcast—indicate that television, as much as contemporary politics, served as the work's thematic content. In the same letter to the White House, Rauschenberg made the mass-media references of his work clear, describing Jackie Kennedy's color as "headlined, televised, radioed purple."[2]

In an article written earlier that year, Rauschenberg's close associate John Cage expanded on the connection between the transfer drawings and television. Relating the rapid back-and-forth motion of the artist's stylus to the movement of a cathode-ray tube, Cage noted that "the pencil lines scan the images transferred from photographs" and immediately reinforced that statement with the observation, "it seems like many television sets working simultaneously all tuned differently."[3] Once made, such an analogy with television seems to encompass nearly all of the transfer drawings' most salient features.[4] In addition to likening the shimmering immateriality of the transferred images to television's then low level of resolution, the connection would also account for the many instances of boxlike framing that proliferate throughout the Dante drawings—both

those figurations of individual, technologized vision like TVs and astronauts' helmets, and the penciled boxes within which the image scanning often takes place.[5] Moreover, the transfer drawings attain a visual hybridization of flatness and depth in which the three-dimensional space of the photographic source is retained, even as the scanning of the surface and the surrounding flows of watercolor collapse it onto the support. This fluid slippage between the images in the transfer drawings and between the different spatial areas in which they are contained finds its echo in television's ability—through entirely different means—to subsume and simulate different historical, dimensional, and perspectival spaces within a continuum where they follow one another without disjunction across the depthless "support-surface" of the television screen.[6] "It's like looking out a window," Cage noted in regard to the transfer drawings, adding, parenthetically, "But our windows have become electronic: everything moves through the point where our vision is focused; wait long enough and you'll get the Asiatic panoply."[7]

Positing such a relationship between the transfer drawings and television would also correspond with what is apparently the most anomalous feature of Rauschenberg's Dante project: its unexpected return to narrative illustration and serial production. Like his incorporation of reproductions of Old Master paintings in his Combines, Rauschenberg's turn to Dante has been seen as evidence of the artist's high regard for past culture or an attempt to prove himself a serious artist.[8] Yet, just as his relationship to the Old Masters was presented in the Combines through postcards and other reproductions, Rauschenberg's relationship to Dante is primarily marked by the formal evidence of its mediation. In this, Rauschenberg's *Inferno* may actually be less an illustration of a great work than a project on the order of a made-for-TV miniseries. Such an understanding would at least bring him closer to the stance of Cage, who declared, in his discussion of Rauschenberg's Dante drawings, "As for me, I'm not so inclined to read poetry as I am one way or another to get myself a television set, sitting up nights looking."[9]

In retrospect, Rauschenberg's transfer drawings appear as the beginning of a larger aesthetic transformation brought on by the pressures of the media. As Rauschenberg recalled about this period, "I was bombarded with TV sets and magazines, by the excess of the world. I thought an honest work should incorporate all of these elements, which were and are a reality."[10] What began in 1958 with the transfer drawings seems to have culminated in 1962 with a series of works in which a more seamless

*Canto XXXI: The Central Pit of Male-
bolge, The Giants,* 1959–1960. Solvent
transfer on paper, with colored pencil,
gouache, and pencil, 14 ½ × 11 ½ in.
The Museum of Modern Art, New
York. Given anonymously. Photograph
© 2001 The Museum of Modern Art,
New York.

coincidence of diverse imagery replaced the discontinuity of his earlier use of collage: these include the Combine painting *Ace;* the sole example of a "transfer painting," *Calendar;* the adoption of lithography; a failed attempt to photosensitize canvas; and, finally, after discovering the technique on a visit to Andy Warhol's studio in September, the utilization of silkscreen.[11] That Rauschenberg's desire to, as he told Brian O'Doherty, "get it back flat to see if [he] really did have anything"[12] in the silkscreen paintings and transfer drawings reflects the growing cultural impact of television seems an art-historical commonplace. Yet television, which appears at first sight a very trivial thing, and easily understood, is in reality (as Marx said in another context) a very odd thing, abounding in metaphysical subtleties.

Perhaps the most prevalent critical understanding of television is as an instrument or agent of spectacle, that replacement of the perceptible world where, as Guy Debord declared, "the commodity contemplates itself in a world of its own making."[13] As Rauschenberg moves from the objectified, materialized imagery of his Combines to the relatively substanceless images in his Dante drawings (literally peeling the images off their supports and further divesting them of their original contexts), he seems almost necessarily to be delivering up the intimate spaces of reading, of drawing, and perhaps even of desire, to the order of spectacle.[14] More recently, however, such a direct association of television with spectacle has been both strengthened and problematized in the work of Jonathan Crary. Following upon a remark made in Debord's *Comments on the Society of the Spectacle* (that in 1967 the spectacle "had barely forty years behind it"),[15] Crary has noted the coincidental historical emergence of spectacle and the perfection of television technology. More than simply the substanceless visuality offered by television—which, by entering directly into people's homes, would make visual representation more extensive, continuous, and atomized than ever before—Crary argues that the development of spectacle is linked primarily to the synchronous conjugation of sound and vision introduced nearly simultaneously by television and the sound film.[16] The effect was a new form of subjective perceptual training, the transformation, in Debord's terms, of images into "tangible figments which are the efficient motor of trancelike behavior."[17] "Spectacular power," Crary observes,

> cannot be reduced to an optical model but is inseparable from a larger organization of perceptual consumption. Sound had of course been part of cinema in various additive forms from the beginning, but the

introduction of sync sound transformed the nature of *attention* that was demanded of a viewer. Possibly it is a break that makes previous forms of cinema actually closer to the optical devices of the late nineteenth century. The full coincidence of sound with image, of voice with figure, not only was a crucial new way of organizing space, time, and narrative, but it instituted a more commanding authority over the observer, enforcing a new kind of attention.[18]

At the same time that he reinforces the connection between television and spectacle, however, Crary warns against the dual critical traps of either ontologizing television as a singular, distinct entity or medium (when, in fact, it is a disparate aggregate of technical, economic, and perceptual forces) or totalizing it—whether pessimistically, as the society of the spectacle, or optimistically, as the imminent utopia of Marshall McLuhan's "global village." "Of course," writes Crary,

> television is a global tracery of linkages that produces truth and that increasingly dominates the arena of the lived; but, at the same time, as with any deployment of power, the surface that television mobilizes also encompasses barely visible alcoves, striations, and folds. . . . These, then, are the overlapping spaces to be comprehended: a circuit of power that can be uniform and seamless as a macrophenomenon, but that is broken, diversified, and never fully controllable in its local usage.[19]

From this perspective, spectacle is only one particular, even predominant, manifestation of the technological, perceptual, and economic functions that come to make up television, but it is not identical with the totality of those functions.

Crary proceeds to specify two of the primary features of television's spectacular operation. The first is that focusing and hold over an individual's attention that was established with the development of sync sound; the second is a particular modality of representation by which the visual field is organized into a unified form—a stability of visual appearance or a "redundancy of representation" onto which formations of signification and power can be erected.[20]

In 1959, the year after beginning the Dante drawings, Rauschenberg began to investigate the conjunction of vision and sound by embedding three radios beneath the surface of the Combine painting *Broadcast*.[21] Given Crary's characterization of the stability of spectacular representa-

Broadcast, 1959. Combine painting: oil, pencil, paper, fabric, newspaper, printed paper, printed reproductions, and plastic comb on canvas, with three concealed radios, 61 × 75 × 5 in. Collection of Kimiko Powers, courtesy of Gagosian Gallery.

tion, it is no doubt significant that Rauschenberg also initially sought to accompany *Broadcast*'s sonic dimension with a more uniform and seamless visual appearance than that which had characterized his earlier work. As reported by Gene Swenson, *Broadcast* was originally much bolder, more broadly and flatly painted, with imagery that, according to Rauschenberg, "you could see from across the room."[22] Yet, even while courting the audiovisual functioning of the spectacle, Rauschenberg worked to counteract its unitary perceptual focus. Although the audience was invited to turn the knobs on the surface of the painting, the radios could not be controlled directly or independently. The two knobs on the painting's surface—one for volume and one for frequency band—manipulate all three radios at once, and by setting all three differently Rauschenberg rigged it so that no two radios would ever play the same station or at the same volume.[23]

Broadcast thus fragments the audience's attention across three asynchronous and interfering channels, creating, in effect, a miniature version of Cage's four-minute aleatory composition "Imaginary Landscape #4" (1951), in which twelve radios were "played" by twenty-four performers.

The visual appearance of *Broadcast* underwent a similar transformation. Although explicitly pursuing a more homogeneous visual surface, Rauschenberg found that the addition of sound rendered the original state of the painting too flat and one-dimensional. He recalled that "The painting went dead," that it looked "superficial" and "static," "like a poster."[24] "I realized," he told Swenson, "that the details should not be taken in at one glance, that you should be able to look from place to place without feeling the bigger image. I had to make a surface which invited a constant change of focus and an examination of detail. Listening happens in time. Looking also had to happen in time."[25]

Thus, in *Broadcast's* final state, Rauschenberg fell back on the aleatory, time-bound, part-by-part perception that had characterized his earlier work. Interspersed within a field of evident and expressionless brushstrokes, *Broadcast's* collage elements—such as a broken comb; newsprint images of a horse race, a submarine, and a cityscape; and printed words like "Help!" and ". . . REIGN"—solicit the meandering, aleatory form of looking that had long been a hallmark of his Combines. What he had been seeking, however, was a more unified and easily recognizable visual appearance, one in which the details would exist within a single depth of field, but which would avoid flattening into an overly static subordination of its component parts. In works like *Trophy II (for Teeny and Marcel Duchamp)* of 1961 and, particularly, in *Ace* of 1962—a work originally intended to house five radios—Rauschenberg returned to this pursuit of a more consistent and quickly perceived visual field.[26]

A work such as *Ace* marks a departure for Rauschenberg, not only in being flatter than his earlier work—a feature emphasized by the broad, rectangular areas of light blue and green paint at the right and, further, by the two cardboard boxes pressed flat against the surface of the canvas—but more importantly in attaining a visual homogeneity that eliminates what he had called "changes of focus."[27] This is noticeable, for example, in Rauschenberg's covering of the printing on the box at the lower left that forecloses any impetus to approach and decipher it, and in the manner in which all the visible letters, including Rauschenberg's stenciled "signature" at the lower right, are of a size that can be read easily "from across the room." It was no doubt to complement this effect that Rauschenberg

Ace, 1962. Combine painting: oil, cardboard, wood, and metal on canvas, 108 × 240 in. Albright-Knox Art Gallery, Buffalo, New York. Gift of Seymour H. Knox, Jr., 1963.

insisted on housing *Ace*'s proposed radio control panel in a separate console at some distance from the painting.[28] In this way there would be no need, as had been the case in *Broadcast*, for the viewer/listener to approach the painting to manipulate its sound.

The silkscreen paintings of the next two years follow *Ace*'s lead in getting rid of the "changes of focus" that characterized his earlier work. Although not entirely eliminating the temporality of viewing (as in the panorama-like *Barge* [1962–1963], which is physically too large to be taken in at a glance), the relative insubstantiality of the silkscreen imagery no longer rewards an in-depth, reading-like scrutiny.[29] Instead, it calls for a scanning of the canvas from a single distance, an effect O'Doherty found characteristic of the "vernacular glance" and, once again, likened to watching TV.[30]

Like Crary, Samuel Weber has also recently warned against ontologizing television. As opposed to a unifying conception of television as a medium, Weber points to the three aspects of production, transmission, and reception as the three distinct "places" (or "times") in which television operates, and by which it is internally divided. "The unity of television as a medium of presentation," he writes,

thus involves a *simultaneity* that is highly ambivalent. It overcomes spatial distance but only by *splitting the unity of place* and with it the unity

of everything that defines its identity with respect to place: events, bodies, subjects. The unity of place is split because the "act" of viewing television does not "take place" simply *in front* of the television set, as it might were it simply to involve the viewing of *images*. . . . As the name of the medium says very precisely, one looks at *a certain kind of vision*. And that vision is taking place not simply on the screen but simultaneously—or rather, quasi-simultaneously, since there is always a time-lag—somewhere *else*.[31]

In Weber's analysis, the primary component of television's spectacular operation derives from the apparent unity and insistent self-presence of the televised image that serves to cover over such constitutive internal differences. "If," he continues, "television is both here *and* there *at the same time,* then, according to traditional notions of space, time and body, it can be *neither fully there nor entirely here.* What it sets before us, in and as the television *set,* is therefore split, or rather, it is a *split* or a *separation* that camouflages itself by taking the form of a visible *image*."[32]

If Rauschenberg's silkscreens manage to defeat or avoid a spectacular representational presence, it is not through any temporality of perceptual scanning, which, as O'Doherty indicated, is entirely consistent with television viewing. Rather, it is by the manner in which the iteration of the silkscreen images—both within and between canvases—institutes a split or fissure into the very unity of the work itself. It is as though Rauschenberg had translated the simultaneous and differential here *and* there of the televised image into a similarly undecidable here and there of silkscreen imagery repeated across more than one canvas at a time.

Such a diffraction of the individual work had already been pioneered in Rauschenberg's *Factum I* and *II* of 1957. Seen as a parodic attack on Abstract Expressionism's pretensions to originality, *Factum* is commonly understood as the painstaking duplication of one apparently spontaneous work by another. Despite the numerical order given in the titles, however, Rauschenberg actually worked on both canvases simultaneously—sometimes adding to one and then the other, and sometimes the reverse—so that, to quote Rauschenberg, "neither one of these paintings was an imitation of the other."[33] Talking to Emile de Antonio, he noted, "I painted two identical pictures, but only identical to the limits of the eye, the hand, the materials adjusting to the differences from one canvas to another. Neither one was painted first to compensate for that."[34] As suggested by this quote, at issue for Rauschenberg was not the exactness of reproduction, but

the differences within repetition. "There I was interested in the role that accident played in my work," he explained to Richard Kostelanetz; "I wanted to see how different, and in what way, would be two different paintings that looked that much alike."[35]

In a comparison of the two works, slight but noticeable differences do begin quickly to emerge: differences such as the placement of the red letter T, a few inches further from the corner in *Factum II* than in *Factum I*; the barely visible remnant of text at the bottom of the *Daily News* clipping in *Factum II*; the slightly different sizes and shapes of the polka-dot fabric at the centers of the two canvases; the fact that the red and yellow brushstrokes are larger in *I* than in *II*, whereas the white brushstroke beneath the trees has more drips in *II* than in *I*; and so on . . . even down to the two canvases' different patterns of discoloration.

A further layer of difference arises out of the works' internal repetitions. The two trees on the piece of cloth at the right, for instance, while twins, subtly diverge from one another in the disposition of their leaves and branches.[36] Both images from the *Daily News* at the bottom of the canvas depict the same burning building, but from slightly different distances and at slightly different moments in time. Even the misprinted calendars on the left-hand side take the form of a repeated array of grids, differentiated by the arrangement of numbers within. The most prominent of *Factum*'s paired images, however, are the two Eisenhower portraits at the upper right. Although initially reading as exact reproductions, the absolute identity of the two images is ultimately unclear, and even studying the work at close range only gives rise to an increasing form of doubt. Is the head on the left turned ever so slightly more forward than its counterpart? Does the bordered white triangle in the corner extend further into the picture at the right? Are they in fact two separate photographs taken at the same sitting? Or, perhaps, two images of the same photograph as printed in separate newspapers? Or a slightly different registration of the image during the course of the same paper's print run? Or do the differences between them arise from Rauschenberg's addition of the layer of translucent scrim or the slight markings of blue paint applied to the image on the right?

In 1961, Cage would describe the ability of the repetitions in and of the *Factums* to release such a proliferating series of differences:

Hallelujah! The blind can see again. Blind to what he has seen so that seeing this time is as though first seeing. How is it that one experiences

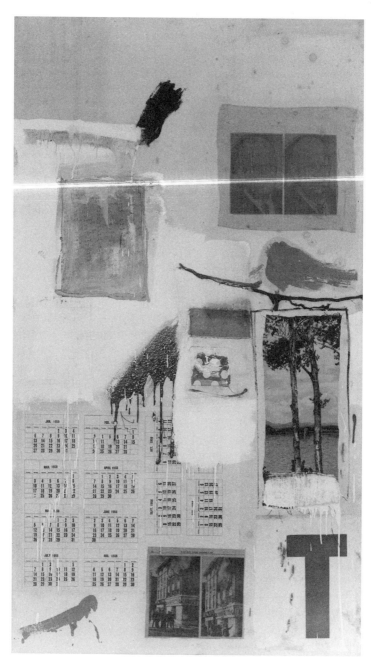

Factum I, 1957. Combine painting:
oil, ink, pencil, crayon, paper, fabric,
newspaper, printed reproductions, and
printed paper on canvas, 62 × 35 ½ in.
The Museum of Contemporary Art,
Los Angeles. The Panza Collection.

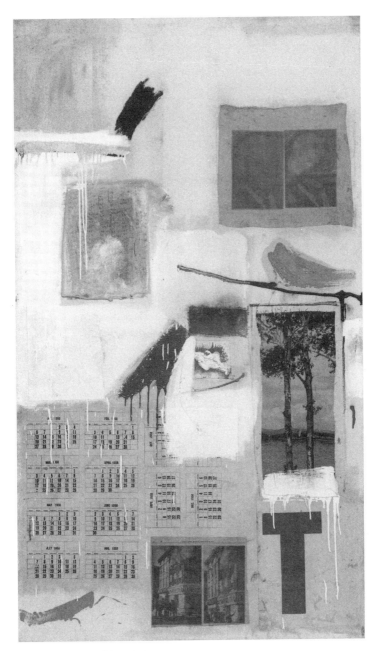

Factum II, 1957. Combine painting: oil, ink, pencil, crayon, paper, fabric, newspaper, printed reproductions, and printed paper on canvas, 62 ⅛ × 35 ½ in. The Museum of Modern Art, New York. Purchase and an anonymous gift and Louise Reinhardt Smith Bequest (both by exchange). Photograph © 2001 The Museum of Modern Art, New York.

this, for example, with the two Eisenhower pictures which for all intents and purposes are the same? (A duplication containing duplications.) Everything is so much the same, one becomes acutely aware of the differences, and quickly. And where, as here, the intention is unchanging, it is clear that the differences are unintentional, as unintended as they were in the white paintings where nothing was done.[37]

Cage's seemingly offhand relation of *Factum I* and *II* back to Rauschenberg's *White Paintings* of 1951 is significant. For in their receptivity to the fleeting and contingent effects of the "lights, shadows, and particles" of dust emanating from their environment, the *White Paintings* functioned as virtually unmediated presentations of difference as a positive force, a force that he and Rauschenberg understood, following Cage's Bergsonian notion of nature, as an infinite differentiation based upon temporal change.[38] Like the *White Paintings,* the repetitions within the *Factums* are not static, but work to reveal the effects of such an external, nonanthropocentric force of difference. Rather than collapsing in on themselves in a fixed and exchangeable identity, Rauschenberg's repetitions form resonating sequences of differences that proliferate throughout each work and into one another. "All it means," Cage wrote about Rauschenberg's "duplication of images," "is that, looking closely, we see as it was everything is in chaos still."[39]

Although readily perceptible in the direct visual encounter of the two canvases, the differences between the two *Factums* prove nearly impossible to recall once removed from such a comparison. Thus, while undoubtedly present, the differences in both the painted and collaged areas of the works remain at an elusive, a–signifying, and preconceptual level that is capable of subverting the dictates of memorization. In so doing, *Factum I* and *II* exemplify the ideal Marcel Duchamp stated in the *Green Box,* one that Cage would come to cite frequently throughout the 1960s: "*To lose* the po*ssibility of* **recognizing** [Identifying] *2 similar objects*—2 colors, 2 laces, 2 hats, 2 forms whatsoever to reach the Impossibility of sufficient *visual* memory, to transfer from one like object to another the *memory* imprint."[40] "The moment a picture begins to look like you think it does," Rauschenberg would later maintain, "it's nearly gone."[41]

Yet, even though unrememberable, the differences between Rauschenberg's two *Factums* do not simply disappear in the observation of one canvas alone. Rather, they continue to haunt each individual work, rendering it incomplete and defeating any claim to full self-presence.[42] As such, neither canvas can any longer attain to the solidity and self-identity

by which it can be privileged as an original against which the other can be judged as a copy. Almost a decade later, Gilles Deleuze would theorize precisely this effect in terms of simulacra. "By simulacrum," he wrote in *Difference and Repetition,*

> we should not understand a simple imitation but rather the act by which the very idea of a model or privileged position is challenged and overturned. The simulacrum is the instance which includes a difference within itself, such as (at least) two divergent series on which it plays, all resemblance abolished so that one can no longer point to the existence of an original and a copy. It is in this direction that we must look for the conditions, not of possible experience, but of real experience (selection, repetition, etc.). It is here that we find the lived reality of a sub-representative domain.[43]

If it became a pressing project for Rauschenberg to explore the subversion of representational self-presence in *Factum I* and *II,* it was not primarily to prolong the aesthetic or artistic life of the paintings, nor even to reveal an underlying ontological condition conceived as chaos. Rather, such an undermining of representational fixity was understood ultimately to oppose the dictates of a generality that subsumed and neutralized perceptible differences in such a way as to render them available to the abstract mechanisms of exchange.[44] Opposing perception to conceptualization in precisely this way, Cage asked of the *Factums,* "And is this a poetry in which Eisenhower could have disappeared and the Mona Lisa taken his place? I *think* so but I do not *see* so."[45] Rauschenberg, for his part, consistently voiced this position as an opposition to the "idea," which he regarded as a debilitating fixation of meaning and therefore akin to "commercial art." This had been explained, in a characteristically hermetic manner, during "The Art of Assemblage" symposium held at the Museum of Modern Art, New York, in 1961, where Rauschenberg dismissively described "understanding" as "a product of good marketing, a general agreement that disposal is necessary," and "an economical way to feel."[46] Rauschenberg broached the issue more clearly and explicitly, however, in describing to Dorothy Gees Seckler his interest in using live radios in such works as *Ace* and *Broadcast:* "To have used a tape" to produce the radio sounds, he stated, "would have been like commercial art in the sense that it would be a rendering of the idea. I'd like for the sound to be as fresh as the daily fall of dust and rust that accumulates. . . . This insistence on the

piece operating in the time situation it was observed in, is another one of the ways of trying to put off the death of the work."[47]

Once again, however, it would be Cage who most clearly articulated the stakes involved in Rauschenberg's position. During questioning after a lecture delivered at Yale in December of 1965, Cage invoked Duchamp's observation about the "impossibility of sufficient *visual* memory" and explained,

> if we take the path of looking for relationships, we will slip over experience-wise all those things that are obvious, like repetition. . . . But . . . if we change our mind and turn utterly around and refuse this business of relationship, to use Duchamp in our own experience, we will be able to see that those things that we thought were the same are in fact not the same. And this is very useful in our lives, which are more and more going to have what appears to be repetition. . . . Now, in a world like that, the perceiving of difference in the repeated, mass-produced items is going to be of the greatest concern to us.[48]

In an uncanny recollection of Cage's comments, Deleuze would propose at the end of *Difference and Repetition* that "there is no other aesthetic problem than that of the insertion of art into everyday life. The more our daily life appears standardized, stereotyped and subject to an accelerated reproduction of objects of consumption, the more art must be injected into it in order to extract from it that little difference which plays simultaneously between other levels of repetition."[49] Nearly twenty years later, however, with the rise of an information economy, Deleuze saw that the standardization of the commodity had ceded in importance to television's no less repetitive and stereotyped subsumption of perception into a single, characteristic "medium shot" or "middle ground" view.[50] As it existed, entirely co-opted by its social function, television represented a wholly technologically and sociologically mediated vision without artistic or critical remainder. "The encyclopedia of the world and the pedagogy of perception" that Deleuze found in postwar cinema,

> collapse to make way for a professional training of the eye, a world of controllers and controlled communing in their admiration for technology, mere technology. . . .

... TV is, in its present form, the ultimate consensus: it's direct social engineering, leaving no gap at all between itself and the social sphere, it's social engineering in its purest form.[51]

For Deleuze, the ascendance of television in the 1960s formed part of an epochal shift in the development of capital and power. It marked the demise of what Michel Foucault had analyzed under the rubric of the older disciplinary regimes and signaled the advent of "the new social power of the postwar period, one of surveillance or control."[52] Whereas the "principal technology" of disciplinary societies was spatial confinement—first within the family, then in an enfilade of schools, barracks, factories, hospitals, and prisons—the "control societies" of the postwar era saw such autonomous institutions progressively replaced by more open-ended, continuous forms of domination. Taking advantage of rapid telecommunication technologies, this new form of control operated across unbounded territories, and, because of the capacity to track individuals nonobtrusively, the electronic tag and the remote video camera became its signal technologies. Yet, in its function of breaking through spatial confinements—its apparent capacity to be present simultaneously in two places at once, to bring "the Asiatic panoply" into Cage's front room—it was actually television that served as the most ubiquitous instigator of the breakdown of all "interiors."[53] While it effected, in this way, a sort of liberation from the sites of disciplinary confinement, television's spectacular operation, in its institution of a hermetic perceptual training and camouflaging of any gap or fissure within the image produced, marked it as an instrument of control; "television," as Deleuze wrote to Serge Daney, "is the form in which the new powers of 'control' become immediate and direct."[54] Faced with this alteration in the regime of power, Deleuze would recast the "sole aesthetic problem" he articulated in *Difference and Repetition* as that of extracting, against television, certain "noncommunicative supplement[s]," differences that would play among its unacknowledged folds, or "circuit breakers" by which to interrupt the viewer's inexorable perceptual training.[55]

It is in the ubiquitous and deterritorialized expansion of television, perhaps, that we begin to open up the full implications of Rauschenberg's silkscreens. For despite their strict unlocatability, the differences between *Factum I* and *II* remain of a physical nature. Revealed in the comparison of the two works are the "accidents" that have befallen each material, the

individual history of each item of collage or application of paint as it, to quote Rauschenberg, "adjust[ed] to the differences from one canvas to another."[56] By contrast, as noted above, the relative immateriality of the silkscreens' imagery does not convey the same specificity of existence at a particular place and time.

Yet, as the silkscreens bring about a decrease in the material distinctions between each image, they effect a corresponding increase in the immaterial haunting of difference internal to each one. No longer attributable to a material given, nor shown in action as in the fleeting shadows that play across the surfaces of the *White Paintings,* difference is revealed in the silkscreens only as an ungraspable, spectral negativity, an absence inhering within the very heart of the image. In this way, each of Rauschenberg's silkscreen images is split internally, divided like the recurrent image of Venus at her mirror (sometimes still heightened by the impression of a stretcher bar or a seam caused by the screen's double registration) or like the astronaut at the top of *Trapeze* (1964)—multiplied and pulled apart into a series of repetitions. Such internal bifurcations proliferate throughout the silkscreen series, appearing, for instance, in the doubled Sunkist orange crates at the bottom of *Whale* (1964), the TV-like sequences of the landing space capsule in *Die Hard* (1963), or the multiplied views of beach umbrellas in *Archive* (1963). As uncanny as the differences found in *Factum I* and *II,* such repetitions within the silkscreen paintings lack their materiality. In the direct comparison of two canvases such as *Retroactive I* and *II* (1963), for example, the astronaut or the pointing figure of JFK does not appear as one image repeated by another so much as it does the *same* image simultaneously visible in two different places at once . . . and thus, as Weber reminds us, not entirely present in either one. At this point, we come to understand more fully the transformation effected by the silkscreen paintings, as Rauschenberg passes from a method reminiscent of mechanical reproduction—physical, separable repetitions, one after the other like two copies of the newspaper—to a method closer to opto-electronic transmission—simultaneous and split simulacra, like an image broadcast on two different television screens at once.[57]

According to Debord, spectacle renders "everything that in human activity exists in a fluid state" into "image-objects" that circulate within a regulated "pseudo-cyclical time" which "is in fact merely the *consumable disguise* of the time-as-commodity of the production system, and [which] exhibits the essential traits of that time: homogeneous and exchangeable units,

Trapeze, 1964. Oil and silkscreen ink
on canvas, 120 × 48 in. Private collec-
tion. Photograph courtesy of Leo
Castelli Gallery.

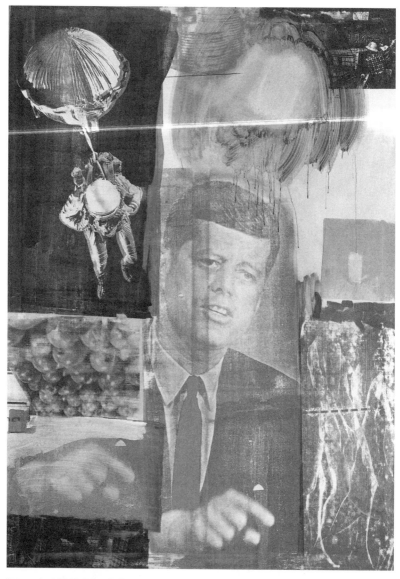

Retroactive I, 1963. Oil and silkscreen
ink on canvas, 84 × 60 in. Wadsworth
Atheneum, Hartford, Gift of Susan
Morse Hilles.

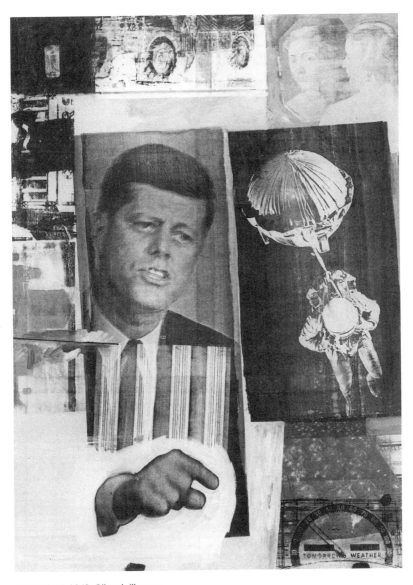

Retroactive II, 1963. Oil and silkscreen ink on canvas, 84 × 60 in. Collection of Stefan T. Edlis. Photograph by Rudolf Burckhardt.

and the suppression of any qualitative dimension."[58] Such, of course, is precisely the temporal experience characteristic of watching TV—an experience where, as Warhol once observed, one encounters "the same plots and the same shots and the same cuts over and over again."[59] Yet such a generalized and indifferent exchange between spectacular moments and images is only possible through the congealed covering over of difference within the units to be exchanged, the "exclusively quantitative" "self-equivalence" that also characterizes the commodity form (even if it, in turn, is covered by a no less exchangeable form of pseudo-differentiation).[60] In the simulacral split of repeated images, however, Rauschenberg produces differences that are unquantifiable, unexchangeable, and that work to undo the generalizable forms of recognition or "visual memory" necessary for spectacular consumption.[61] In releasing perceptible differences from the rule of abstract conceptualization and exchange, Rauschenberg's silkscreens uncover the differences that the spectacular image works to conceal, revealing what Crary called the "barely visible alcoves, striations, and folds" underneath representation.

In 1967, the same year as the appearance of *The Society of the Spectacle* and one year before the appearance of *Difference and Repetition,* Michael Fried would address the stakes involved in the competing perceptual models advanced by contemporary art. In "Art and Objecthood," Fried famously defended as "presentness" an instantaneous form of visual apprehension that he found synonymous with aesthetic quality. Before a convincing late modernist artwork, he proposed, "it is as though one's experience . . . *has no* duration—not because one *in fact* experiences a picture by [Kenneth] Noland or [Jules] Olitski or a sculpture by David Smith or [Anthony] Caro in no time at all, but because *at every moment the work itself is wholly manifest.*"[62] As this and other of Fried's writings make clear, the image's manifest self-presence was to serve the interrelated functions of safeguarding it from the debasement of commercial culture, or kitsch, and guaranteeing the unitary and transcendent status of its viewing subject. As the perceptual hypostatization of modern art's claim to autonomy, Fried's metaphysic of artistic presence was dependent not only on a certain discourse of formalist art history, however, but also on the exclusionary, institutional confines of the museum.[63] It was for this reason that Fried rightfully understood that the art he was defending was "at war" with those currents that were developing within Minimalism.[64] For the Minimalist object not only opposed "presentness" with a mundane perceptual

temporality that Fried likened to theater, but led to an awareness of the phenomenological aspects of the viewing subject's perceptual activity and, eventually, to a realization of the institutional and even disciplinary constraints upon it as well.[65]

Less remarked than Fried's polemic against Minimalism is the ad hominem attack of "Art and Objecthood" on Rauschenberg and Cage, both of whom Fried figured as synonymous with the degeneration of artistic standards. "A failure to register the enormous difference in quality between, say, the music of [Elliott] Carter and that of Cage or between the paintings of [Morris] Louis and those of Rauschenberg," Fried maintained,

> means that the real distinctions—between music and theatre in the first instance and between painting and theatre in the second—are displaced by the illusion that the barriers between the arts are in the process of crumbling (Cage and Rauschenberg being seen, correctly, as similar) and that the arts themselves are at last sliding towards some kind of final, implosive, hugely desirable synthesis.[66]

Fried singled out Susan Sontag as having promulgated this vision from a mistaken trust in her own "theatrical" sensibility,[67] but this dissolution of the distinctions between media would seem better understood as, in effect, a local manifestation of the larger breakdown of all interiors heralded by television. Debord would most clearly present the socioeconomic significance behind such developments. Despite its pretensions to autonomy, and regardless of its genre, art in the modern period had become "subject, as one instance among others, to the movement governing the history of the whole of culture as a separated realm,"[68] subject, in other words, by the midpoint of the century, to the pressures of spectacle. In their uniform recourse to a strategy of interchangeable serial production, the artists championed by Fried bore the stigma of this condition no less than any others.[69]

Yet, to the two more well-known formalist and Minimalist models of aesthetic perception discussed within "Art and Objecthood," Rauschenberg adds a third, one that was as opposed as Minimalism to the false claims of self-presence, which, far from protecting art from the encroachments of commercialism, served only to reproduce or guarantee the operation of spectacle. Rather than proffering a claim to manifest presence, Rauschenberg's silkscreens are fractured among different places and times and solicit

a form of perception that (unlike both Fried's transcendent model and the phenomenology so important to the Minimalist position) is also internally split and haunted by difference. And if Rauschenberg proved to be un-interested in the contemporaneously developing Minimalist and post-Minimalist practices of institution critique, this may have been because his interests were no longer primarily focused on the confines of disciplinary institutions but already, as his investigation of television makes clear, across the mediatized or technological spaces of control.

Notes

1. Letter from Robert Rauschenberg to White House, April 1961. Quoted in Joan Young and Susan Davidson, "Chronology," in Walter Hopps and Susan Davidson, eds., *Robert Rauschenberg: A Retrospective* (New York: Solomon R. Guggenheim Museum, 1997), p. 559.

2. Ibid.

3. John Cage, "On Robert Rauschenberg, Artist, and His Work" (1961), in *Silence* (Middletown, Conn.: Wesleyan University Press, 1961), p. 105.

4. For another treatment of Rauschenberg's relation to television, which reaches different conclusions than those of this paper, see John Alan Farmer, "Art into Television, 1960–65" (Ph.D. dissertation, Columbia University, 1998).

5. In this and the following description of Rauschenberg's transfer drawings, I am indebted to Rosalind Krauss's analysis in "Perpetual Inventory," in *Robert Rauschenberg: A Retrospective,* pp. 206–223; reprinted in this volume. In it, Krauss argues that the transfer drawings and silkscreen paintings mark a new phase in Rauschenberg's production, one in which he leaves behind the tenets of what Leo Steinberg famously termed the "flatbed picture plane" (in this volume, p. 114). Although I take those observations in a different direction, it is the same transformation in the "flatbed" paradigm that I want to investigate here.

6. This characterization of television derives from Paul Virilio, who has noted that, al-though television may appear as a window opening out into three dimensions, it is actually a "third window" in which perspectival space and depth of field are replaced by a depthless "interface" or "support-surface" that is able to project, resemble, or simulate three-dimensional spaces. In this realm where dimensional appearance is actually only a surface effect, "classical optical perspective" is put to an end by "an image whose formal perfection springs not from an optic convergence but from a commutation of various forms of infor-mation" (Paul Virilio, *The Lost Dimension,* trans. Daniel Moshenberg [New York: Semio-text(e), 1991], p. 85). See also Paul Virilio, "The Third Window," trans. Yvonne Shafir, in Cynthia Schneider and Brian Wallis, eds., *Global Television* (New York and Cambridge: Wedge Press and MIT Press, 1988), pp. 185–197.

7. Cage, "On Robert Rauschenberg," p. 106.

8. Such readings run from Charles F. Stuckey, "Reading Rauschenberg," *Art in America* 65, no. 2 (March-April 1977), pp. 74–84, to Thomas Crow, "This Is Now: Becoming Robert Rauschenberg," *Artforum* 36, no. 1 (September 1997), pp. 95–96, 98, 100, 139, 142, 144, 152.

9. Cage, "On Robert Rauschenberg," p. 105. He also writes: "Poetry is free-wheeling. You get its impact by thumbing through any of the mass media" (ibid., p. 106).

10. In Robert Hughes, *The Shock of the New* (New York: Alfred A. Knopf, 1981), p. 345, as quoted in Mary Lynn Kotz, *Rauschenberg: Art and Life* (New York: Harry N. Abrams, 1990), p. 99.

11. Despite some controversy, the consensus of opinion seems to be that Warhol was the first to use silkscreened images in his work, and that Rauschenberg learned of the technique from this visit to Warhol's studio. See Young and Davidson, "Chronology," p. 561; as well as Roni Feinstein, *Robert Rauschenberg: The Silkscreen Paintings, 1962–64* (New York: Whitney Museum of American Art, 1990), p. 45; and David Bourdon, *Warhol* (New York: Harry N. Abrams, 1989), p. 132. On the progression of Rauschenberg's work to the silkscreens, see Feinstein, p. 42.

12. Rauschenberg in 1965, quoted in Brian O'Doherty, *Object and Idea: An Art Critic's Journal, 1961–1967* (New York: Simon and Schuster, 1967), p. 116.

13. Guy Debord, *The Society of the Spectacle*, trans. Donald Nicholson-Smith (New York: Zone Books, 1995), p. 34.

14. The term "materialized imagery" derives from Rosalind Krauss, "Rauschenberg and the Materialized Image," *Artforum* 13, no. 4 (December 1974), pp. 36–43, reprinted in this volume. For a discussion of desire in the Dante drawings, see Laura Auricchio, "Lifting the Veil: Robert Rauschenberg's *Thirty-four Drawings for Dante's Inferno* and the Commercial Homoerotic Imagery of 1950s America," in Thomas Foster, Carol Siegel, and Ellen E. Berry, eds., *The Gay '90s: Disciplinary and Interdisciplinary Formation in Queer Studies*, Genders, vol. 26 (New York: New York University Press, 1997), pp. 119–154. While I find the line of iconographic analysis pursued by the author ultimately unconvincing, Auricchio's discussion of Rauschenberg's representation of male bodies and the possible relation to a certain figuration of desire merits further investigation.

15. Guy Debord, *Comments on the Society of the Spectacle*, trans. Malcolm Imrie (London: Verso, 1998), p. 3, referenced in Jonathan Crary, "Spectacle, Attention, Counter-Memory," *October* 50 (Fall 1989), p. 100.

16. Crary, "Spectacle, Attention, Counter-Memory," pp. 97–107.

17. Debord, *The Society of the Spectacle*, p. 17.

18. Crary, "Spectacle, Attention, Counter-Memory," p. 102.

19. Jonathan Crary, "Eclipse of the Spectacle," in Brian Wallis, ed., *Art after Modernism: Rethinking Representation* (Boston: David R. Godine, 1984), p. 285.

20. Crary, "Spectacle, Attention, Counter-Memory," p. 103. Crary cites Gilles Deleuze and Félix Guattari's discussion of "bleak redundancies of representations."

21. Irving Sandler noted in his review of *Broadcast*'s debut exhibition, "the two knobs protruding from the surface of *Radio Piece* [sic] control three concealed synchronized radios that flood the room with noise. One's attention is forced to the canvas which gets to resemble a multiple-image TV screen" (Irving Sandler, "Reviews and Previews: Robert Rauschenberg," *Art News* 59, no. 2 [April 1960], p. 14). As we shall see, the qualification "multiple-image" is not insignificant.

22. G. R. Swenson, "Rauschenberg Paints a Picture," *Art News* 62, no. 2 (April 1963), p. 45.

23. David White, Rauschenberg's curator, has confirmed details of the operation of *Broadcast*, noting that its aural effect is one of a "general cacophony." Telephone conversation with David White, April 16, 1999.

24. Swenson, "Rauschenberg Paints a Picture," p. 45.

25. Ibid.

26. The augmentation of the number of radios from three to five was significant, no doubt according with Cage's contention that it was the minimum number at which indeterminacy could occur. "One loud-speaker is insufficient," Cage had written in 1954, "and so are two or three or four: five is when it seems to me to begin. What begins is our inability to comprehend" ("45' for a Speaker," in *Silence*, p. 186). Cf. "For a calculated theatrical activity I would say offhand that the minimum number of necessary actions going on at once is five. Bright people can clear up rather quickly perplexity arising from lower numbers" (ibid., p. 173).

27. Robert Rauschenberg, "How Important Is the Surface to Design?" *Print* 13, no. 1 (January–February 1959), p. 31.

28. On the development of *Ace*, and its original technological component, see Swenson, "Rauschenberg Paints a Picture," pp. 45–46, and Billy Klüver and Julie Martin, "Working with Rauschenberg," in Hopps and Davidson, eds., *Robert Rauschenberg: A Retrospective*, pp. 310–327.

29. In this, it is interesting to note that printed words, which are so prevalent in Rauschenberg's Combines, largely disappear from the silkscreen paintings.

30. Brian O'Doherty, "Rauschenberg and the Vernacular Glance," *Art in America* 61, no. 5 (September–October 1973), p. 85.

31. Samuel Weber, "Television: Set and Screen," in *Mass Mediauras: Form, Technics, Media* (Stanford: Stanford University Press, 1996), pp. 117–118. Emphasis in original.

32. Weber, "Television: Set and Screen," p. 120. Emphasis in original. Weber draws from a developing current within the analysis of television that includes Jane Feuer, "The Concept of Live Television: Ontology as Ideology," in E. Ann Kaplan, ed., *Regarding Television: Critical Approaches—An Anthology* (Frederick, Md.: University Publications of America, 1983), pp. 12–22; Mary Ann Doane, "Information, Crisis, Catastrophe," in Patricia Mellencamp, ed., *Logics of Television: Essays in Cultural Criticism* (Bloomington: Indiana University Press, 1990), pp. 222–239; and Deborah Esch, "No Time Like the Present," in her *In the Event: Reading Journalism, Reading Theory* (Stanford: Stanford University Press, 1999), pp. 61–70. Most recently, Rosalind Krauss has drawn upon Weber's analysis of television to theorize the notion of "the medium," most particularly in the work of Marcel Broodthaers. See Rosalind Krauss, *"A Voyage on the North Sea": Art in the Age of the Post-Medium Condition* (New York: Thames and Hudson, 2000).

33. Richard Kostelanetz, "A Conversation with Robert Rauschenberg," *Partisan Review* 35, no. 1 (Winter 1968), p. 97.

34. Emile de Antonio and Mitch Tuchman, *Painters Painting: A Candid History of the Modern Art Scene, 1940–1970* (New York: Abbeville, 1984), p. 94.

35. Kostelanetz, "A Conversation with Robert Rauschenberg," pp. 96, 97.

36. A pairing that brings to mind comments of Cage's such as, "If it [one leaf] were the same as another leaf it would be a coincidence from which each leaf would be free because of its own unique position in space" (Cage, "Juilliard Lecture" [1952], in *A Year from Monday* [Middletown, Conn.: Wesleyan University Press, 1967], p. 99).

37. Cage, "On Robert Rauschenberg," p. 102.

38. Cage's quotation is found in "On Robert Rauschenberg," p. 102. The understanding of Rauschenberg's *White Paintings* in relation to Cage's idea of silence and the thought of Henri Bergson forms the subject of my article "White on White," *Critical Inquiry* 27, no. 1 (Autumn 2000), pp. 90–121.

39. Cage, "On Robert Rauschenberg," p. 100.

40. *The Writings of Marcel Duchamp,* ed. Michel Sanouillet and Elmer Peterson (New York: Da Capo, 1973), p. 31. Cage would paraphrase this statement many times, the first of which seems to have been in "Jasper Johns: Stories and Ideas" (1964), in *A Year from Monday,* p. 79.

41. Quoted in O'Doherty, *Object and Idea,* p. 118.

42. On the "haunting" of difference, discussed in relation to television, see Mark Lewis and Andrew Payne, "The Ghost Dance: An Interview with Jacques Derrida," *Public* 2 (1989), pp. 60–73.

43. Gilles Deleuze, *Difference and Repetition* (1968), trans. Paul Patton (New York: Columbia University Press, 1994), p. 69.

44. As Deleuze explained on page 1 of *Difference and Repetition:* "Repetition is not generality. . . . The exchange or substitution of particulars defines our conduct in relation to generality. . . . By contrast, we can see that repetition is a necessary and justified conduct only in relation to that which cannot be replaced. Repetition as a conduct and as a point of view concerns non-exchangeable and non-substitutable singularities. . . . If exchange is the criterion of generality, theft and gift are those of repetition. There is, therefore, an economic difference between the two."

45. Cage, "On Robert Rauschenberg," p. 102. Emphasis added.

46. "The Art of Assemblage: A Symposium," in James Leggio and Helen M. Franc, eds., *Studies in Modern Art* (New York: Museum of Modern Art, 1992), p. 137.

47. Dorothy Gees Seckler, "The Artist Speaks: Robert Rauschenberg," *Art in America* 54, no. 3 (May-June 1966), p. 84. Rauschenberg is discussing the multipart sculpture *Oracle* (1962–1965), which contains five radios and was the direct descendant of the initial idea for *Ace.*

48. John Cage, "Questions," *Perspecta* 11 (1967), p. 71.

49. Deleuze, *Difference and Repetition,* p. 293.

50. Deleuze, "Letter to Serge Daney: Optimism, Pessimism, and Travel" (1990), trans. Martin Joughin, in *Negotiations, 1972–1990* (New York: Columbia University Press, 1995), p. 72 and n. 8.

51. Ibid., pp. 72, 74.

52. Ibid., p. 71. The description of "control" that follows is drawn from Deleuze's discussions in "Control and Becoming" and "Postscript on Control Societies" in *Negotiations,* pp. 169–176 and 177–182. On the relationship of Debord to Foucault (and television), see Jonathan Crary, *Suspensions of Perception: Attention, Spectacle, and Modern Culture* (Cambridge: MIT Press, 1999), pp. 71–79.

53. Deleuze writes, "We're in the midst of a general breakdown of all sites of confinement—prisons, hospitals, factories, schools, the family. The family is an 'interior' that's breaking down like all other interiors—educational, professional, and so on" ("Postscript on Control Societies," p. 178). Television, as a force that breaks down interiors, that connects the family room to the outside, is constantly blamed for destroying the family. See Lynn Spigel, *Make Room for TV: Television and the Family Ideal in Postwar America* (Chicago: University of Chicago Press, 1992).

54. Deleuze, "Letter to Serge Daney," p. 75.

55. Deleuze, "Letter to Serge Daney," p. 74, and "Postscript on Control Societies," p. 175.

56. Quoted in de Antonio and Tuchman, *Painters Painting,* p. 94.

57. Such an analysis invokes Rauschenberg's more general relationship to technology. Although he was undoubtedly a technological optimist (witness his almost entirely affirmative reaction to the space program), he was not by any means content with technology's

actually existing condition at the hands of industry. His cofounding of Experiments in Art and Technology (E.A.T.) in 1966 would be, in part, an attempt to transform technology's contemporary usage.

58. Debord, *The Society of the Spectacle,* pp. 26, 16, 110.

59. Andy Warhol and Pat Hackett, *Popism: The Warhol Sixties* (New York: Harcourt Brace Jovanovich, 1980), p. 50. This is essentially the same observation made by Stephen Heath and Gillian Skirrow, that "the 'central fact of television experience' is much less flow than *flow and regularity;* the anachronistic succession is also a constant repetition, and these terms of movement and stasis can be found as well within the single programme as within the evening's viewing—or, at least, something of the terms of the latter can be suggested in analysis of the former" (Heath and Skirrow, "Television: A World in Action," *Screen* 18, no. 2 [Summer 1977], p. 15).

60. Debord, *The Society of the Spectacle,* pp. 26–27.

61. It is important here that "visual memory" not be understood as the form of cultural memory discussed within a Frankfurt School discourse. From that perspective, the pseudo-repetition of spectacular time is only made possible on the basis of an annihilation of cultural memory, reference to which would give the lie to the spectacle's continual proclamation of the new. The form of visual memory here in question is more closely related to that comforting recognition that is the handmaiden of habit, that form of memory that leads the subject to accept and feel comfortable with the repetition of, for example, "the same plots and the same shots and the same cuts" of popular television.

62. Michael Fried, "Art and Objecthood" (1967), in Gregory Battcock, ed., *Minimal Art: A Critical Anthology* (Berkeley: University of California Press, 1995), p. 145. It should be noted that, although Fried hypostatizes painting's "essence," he nonetheless regards it as historical. See "Art and Objecthood," pp. 123–124, n. 4.

63. For an analysis of the museum as a disciplinary institution, and Rauschenberg's place within it, see Douglas Crimp, *On the Museum's Ruins* (Cambridge: MIT Press, 1993), the title essay of which is reprinted in this volume.

64. Fried, "Art and Objecthood," p. 139.

65. On Minimalism's development into institution critique, see Hal Foster, "The Crux of Minimalism," in *The Return of the Real* (Cambridge: MIT Press, 1996), pp. 35–69. In it, Foster draws upon the passage from Deleuze's *Difference and Repetition* cited above (see n. 50) to posit the potential of Pop and Minimalism to mobilize repetition as a force of subversion (pp. 66–68).

66. Fried, "Art and Objecthood," p. 141. This passage occurs as the sole example within the section titled "Art degenerates as it approaches the condition of theatre."

67. Ibid., p. 141, n. 17.

68. Debord, *The Society of the Spectacle,* p. 133.

69. It is precisely, I want to argue, in their maintenance of a self-presence that such late modernist paintings actually acquiesced all the more to spectacle's dictates. A similar argument was also posited by Rosalind Krauss in her discussion of the effect of "abstract presence" produced by the postpainterly abstraction championed by Fried (Rosalind Krauss, "Theories of Art after Minimalism and Pop," in Hal Foster, ed., *Discussions in Contemporary Culture* [Seattle: Bay Press, 1987], p. 61). Krauss's assimilation of Pop art within such an analysis, at least as regards Rauschenberg, however, runs counter to the argument of this paper.

Index of Names